Nikon® D700
Digital Field Guide

Nikon® D700 Digital Field Guide

J. Dennis Thomas

WILEY

Wiley Publishing, Inc.

Nikon® D700 Digital Field Guide

Published by
Wiley Publishing, Inc.
10475 Crosspoint Boulevard
Indianapolis, IN 46256
www.wiley.com

WILEY

About the Author

J. Dennis Thomas is a freelance photographer based out of Austin, Texas. He's been using a camera for fun and profit for almost 25 years. Schooled in photography first in high school then at Austin College, he has won numerous awards for both his film and digital photography. Denny has a passion for teaching others about photography and teaches black-and-white film photography to middle school students as well as lighting and digital photography seminars in Austin. He enjoys all types of photography and his photographic subjects are diverse, from weddings and studio portraits to concerts and extreme sports events. He has written six highly successful *Digital Field Guides* for Wiley Publishing and has another in the works. His work has been featured in numerous galleries, magazines, and newspapers in the central Texas area and beyond.

Credits

Acquisitions Editor
Courtney Allen

Project Editor
Jama Carter

Technical Editor
Michael Corrado

Copy Editor
Lauren Kennedy

Editorial Manager
Robyn B. Siesky

Business Manager
Amy Knies

Senior Marketing Manager
Sandy Smith

Vice President and Executive Group Publisher
Richard Swadley

Vice President and Executive Publisher
Barry Pruett

Project Coordinator
Erin Smith

Graphics and Production Specialists
Andrea Hornberger
Jennifer Mayberry
Christin Swinford

Quality Control Technician
John Greenough

Proofreading
Linda Quigley

Indexing
Galen Schroeder

Acknowledgments

Thanks to Courtney, Cricket, Jama, and Laura at Wiley. Thanks to Robert at Precision Camera in Austin for always getting me the camera as soon as it arrives. A special thanks to everyone who appears in my photos, without you the images would have no subject.

Contents at a Glance

Contents

Chapter 3: Setting Up the Nikon D700 65

Part II: Capturing Great Images with the Nikon D700 113

Chapter 4: Selecting and Using Lenses 115

Chapter 5: Essential Photography Concepts 141

Chapter 6: Working with Light 159

Chapter 7: Advanced Shooting Techniques 191

Chapter 8: Viewing and In-Camera Editing 225

Part III: Appendixes 235

Appendix A: Accessories 237

Appendix B: D700 Specifications 243

Appendix C: Online Resources 249

Introduction

Welcome to the *Nikon D700 Digital Field Guide*. This guide is a handy reference book to get you started using your new camera and help you understand the different features and functions that this amazing camera offers.

It is aimed at a wide variety of readers, from beginners to advanced amateurs. Some of you are familiar with many of the concepts, while others of you may be new to digital photography with a digital single lens reflex (dSLR) or new to photography altogether. You'll find sections to help you, regardless of your level.

With its many different buttons and features, the D700 can be daunting. My goal is to explain these settings and features as clearly as possible as you learn the layout of the D700 and how to use the features out in the field.

About the D700

The D700 is the little brother to the D3, which came on the market August 2007. The D3 was Nikon's first camera with a 24 × 36mm full-frame sensor (which Nikon dubs FX). Unfortunately the $5,000 price tag was a bit beyond what most casual photographers could afford. Nikon addressed the need for a more affordable FX camera with a more compact body, and announced the D700 on July 1, 2008. The D700 is essentially a D3 within the body of a D300.

The D700's FX sensor is identical to the D3's 12.1 megapixel CMOS sensor. One of the advantages of having a larger FX sensor is that you have larger pixels that collect light more effectively; this enables you to use higher ISO settings without digital noise.

Another advantage is that the D700's FX sensor allows you to use your lenses without worrying about the pesky "crop factor" that plagues the DX camera lines. Indeed, a 28mm lens is once again a wide-angle lens on the D700. For those of you who started with a DX camera and purchased DX-only lenses such as Nikon's AF-S 17-55mm f/2.8, no worries. Nikon has built in a feature that allows the D700 to crop down to a DX-sized image; this way you can use your DX lenses effectively on the D700 camera body, albeit the sensor resolution is reduced from 12.1 megapixels to 5.1 megapixels. The D700 is compatible with almost all the Nikon lenses ever made. Nikon lenses are world renowned for their quality and durability. You can use hundreds of different lenses on the D700, and any new lens Nikon releases will be compatible.

The D700 is also compatible with Nikon's proprietary Creative Lighting System. The D700 has a built-in flash with a wireless commander mode so, unlike the D3 without a pop-up flash, the D700 can control a number of off-camera Speedlights wirelessly for the ultimate control of your lighting. You can use the D700 with a number of Nikon's Speedlights, from the new flagship flash, the SB-900, on down to the SB-800, SB-600, SB-400, or the macro lighting kit, the R1C1.

As with all Nikon professional cameras, the D700 boasts a sturdy magnesium-framed body that is augmented by weather-sealing gaskets made to keep dust, dirt, and moisture from getting inside the camera body and damaging the internal components. The D700's rugged yet compact camera body can withstand the abuse of any demanding photographer and should last for years to come.

Although the D700 is relatively affordable, Nikon hasn't stripped down any of its features as some other camera manufacturers are known to do. The D700 sports the same impressive Multi-CAM 3500FX 51-point autofocus (AF) system as the D3, the D3's EXPEED imaging processor, and a 14-bit analog-to-digital converter, as well as 16-bit image processing. Like the D3 and the D300, the D700 is also equipped with the versatile Live View function, which allows you to compose your images on the amazing high-resolution, 922,000-pixel, 3-inch LCD screen — a handy feature for framing subjects that may be difficult when you're looking through the viewfinder.

All in all, as you've gathered by now, the D700 is an impressive, durable camera in a compact body that offers many features you previously could only find in the substantially more expensive D3, and that will be sure to last for many years to come.

Using the Nikon D700

Exploring the Nikon D700

The Nikon D700 is considered one of Nikon's pro-level performance camera models and, therefore, has many more buttons, dials, and knobs than most consumer and mid-level cameras. This makes it faster and easier to access the controls that are used most, especially for advanced or professional photographers. To use the same functions in consumer cameras such as the D60 and D90, you need to navigate the menu functions, which can cost precious time when you are in the midst of shooting. Instead of pressing the Multi-selector ten times to find the correct option in the menu system, you simply press one button and rotate a dial — it's quick and easy

With its many buttons and dials, the D700 can be daunting, especially if you are upgrading from a consumer camera, are new to photography in general, or are switching camera brands. This chapter helps you become familiar with the D700's various features, as well as the LCD control panel and viewfinder displays.

D700 FX-format CMOS Sensor

The FX-format CMOS (Complimentary Metal Oxide Semi-conductor) sensor is arguably the most important part of the camera and the main reason why many photographers buy the D700. For quite a few years, Nikon has been using APS-C sized sensors (which they call DX-format) in all their cameras. They are about 24mm × 16mm and because they are much smaller than a standard frame of 35mm film, lenses are subject to a "crop factor." This causes the lenses to perform differently than they have on film cameras. Finally Nikon released the D3, their first "full-frame," or FX, dSLR, meaning that the sensor is the same size as a standard frame of 35mm film. This allows lenses to perform exactly as they had with film

cameras, giving you the same angle of view. Unfortunately, the D3 was a bit expensive, out of the price range for most amateurs. Surprisingly, not long after the launch of the D3, Nikon released a dSLR that is essentially a D3 in a D300-sized body at nearly half the price. This amazing 36 × 24mm, 12 megapixel CMOS sensor gives almost no noise, even at ISO settings up to 6400.

 Cross-Reference *For more information on DX sensors and lenses, see Chapter 4.*

From analog to digital

Believe it or not, digital image sensors are actually analog devices that capture light just like emulsion on a piece of film. When the shutter is opened, light from the scene that you're photographing, whether it be sunlight or flash, travels through the lens and is projected (hopefully in focus) onto the sensor. Each sensor has millions of pixels, which act as a receptacle that collects individual photons of light. A *photon* is a quantum particle of light, which is a form of electromagnetic radiation. The more photons the pixel collects, the brighter the area is; conversely, if the pixel doesn't collect a lot of photons, the area is dark.

Each pixel has a photodiode that converts these photons into minute electrical charges that the Analog/Digital (A/D) converter reads. The A/D converter renders this analog data into digital data that can be utilized by Nikon's EXPEED imaging processor.

CMOS versus CCD

About half of Nikon's dSLRs use Charge Coupled Device (CCD) sensors, although Nikon appears to be moving away from this technology by putting a CMOS sensor in the consumer level D90. Although CMOS and CCD sensors do the same job, they do it differently and each type of sensor has its own strengths and weaknesses.

CCD

The name Charge Coupled Device refers to how the sensor moves the electrical charges created by the photons that the pixels have collected. The CCD sensor moves these electrical charges from the first row of pixels to a *shift register* (a digital circuit that allows the charges to be shifted down the line) and from there, the signal is amplified so the A/D converter can read it. The sensor then repeats the processes with each row of pixels until every row of pixels on the sensor has been processed. This is a pretty precise method of transfer, but in digital terms it's quite slow. It requires a large amount of power, relatively speaking, so it uses more of the camera battery, which equals fewer shots per charge. CCD sensors have a higher signal to noise ratio; which makes them less prone to high ISO noise than CMOS sensors and enables them to provide a higher image quality.

CMOS

Just like a CCD sensor, a CMOS sensor has millions of pixels and photodiodes. The main difference between the CMOS and CCD sensor is that each pixel has its own amplifier and it converts the charge to voltage on the spot. It's much more efficient to transfer voltage than it is to transfer a charge; therefore, CMOS sensors use less power than CCDs. Multiple channels of sensor data can also be sent out at the same time, so the CMOS sensor can send the data to the A/D converter much faster. CMOS chips are also cheaper to manufacture than CCDs.

Pixels

The more pixels the sensor has, the higher the resolution of the sensor. However, packing more pixels onto a sensor means that although the resolution is higher, each pixel becomes less effective at gathering light because its much smaller. A larger pixel is more effective at gathering photons; therefore you get a wider dynamic range and a better signal-to-noise ratio, which means less inherent noise and the ability to achieve a higher ISO sensitivity.

One of the reasons that Nikon chose to use a lower resolution sensor on their full-frame sensor than their competitors do is to keep the pixel size larger, thereby allowing better low-light capability. The D700 and D3 sensor has a pixel size of 8.5 microns, which is the largest pixel pitch of any digital sensor on the market at this time.

Micro-lenses

In addition to having larger pixels to gather more light, camera manufacturers place micro-lenses over the pixels. These micro-lenses collect the light and focus them onto the photodiode much the same way the camera lens focuses the image onto the sensor. By making the micro-lenses larger, Nikon has decreased the gaps between the pixels, increasing the effective light gathering ability of each one.

Interpreting color

The light-sensitive pixels on the sensor only measure the brightness in relation to how many photons it has gathered, so the basic image captured is, in effect, black and white. To determine color information, the pixels are covered with red, green, or blue colored filters. These filters are arranged in a Bayer pattern. (Dr. Bryce Bayer was a scientist at Kodak who developed this pattern.) The Bayer pattern lays the filters out in an array that consists of 50 percent green, 25 percent blue, and 25 percent red. The green filters are luminance (brightness) sensitive elements and the red and blue filters are chrominance (color) sensitive elements. Twice as many green filters are used to simulate human eyesight given our eyes are more sensitive to green than to red or blue.

The camera determines the colors in the image by a process called *demosaicing*. In demosaicing, the camera interpolates the red, green, and blue data for each pixel by using information from adjacent pixels. *Interpolation* is a mathematical process in which sets of known data are used to determine new data points. (I like to call it an educated guess.)

Key Components of the D700

If you've used a Nikon dSLR before, you should be pretty familiar with the basic buttons and switches that you need to do the basic settings. In this section, I cover the camera from all sides and break down the layout so that you know what everything on the surface of the camera does.

Although you can access many features with just the push of a button, oftentimes you can change the same setting using menu options. The great thing about the buttons, however, is that they give you speedy access to important settings — settings you will use often. Missing shots because you are searching through the menu options can get irritating fast, which is one of the key reasons

most people upgrade from a consumer model camera to a professional-grade camera like the D700.

 Cross-Reference *For information about specific menus and their functions, see Chapter 3.*

Top of the camera

The most important buttons are on the top of the D700. This is where you'll find the buttons for the settings you'll tend to change most frequently. I've also included is a brief description of some of the features you will find on the top of the lens in this section. Although your lens may vary, most of the features are quite similar from lens to lens.

✦ **Shutter Release button.** In my opinion, this is the most important button on the camera. Halfway pressing this button activates the camera's autofocusing and light meter. When you fully depress this button, the shutter is released and a photograph is taken. When the camera is set to CL or Ch, pressing and holding this button takes a sequence of photos. When the camera has been idle and has "gone to sleep," lightly pressing the Shutter Release button wakes the camera up. When the image review is on, lightly pressing the Shutter Release button turns off the LCD control panel and prepares the camera for another shot.

✦ **On/Off switch/LCD illuminator.** This switch turns on the camera. It's concentric with the Shutter Release button. You push the switch all the way to the left to turn the camera off. When the switch is in the center position, the camera

is turned on. When you push the spring-loaded switch all the way to the right, the top-panel LCD illuminator turns on. This enables you to view your settings when in a dimly lit environment. The LCD illuminator turns off automatically after a few seconds or when the shutter is released. In Custom Settings menu (CSM) f1, you can also specify that this switch be used to display the Shooting info display on the rear LCD screen.

✦ **Exposure mode button.** This button is used in conjunction with the Main Command dial and allows you to change among the different exposure modes. You can choose Programmed Auto (P), Shutter Priority (S), Aperture Priority (A), or Manual (M) modes. This button also doubles as a format button when you press it down in conjunction with the Delete button. Pressing and holding down these two buttons simultaneously allows you to format your CompactFlash (CF) card without entering the Setup menu.

✦ **Exposure Compensation button.** Pressing this button in conjunction with spinning the Main Command dial allows you to modify the exposure that is set by the D700's light meter or the exposure you set in Manual exposure mode. Turning the Main Command dial to the right decreases exposure, while turning the dial to the left increases the exposure. This button also doubles as the camera reset button when used in conjunction with the Quality button. Pressing these buttons at the same time restores the camera to the factory default settings.

✦ **LCD control panel.** This displays many of the main camera settings. I cover this panel in detail later in this chapter.

✦ **Focal plane mark.** The focal plane mark shows you where the plane of the CMOS image sensor is inside the camera. The sensor isn't exactly where the mark is; the sensor is directly behind the lens opening. When doing certain types of photography, particularly macro photography using a bellows lens, you need to measure the length of the bellows from the front element of the lens to the focal plane. This is where the focal plane mark comes in handy.

✦ **Hot shoe.** You attach an accessory flash to the camera body here. The hot shoe has an electronic contact that tells the flash to fire when the shutter is released. There are also a number of other electronic contacts that allow the camera to communicate with the flash to enable the automated features of a dedicated flash unit such as the SB-600.

✦ **Release Mode dial.** Rotating this dial changes the release mode of the camera. You can choose from Single shot, Continuous Low mode, Continuous High mode, Live View, Self-timer, and Mirror up. To rotate the dial, you must press the Release Mode dial lock release.

✦ **Release Mode dial lock release.** This button locks the Release Mode dial to prevent it from accidentally being changed.

✦ **Quality button.** Press this button and rotate the Main Command dial to change the file format that your camera is saving in as well as the

quality of the JPEG if you are shooting that format. You can choose from RAW, TIFF, JPEG, or RAW + JPEG. Your JPEGs are saved at Fine, Normal, or Basic quality. Rotating the Sub-command dial while pressing this button allows you to change the size of the image when the camera is set to save in TIFF, JPEG, or RAW + JPEG. Rotating the Sub-command dial when the camera is set to save RAW files has no effect.

> **Cross-Reference** *For more information on image quality and size settings, see Chapter 2.*

✦ **ISO button.** Press this button and rotate the Main Command dial to change the ISO sensitivity. The higher the ISO setting, the less light needed to make an exposure. The ISO value is displayed on the LCD control panel while the ISO button is pressed. The ISO value is also displayed in the viewfinder. To learn more about ISO, see Chapter 2.

✦ **White Balance button.** Press this button and rotate the Main Command dial to choose from one of the predefined white balance (WB) settings such as Daylight, Incandescent, or Fluorescent. You can also choose to set your own WB (PRE) or choose a specific color temperature (K). White balance is used to compensate for the effect that different colored light sources have on your photos. Adjusting the WB gives your images a natural look. When the D700 is set to a predefined WB, holding the button and rotating the Sub-command dial allows you to adjust the WB by making it cooler (right) or warmer (left). For more on white balance settings, see Chapter 2.

✦ **Focus ring.** Rotating the focus ring enables you to manually focus the lens. With some lenses, such as the high-end Nikkor AF-S lenses, you can manually adjust the focus at any time. On other lenses, typically older and non-Nikon lenses and consumer-level AF-S lenses, you must switch the lens to Manual focus to disable the focusing mechanism.

✦ **Zoom ring.** Rotating the zoom ring enables you to change the focal length of the lens. Prime lenses do not have a zoom ring.

Cross-Reference *For more information on lenses, see Chapter 4.*

✦ **Focus distance scale.** This displays the approximate distance from the camera to the subject.

Back of the camera

The buttons that mainly control playback and menu options are on the back of the camera, although there are a few that control some of the shooting functions. Most of the buttons have more than one function — a lot of them are used in conjunction with the Main Command dial or the Multi-selector. You will also find several key features, including the all-important viewfinder and LCD screen.

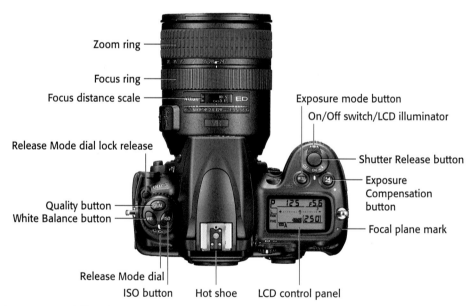

Zoom ring
Focus ring
Focus distance scale
Exposure mode button
On/Off switch/LCD illuminator
Release Mode dial lock release
Shutter Release button
Exposure Compensation button
Quality button
White Balance button
Focal plane mark
Release Mode dial
ISO button Hot shoe LCD control panel

Image courtesy of Nikon, Inc.

1.1 Top of the camera controls

✦ **LCD screen.** This is the most obvious feature on the back of the camera. Nikon's 3-inch, 920,000-dot liquid crystal display (LCD) screen is, so far, the highest resolution LCD on the market today (the D3 and D300 share this feature). The LCD screen is where you review your images after shooting, or compose them using Live View. The menus are also displayed here.

✦ **Viewfinder.** This is what you look through to compose your photographs (unless you're using Live View). Light coming through the lens is reflected from a mirror up to a pentaprism that reflects the image through the viewfinder to your eye, enabling you to see exactly what you're shooting (as opposed to a rangefinder camera, which gives you an approximate view). Around the viewfinder is a rubber eyepiece that serves to give you a softer place to rest your eye and to block any extra light from entering the viewfinder as you compose and shoot your images. Looking in the viewfinder you will also see a control panel; more on this later in the chapter.

✦ **Eyepiece shutter lever.** Flipping this lever closed closes a shutter over the viewfinder. You can use this option when you are shooting without looking directly in the viewfinder (for example, with timed exposures on a tripod or when you're using Live View). This stops light from entering into the viewfinder and fooling the camera's exposure meter, causing it to underexpose. You must also close this lever to remove the eyepiece.

✦ **Diopter adjustment control.** Just to the right of the viewfinder is the Diopter adjustment control. Use this control to adjust the viewfinder lens to suit your individual vision differences (not everyone's eyesight is the same). To adjust this, look through the viewfinder; if the viewfinder display, focus points, and AF area brackets aren't quite sharp, pull out the button and turn the Diopter adjustment control until everything appears in focus. When you are satisfied with the results, be sure to push the button back in.

✦ **Metering Mode dial.** You use this dial to choose the metering mode: Matrix, Center-weighted, or Spot metering. This dial is concentric with the Auto-Exposure/Autofocus lock (AE-L/AF-L) button.

✦ **AE-L/AF-L button.** The AE-L/AF-L button is used to lock the Auto-Exposure (AE) and Autofocus (AF). This button can be customized to perform several different functions in CSM f7.

✦ **AF-ON button.** The Autofocus On button activates the AF mechanism without your having to press the Shutter Release button. When in Single Focus mode, the AF-ON button also locks in the focus until the button is released.

✦ **Main Command dial.** You use this dial to change a variety of settings depending on which button you are using in conjunction with it. By default, it is used to change the shutter speed when you're in S and M mode. It can also be used with the ISO, QUAL, and WB buttons.

✦ **Multi-selector.** The Multi-selector is another button that serves a few different purposes. When the D700 is in Playback mode, you use the Multi-selector to scroll through the photographs you've taken, and you can also use it to view image information such as histograms and shooting settings. When the camera is in Shooting mode, you can use the Multi-selector to change the active focus point when the camera is in Single-point or Dynamic-area AF mode.

✦ **Focus selector lock.** You can use this switch to lock the active focus point so it's not accidentally changed if the Multi-selector is pushed. Slide the switch to the L position to lock the focus point.

✦ **AF Area Mode selector.** You use this three-position switch to choose among focus modes: Single-area AF, Dynamic-area AF, or Auto-area AF.

✦ **Info button.** Press this button once to view the Shooting info display, which displays the current camera settings. Press this button twice to enter the Quick Settings Display, which allows you to quickly change a few options such as Noise Reduction, Picture Controls, and color space.

✦ **CF card access lamp.** This lamp lights up to let you know that data is being transferred between the camera and the CF card. Under no circumstance should you remove the CF card while this lamp is lit.

✦ **Playback button.** Pressing this button displays the most recently taken photograph. You can also view other pictures by pressing the Multi-selector left and right.

✦ **Delete button.** When reviewing your pictures, if you find some that you don't want to keep, you can delete them by pressing this button, marked with a trashcan icon. To prevent the accidental deletion of images, the camera displays a dialog box asking you to confirm that you want to erase the picture. Press the Delete button a second time to permanently erase the image.

✦ **Menu button.** Press this button to access the D700 menu options. There are a number of different menus including Playback, Shooting, Custom Settings, and Retouch. Use the Multi-selector to choose the menu you want to view.

✦ **Protect/Help button.** The Protect button has the icon of a key on it. The primary use of the Protect button is to lock the image to prevent it from being deleted. You can only access this function when the camera is in Playback mode. When viewing the image you want to protect, simply press this button. A small key icon will be displayed in the upper-right-hand corner of images that are protected. Pressing the Shutter Release button lightly brings you back to default shooting mode. When you're viewing the menu options, pressing this button displays a help screen that explains the functions of that particular menu option.

✦ **Thumbnail/Zoom out button.** In Playback mode, pressing this button allows you to go from full-frame playback (or viewing the whole image) to viewing thumbnails. You can view thumbnails either four images or nine images on a page.

✦ **Zoom in button.** When reviewing your images, you can press the Zoom in button to get a closer look at the details of your image. This is a handy feature for checking the sharpness and focus of your shot. When you're zoomed in, use the Multi-selector to navigate around within the image. To view your other images at the same zoom ratio, rotate the Main Command dial. To return to full-frame playback, press the Zoom out button. You may have to press the Zoom out button multiple times depending on how much you have zoomed in.

✦ **OK button.** When you're in the Menu mode, press this button to select the menu item that is highlighted.

Front of the camera

The front of the D700 (lens facing you) is where you find the buttons to quickly adjust the flash settings as well as some camera focusing options, and with certain lenses you will find buttons that control focusing and Vibration Reduction (VR).

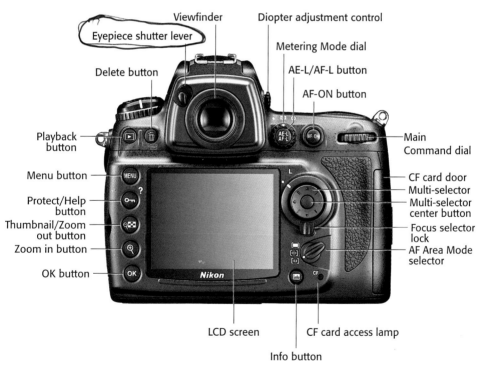

Image courtesy of Nikon, Inc.
1.2 Back of the camera controls

Right front

The right front of the camera has the following controls:

✦ **Built-in flash.** This option is a handy feature that allows you to take sharp pictures in low-light situations. Although it's not as versatile as one of the external Nikon Speedlights, such as the SB-800 or SB-600, you can use the built-in flash very effectively and it is great for snapshots. However, I don't recommend using this without first getting a pop-up flash diffuser. The best feature of the built-in flash is you can also use it as a commander unit to trigger Nikon CLS-compatible Speedlights wirelessly for off-camera use.

Cross-Reference *For more on using flash, see Chapter 6.*

✦ **Flash pop-up button.** Press this button to open and activate the built-in flash.

✦ **Flash mode button.** Pressing this button and rotating the Main Command dial on the rear of the camera allows you to choose a flash mode. You can choose from among Front-Curtain Sync, Red-Eye Reduction, Red-Eye Reduction with Slow sync, Slow Sync, and Rear-Curtain Sync. Pressing the Flash mode button and rotating the Sub-command dial, located just below the Shutter Release button, enables you to adjust the Flash Exposure Compensation (FEC). FEC allows you to adjust the flash output to make the flash brighter or dimmer depending on your needs.

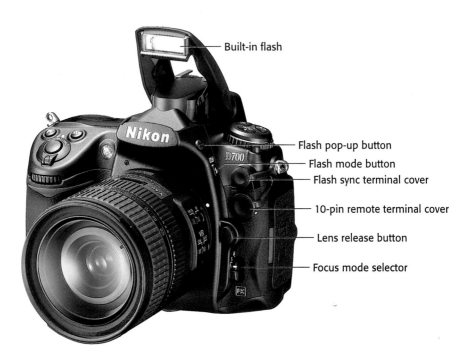

Built-in flash

Flash pop-up button
Flash mode button
Flash sync terminal cover

10-pin remote terminal cover

Lens release button

Focus mode selector

Image courtesy of Nikon, Inc.
1.3 Right front camera controls

✦ **Flash sync terminal cover.**
Underneath this rubber cover is the
flash sync terminal. This terminal,
also known as PC sync, allows you
to connect a PC cord to trigger an
external flash or studio strobe.

✦ **10-pin remote terminal cover.**
Underneath this rubber cover is the
10-pin remote terminal. This termi-
nal allows the camera to be con-
nected to a variety of accessories.
Some of these include the Nikon
MC-30 remote shutter release cord
and Global Positioning System
(GPS) devices.

✦ **Lens Release button.** This button
disengages the locking mechanism
of the lens, allowing the lens to be
rotated and removed from the lens
mount.

✦ **Focus Mode selector.** This three-
way switch is used to choose which
focus mode the camera operates
in: Single AF (AF-S), Continuous AF
(AF-C), or Manual (M) focus. Keep
in mind that your lens may also
have a focus mode switch and that
it must be in the A or M/A position
to work with the AF-S or AF-C
modes.

Left front

The left front of the camera has the follow-
ing controls:

✦ **AF-assist illuminator.** This is an
LED that shines on the subject to
help the camera to focus when the
lighting is dim. The AF-assist illumi-
nator only lights when it's in Single
Focus mode and when the camera

is in Auto-area AF mode, or when
in Dynamic- or Single-area AF and
the focus point is set to the center
position. This illuminator also
shines when the Speedlight is set
to Red-Eye Reduction mode. The
light shines on the subject, causing
the pupils to contract, which
reduces the red-eye effect. When
the self-timer is activated, this light
blinks to count down the timer. It's
recommended that you remove
your lens hood when using this
feature because the hood can block
the light reducing the effectiveness.

✦ **Sub-command dial.** You use this
dial, by default, to change the aper-
ture setting when in Aperture
Priority and Manual exposure
mode. You also use it to change
JPEG file size when used with the
QUAL button and to fine-tune
white balance when used with the
WB button. When you use the Sub-
command dial in conjunction with
the Flash mode button, you can
adjust the Flash Exposure
Compensation (FEC)

✦ **Depth-of-field preview button.**
While using the camera's default
settings, pressing this button stops
down the aperture of the lens so you
can preview how much of the sub-
ject is in focus (the depth of field).
The image in the viewfinder gets
darker as the aperture decreases.
You can also customize the Depth-
of-field preview button in CSM f6 or
in the Quick Settings Display.

Cross-
Reference *For more information on aper-
tures, see Chapter 5.*

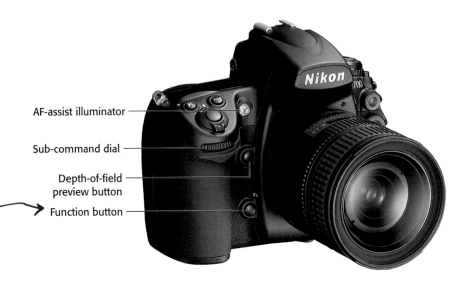

Image courtesy of Nikon, Inc.

AF-assist illuminator

Sub-command dial

Depth-of-field preview button

Function button

1.4 Left front camera controls

✦ **Function button.** You can customize the Function (Fn) button to perform different functions depending on user preference. You can use it to set exposure, flash, WB bracketing, flash value (FV) lock, and a number of other settings. You can set the Function button in CSM f4.

Cross-Reference *For more information on the CSM, see Chapter 3.*

Sides and bottom of camera

The sides and bottom of the camera have places for connecting and inserting things such as cables, batteries, and memory cards.

Right side

The D700's various output terminals are on the right side of the camera (with the lens facing you). These are the connections you use if you would like to view your images straight from the camera as a slide show on your television. Or you may have a high-definition (HD) monitor in your studio and use the Live View function along with Camera Control Pro 2 to view your images in HD before you even release the shutter. You can also attach an AC adaptor for those long studio shoots that require plenty of juice without worrying about the batteries giving out on you. The output terminals are

✦ **Standard video out.** You use this connection, officially called Standard video output, to connect the camera to a standard TV or VCR for viewing your images on-screen. The D700 is connected with the EG-D100 video cable that is supplied with the camera.

✦ **HDMI out.** You use the HDMI (High-Definition Multimedia Interface) output terminal to connect the camera to an HD television (HDTV). The

camera is connected with an optional Type A HDMI cable that you can purchase at an electronics store.

✦ **DC power in.** This AC adapter input connection allows you to plug the D700 into a standard electrical outlet using the Nikon EH-5 or EH-5a AC adapter. This allows you to operate the camera without draining your batteries. The AC adapter is available separately from Nikon.

✦ **USB 2.0 port.** This is where the USB cable plugs in to attach the camera to your computer to transfer images straight from the camera. You can also use the USB cable to connect the camera to the computer when you're using Nikon's optional Camera Control Pro 2 software.

Left side

The CF card slot cover is on the left side of the camera (with the lens facing you). Slide this cover back and the door springs open. Insert the CF card with label side facing toward the back of the camera. Press the card firmly in until the grey button pops out. To eject the card, firmly press the grey button until the CF card is loose.

Bottom

The bottom of the camera has a few features that are quite important:

✦ **Battery chamber cover.** This covers the chamber that holds the EN-EL3e battery that is supplied with your D700.

✦ **Tripod socket.** This is where you attach a tripod or monopod to help steady your camera.

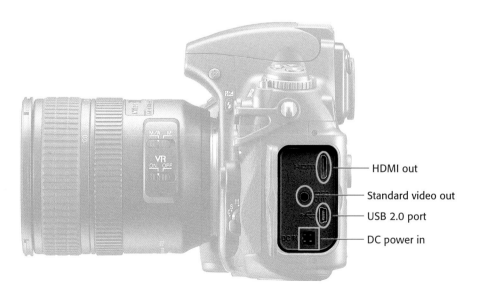

HDMI out
Standard video out
USB 2.0 port
DC power in

Image courtesy of Nikon, Inc.
1.5 The D700's output terminals

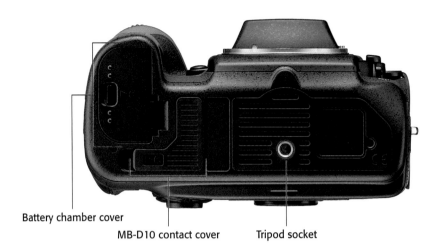

Battery chamber cover

MB-D10 contact cover Tripod socket

Image courtesy of Nikon, Inc.
1.6 The bottom of the D700

✦ **MB-D10 contact cover.** This rubber cover is used to protect the contact points for the optional MB-D10 Multi-power Battery Grip that attaches to the bottom of the camera. The MB-D10 allows you to use a variety of battery types as well as to control the camera when holding it in the vertical position.

Viewfinder Display

When looking through the viewfinder, you see a lot of useful information about the photo you are setting up. Most of the information is also displayed in the LCD control panel screen on the top of the camera, but it is less handy on top when you are composing a shot. Here is a complete list of the information you get from the viewfinder display.

✦ **Framing grid.** When this option is turned on in CSM d2, you will see a grid displayed in the viewing area. This helps with composition. Use the grid to help line up elements of your composition to ensure that things are straight (or not).

✦ **AF-area brackets.** These brackets give you a rough estimate of where the group of 51 AF points is located. Anything in the frame outside of this bracket cannot be locked into focus. Switching to DX mode gives you wider range of AF coverage due to the reduced frame size.

✦ **12mm reference circle.** These curves located at the top and bottom of the AF-area brackets give you an idea of how much of an area of the frame is used for Center-weighted metering. The curves show you an area of 12mm,

which is the default circle size for center-weighted metering. Note that although you can change the size of the area for center-weighted metering (CSM b12), this display does not change.

✦ **Focus points.** The first thing you are likely to notice when looking through the viewfinder is a small rectangle near the center of the frame. This is your active focus point. Note that the focus point is

only shown full time when the D700 is in the Single- or Dynamic-area AF setting. When the camera is set to Auto-area AF and Single Focus, the focus point isn't shown until you half-press the Shutter Release button and focus is achieved. When the D700 is in Auto-area AF and set to Continuous Focus mode, the focus point is not displayed at all.

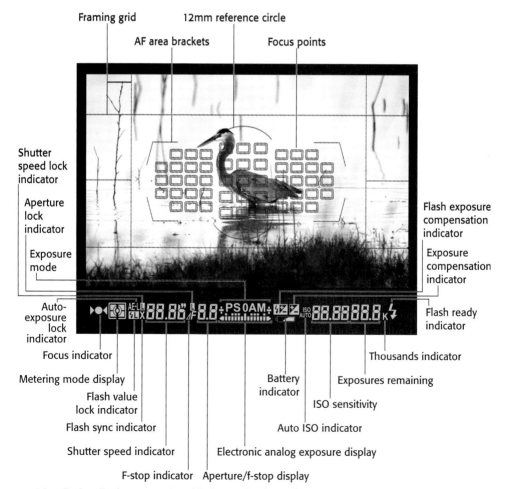

1.7 Viewfinder display. Note that this figure displays all possible focus points. Only the active focus points will be visible in actual shooting conditions.

A black bar with LCD readouts on it appears below the image portion of the viewfinder. Not only do you find your shooting information here, but also depending on the settings you've selected, other useful indicators appear as well. From left to right these items are

✦ **Focus indicator.** This green dot and arrows lets you know if the camera detects that the scene is in focus. When the camera attempts to autofocus, the arrows located to either side of the dot blink. The left arrow or the right arrow may blink simultaneously or one at a time, depending on where the camera is trying to focus. When focus is achieved, the green dot lights up; if the camera is unable to lock focus, both arrows blink. When you are focusing manually, you can use the arrows as a guide to find focus. When the arrow on the left is lit, your focus is falling between the camera and the subject. If the arrow on the right is lit, the focus is falling behind the subject. If the camera is unable to detect enough contrast to determine if the subject is in focus, both arrows blink.

✦ **Metering mode display.** This display shows which metering mode you are in: Spot, Center-weighted, or Matrix.

✦ **AE lock indicator.** This tells you that the auto-exposure meter is locked. Depending on your settings, the AE-L/AF-L button may be pressed or the shutter is half-pressed. When this is locked you can recompose the image while maintaining the correct exposure for the subject.

✦ **FV lock indicator.** When the FV lock indicator is on, it means you have locked in the flash exposure value. The flash value can only be locked when the Function (or Preview or AE-L/AF-L) button has been set to do this.

✦ **Shutter speed lock indicator.** This indicates that your shutter speed has been locked to prevent accidental changes. You can lock your shutter speed in CSM f8.

✦ **Flash sync indicator.** This indicator is displayed as an X. This comes on when you set your camera to the flash sync speed limit that is set in CSM e1. This is only available when in Shutter Priority or Manual mode. To set the camera to the preset sync speed, dial the shutter speed down one setting past the longest shutter time, which is 30 seconds in S and bulb in M.

✦ **Shutter speed display.** This shows how long your shutter is set to stay open. Rotating the Main Command dial when in S or M mode can change the shutter speed.

✦ **Aperture lockindicator.** This indicates that your aperture has been locked to prevent accidental changes. You can lock this aperture setting in CSM f8.

✦ **Aperture/f-stop display.** This shows what your current lens opening setting is. You adjust aperture by rotating the Sub-command dial when in M or A mode.

✦ **Exposure mode display.** This tells you which exposure mode you are currently using: P, S, A, or M.

✦ **Electronic analog exposure display.** Although Nikon gives this feature a long and confusing name, in simpler terms, this is your light meter. When the bars are in the center, you are at the proper settings to get a good exposure; when the bars are to the left, you are overexposed; and when the bars are to the right, you are underexposing your image. You can reverse this in CSM f12. This feature is especially handy when using Manual exposure. This display also doubles as the virtual horizon indicator. When the camera is tilted to the right, the bars are displayed on the left. When the camera is tilted to the left, the bars are displayed on the right. When the camera is level, a single bar appears directly under the zero.

✦ **FEC indicator.** When this is displayed, your Flash Exposure Compensation is on. You adjust FEC by pressing the Flash mode button and rotating the Sub-command dial.

✦ **Exposure compensation indicator.** When this appears in the viewfinder, your camera has exposure compensation activated. You adjust exposure compensation by pressing the Exposure Compensation button and rotating the Main Command dial.

✦ **Battery indicator.** When this icon appears, your battery is low; if it is blinking, your battery is dead and the Shutter Release button is disabled.

✦ **Auto ISO indicator.** This is displayed when the Auto ISO setting is activated to let you know that the camera is controlling the ISO settings. You can turn on Auto ISO in the ISO sensitivity settings located in the Shooting menu.

✦ **ISO sensitivity display.** This tells you what the ISO sensitivity is currently set to.

✦ **Exposures remaining.** This set of numbers lets you know how many more exposures can fit on the CF card. The actual number of exposures may vary according to file information and compression. When you half-press the Shutter Release button, the display changes to show how many exposures can fit in the camera's buffer before the buffer is full and the frame rate slows down. The buffer is in-camera RAM that stores your image data while the data is being written to the memory card. This also shows the WB preset recording information as well as your exposure compensation values.

✦ **Thousands indicator.** This lets you know that there are more than 1,000 exposures remaining on your memory card.

✦ **Flash ready indicator.** When this is displayed the flash, whether it is the built-in flash or an external Speedlight attached to the hot shoe, is fully charged and ready to fire at full power.

Control Panel

The monochrome control panel on top of the camera displays some of the same shooting information that appears in the viewfinder, but there are also some settings that are only displayed here. This LCD control panel allows you to view and change the settings without looking through the viewfinder. The settings are as follows:

✦ **Shutter speed.** By default this set of numbers shows you the shutter speed setting. This set of numbers also shows a myriad of other settings depending on which buttons are being pressed.

- **Exposure compensation value.** When you press the Exposure Compensation button and rotate the Sub-command dial, the exposure value (EV) compensation number is displayed.

- **FEC value.** Pressing the Flash mode button and rotating the Sub-command dial displays the FEC value.

- **ISO.** The ISO sensitivity appears when you press the ISO button. Rotating the Main Command dial changes the sensitivity.

- **WB fine-tuning.** Pressing the WB button and rotating the Sub-command dial fine-tunes the white balance setting. A is warmer, and B is cooler.

- **Color temperature.** When the WB is set to K, the panel displays the color temperature in the Kelvin scale when you press the WB button.

Cross-Reference *For more information on white balance and Kelvin, see Chapter 2.*

- **WB preset number.** When the WB is set to one of the preset numbers, pressing the WB button displays the preset number that is currently being used.

- **Bracketing sequence.** When the D700 auto-bracketing feature is activated, pressing the Function button displays the number of shots left in the bracketing sequence. This includes WB, exposure, and flash bracketing.

- **Interval timer number.** When the camera is set to use the interval timer for time-lapse photography, this displays the number of shots remaining in the current interval.

- **Focal length (non-CPU lenses).** When the camera's Function button is set to choose a non-CPU lens number when the Function button is pressed, the focal length of the non-CPU lens is displayed. You must enter the lens data in the Setup menu.

✦ **Shutter speed lock indicator.** This lets you know that your shutter speed is locked to prevent accidental changes. The shutter speed can be locked in CSM f8.

✦ **Flexible program indicator.** This asterisk appears next to the Exposure mode when you're in P, or Programmed Auto, mode. It lets you know that you have changed the default auto-exposure set by the camera to better suit your creative needs.

✦ **Exposure mode.** This tells you which exposure mode you are currently using: P, S, A, or M.

Cross-Reference *Flexible program mode is discussed more in depth in Chapter 2.*

✦ **Image size.** When you're shooting JPEG, TIFF, or RAW + JPEG files, this tells you whether you are recording Large, Medium, or Small files. This display is turned off when shooting RAW files.

✦ **Image quality.** This displays the type of file format you are recording. You can shoot RAW, TIFF, or JPEG. When shooting JPEG or RAW + JPEG, it displays the compression quality: FINE, NORM, or BASIC.

✦ **WB fine-tuning indicator.** When the white balance fine-tuning feature is activated, these two arrows are displayed. You can fine-tune WB by pressing the WB button and rotating the Sub-command dial.

✦ **WB setting.** This shows you which white balance setting is currently selected.

✦ **Exposures remaining.** By default, this displays the number of exposures remaining on your CF card. When you half-press the Shutter Release button to focus, the display changes to show the number of shots remaining in the camera's buffer. In preset WB, the icon PRE appears when the camera is ready to set a custom WB. When using Camera Control Pro 2 to shoot tethered to a computer, this appears as PC.

✦ **Thousands indicator.** A K appears when the number of remaining exposures exceeds 1,000. This is not to be confused with the K that may appear in the WB area, which is used to denote the Kelvin temperature.

✦ **Flash mode.** These icons denote which flash mode you are using. The flash modes include Red-Eye Reduction, Red-Eye with Slow sync, Slow Sync, and Rear-Curtain Sync. To change the flash sync mode, press the Flash mode button and rotate the Main command dial.

✦ **Multiple exposure indicator.** This icon informs you that the camera is set to record multiple exposures. Set multiple exposures in the Shooting menu.

✦ **F-stop/Aperture number.** At default settings, this displays the aperture at which the camera is set. This indicator also displays other settings as follows:

 • **Auto-bracketing compensation increments.** The exposure bracketing can be adjusted to over- and underexpose in 1/3-stop increments. When the Function button is set to Auto-bracketing, the number of EV stops is displayed in this area. The choices are 0.3, 0.7, or 1.0 EV. The WB auto-bracketing can also be adjusted; the settings are 1, 2, or 3.

 • **Number of shots per interval.** When the D700 is set to Interval Timer shooting, the number of frames shot in the interval is displayed here.

 • **Maximum aperture (non-CPU lenses).** When the non-CPU lens data is activated, the maximum aperture of the specified lens appears here.

✦ **F-stop indicator.** This icon, which appears as a right triangle, appears when a non-CPU lens is attached to the camera.

✦ **FEC indicator.** When this is displayed, your FEC is on. Adjust the FEC by pressing the Flash mode button and rotating the Sub-command dial.

✦ **Exposure compensation indicator.** When this appears in the control panel, your camera has exposure compensation activated. This will affect your exposure. Adjust the exposure compensation by pressing the exposure compensation and rotating the Main Command dial.

✦ **Flash sync indicator.** This indicator is displayed as an X. This comes on when you set your camera to the sync speed that is set in CSM e1. This is only available when in S or M mode. To set the camera to the preset sync speed, dial the shutter speed down one setting past the longest shutter time, which is 30 seconds in S and bulb in M.

✦ **Auto ISO indicator.** This is displayed when the Automatic ISO setting is activated to let you know that the camera is controlling the ISO settings. You can activate Auto ISO in the Shooting menu.

✦ **Clock indicator.** When this appears in the control panel, the camera's internal clock needs to be set. You can find the Clock settings in the Setup menu.

✦ **MB-D10 battery indicator.** When the MB-D10 battery grip is attached and the camera is using the battery installed in the grip, this icon is displayed.

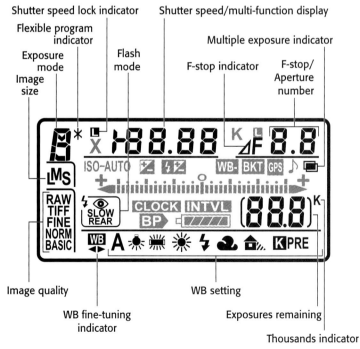

Shutter speed lock indicator Shutter speed/multi-function display

Flexible program indicator

Exposure mode Flash mode Multiple exposure indicator

Image size F-stop indicator F-stop/Aperture number

Image quality WB setting

WB fine-tuning indicator Exposures remaining

Thousands indicator

1.8 The LCD control panel display 1

✦ **Battery indicator.** This display shows the charge remaining on the active battery. When this indicator is blinking, the battery is dead and the shutter is disabled.

✦ **Interval timer indicator.** When the camera's Interval Timer option is turned on, this appears in the control panel. You set the Interval timer in the Shooting menu.

✦ **Electronic analog exposure display.** This is your light meter. When the bars are in the center, you are at the proper settings to get a good exposure; when the bars are to the left, you are overexposed; when the bars are to the right, you are underexposing your image. This is displayed when the camera is set to M mode. When it is in P, S, or A mode, this is only displayed when the current settings will cause an under- or overexposure.

✦ **Beep indicator.** This informs you that the camera will beep when the self-timer is activated or when the camera achieves focus when in Single Focus mode.

✦ **GPS connection indicator.** This icon appears in the LCD control panel when a GPS system is connected to the D700's 10-pin connector.

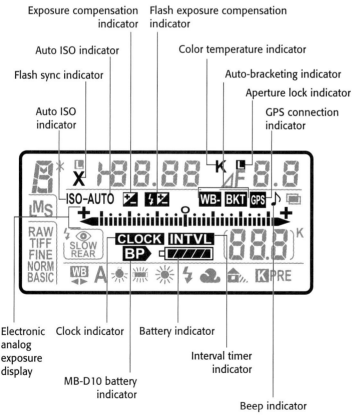

1.9 The LCD control panel display 2

✦ **Auto-bracketing indicator.** When in Auto-Exposure or flash bracketing, this appears on the control panel; when using WB bracketing, a WB icon also appears above the icon. You set auto-bracketing in CSM e5.

✦ **Aperture lock indicator.** This informs you that your aperture setting is locked to prevent accidental changes. You can lock the aperture in CSM f8

✦ **Color temperature indicator.** When this indicator is shown, the WB is set to Kelvin.

Shooting Info Display

The Shooting info display is shown on the back LCD screen when you press the Info button found underneath the AF-area mode selector (where the CF card door latch used to be for you D200/300 users).

The Shooting info display definitely comes in handy when shooting on a tripod, but other than that, I don't find myself using it very often. I just find it easier to glance at the LCD control panel to find what I need. A drawback to this display is that it depletes your batteries faster because the display is shown on the large three-inch LCD screen.

That being said, the Shooting info display does show quite a wealth of information. It shows everything that is available in the viewfinder display, the control panel, and a few other things that aren't found anywhere else.

Here's a complete rundown of everything that appears on the Shooting info display:

✦ **Exposure mode display.** This tells you which exposure mode you are currently using: P, S, A, or M.

✦ **Flexible program indicator.** This is an asterisk that appears next to the exposure mode when in P mode. This lets you know that you have changed the default auto-exposure set by the camera to better suit your creative needs.

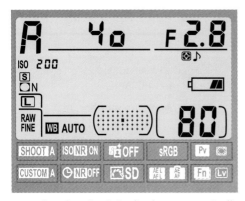 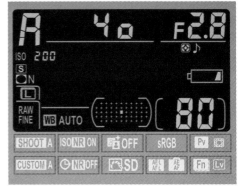

1.10 The Shooting info display automatically changes from light to dark depending on the brightness of the ambient light, or you can set it manually in CSM d7.

✦ **Shutter speed lock indicator.** This lets you know that your shutter speed is locked to prevent accidental changes. The shutter speed can be locked in CSM f8.

✦ **Shutter speed.** By default, this set of numbers shows you the shutter speed setting. This set of numbers also shows a myriad of other settings depending on which buttons you press.

• **EV value.** When pressing the Exposure Compensation button and rotating the Sub-command dial, the EV compensation number is displayed.

• **FEC value.** Pressing the Flash mode button and rotating the Sub-command dial displays the FEC value.

• **ISO.** The ISO sensitivity appears when you press the ISO button. Rotating the Main Command dial changes the sensitivity.

• **WB fine-tuning.** Pressing the WB button and rotating the Sub-command dial fine-tunes the white balance setting. A is warmer, and B is cooler.

• **Color temperature.** When the WB is set to K, the panel displays the color temperature in the Kelvin scale when you press the WB button.

• **WB preset number.** When the WB is set to one of the preset numbers, pressing the WB button displays the preset number that is currently being used.

• **Bracketing sequence.** When the D700 auto-bracketing feature is activated, pressing the Function button displays the number of shots left in the bracketing sequence. This includes WB, exposure, and flash bracketing.

• **Interval timer number.** When the camera is set to use the interval timer for time-lapse photography, this displays the number of shots remaining in the current interval.

• **Focal length (non-CPU lenses).** When the camera's Function button is set to choose non-CPU lens numbers when the Function button is pressed, the focal length of the non-CPU lens is displayed. You must enter the lens data in the Setup menu.

✦ **Color temperature indicator.** When this indicator is shown, the WB is set to Kelvin.

✦ **f-stop indicator.** This icon, which appears as a right triangle, appears when a non-CPU lens is attached to the camera.

✦ **Aperture lock indicator.** This lets you know that your aperture is locked to prevent accidental changes. The shutter speed can be locked in CSM f8.

✦ **F-stop/Aperture number.** At default settings, this displays the aperture at which the camera is set. This indicator also displays other settings as follows:

- **Auto-bracketing compensation increments.** The exposure bracketing can be adjusted to over- and underexpose in 1/3-stop increments. When the Function button is set to Auto-bracketing, the number of EV stops is displayed in this area. The choices are 0.3, 0.7, or 1.0 EV. The WB auto-bracketing can also be adjusted; the settings are 1, 2, or 3.

- **Number of shots per interval.** When the D700 is set to Interval Timer shooting, the number of frames shot in the interval is displayed here.

- **Maximum aperture (non-CPU lenses).** When the non-CPU lens data is activated, the maximum aperture of the specified lens appears here.

✦ **Electronic analog exposure display.** This is your light meter. When the bars are in the center, you are at the proper settings to get a good exposure; when the bars are to the left, you are overexposed; when the bars are to the right, you are underexposing your image. This is displayed when the camera is set to M mode. When in P, S, or A mode, this is only displayed when the current settings will cause an under- or overexposure.

✦ **Camera battery indicator.** This displays how much of a charge is left in the EN-EL3e battery in the camera.

✦ **MB-D10 battery indicator.** This shows the remaining charge on the battery that is being used in the MB-D10 grip (if attached). This also displays the type of battery that is installed in the grip.

✦ **Thousands indicator.** A K appears when the number of remaining exposures exceeds 1,000. This is not to be confused with the K that may appear in the WB area, which is used to denote the Kelvin temperature.

✦ **Exposures remaining.** This number indicates the approximate amount of exposures you can store on your CF card. This display also shows the lens number of the saved Non-CPU lens when that option is set to a function button.

✦ **AF-area mode display.** This icon shows you which AF-area mode you are in. For more information on AF-area modes, see Chapter 2.

✦ **WB setting.** This displays the icon of the current WB setting. When fine-tuning has been applied to the default setting, two small arrows appear beneath the WB icon to remind you.

✦ **Image quality.** This tells you the type and quality of file that is being written to your CF card as you take photos. The options are RAW, RAW+JPEG, JPEG, and TIFF. Change this by pressing the QUAL button and rotating the Main Command dial.

✦ **Image size.** This tells you the resolution size of the file when saving to JPEG or TIFF: Large (L), Medium (M), or Small (S). Change this setting by pressing the QUAL button and rotating the Sub-command dial.

✦ **Vignette control indicator.** This icon is displayed when the option vignette control is turned on. Additionally, next to the icon is the amount of vignette control being applied: High (H), Normal (N), or Low (L).

✦ **Release mode indicator.** This informs you of the release mode that's currently selected for the camera: Single or Continuous. When the camera is set to Continuous shooting, the maximum frame rate is also displayed.

✦ **Flash sync indicator.** This indicator is displayed as an X. This comes on when you set your camera to the sync speed that is set in CSM e1. This is only available when in Shutter Priority or Manual mode. To set the camera to the preset sync speed, dial the shutter speed down one setting past the longest shutter time, which is 30 seconds in S and bulb in M.

Shutter speed lock indicator Shutter speed/multi-function display

Flexible program indicator

Aperture lock indicator

Exposure mode Flash sync indicator Color temperature indicator F-stop indicator F-stop/ Aperture number

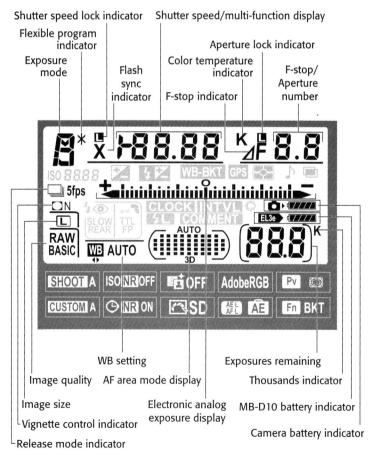

WB setting

Image quality AF area mode display

Exposures remaining

Thousands indicator

Image size

Electronic analog exposure display

MB-D10 battery indicator

└ Vignette control indicator

Camera battery indicator

└ Release mode indicator

1.11 The Shooting info display 1

✦ **ISO sensitivity display.** This shows your ISO setting. ISO Auto appears when the Automatic ISO setting is activated to let you know that the camera is controlling the ISO settings. You can activate Auto ISO in the Shooting menu.

✦ **Exposure compensation indicator.** When this appears in the LCD control panel, your camera has exposure compensation activated. This will affect your exposure. Adjust the exposure compensation by pressing the exposure compensation and rotating the Main Command dial.

✦ **FEC indicator.** When this is displayed, your Flash Exposure Compensation is on. Adjust the FEC by pressing the Flash mode button and rotating the Sub-command dial.

✦ **Auto-bracketing indicator.** When in Auto-Exposure or flash bracketing, this appears on the control panel; when using WB bracketing, a WB icon also appears above the icon. You set auto-bracketing in CSM e5.

✦ **GPS connection indicator.** This icon appears in the LCD control panel when a GPS system is connected to the D700's 10-pin connector.

✦ **Metering mode display.** This display shows which metering mode you are in: Spot, Center-weighted, or Matrix.

✦ **Beep indicator.** This informs you that the camera will beep when the self-timer is activated or when the camera achieves focus when in Single Focus mode.

✦ **Multiple exposure indicator.** This icon informs you that the camera is set to record multiple exposures. Set multiple exposures in the Shooting menu.

✦ **Interval timer indicator.** When the camera's Interval Timer option is turned on, this appears in the control panel. Set the interval timer in the Shooting menu.

✦ **Copyright information indicator.** This icon appears when the optional copyright information has been entered and activated. You can find copyright information in the Setup menu.

✦ **Image comment indicator.** This icon is shown when the image comment option is enabled. You can add an image comment in the Setup menu.

The following items on the Shooting Menu Display can be accessed and changed by entering the Quick Settings Display. You can enter the Quick Settings Display by pressing the Info button while the Shooting Menu Display appears on the rear LCD. For more information on the Quick Settings Display, see Chapter 3.

✦ **Active D-Lighting indicator.** This icon alerts you to the status of the Active D-Lighting option. The settings are Auto, High (H), Normal (N), Low (L), and Off.

✦ **Color space indicator.** This tells you the color space that you are saving your files in: Adobe RGB or sRGB. For more information on color space, see Chapter 3.

✦ **Preview button assignment.** This tells you which custom function is assigned the Depth-of-field preview button.

✦ **Function button assignment.** This tells you what custom function is assigned to the FUNC. button.

✦ **AE-L/AF-L button assignment.** This tells you what custom function is assigned to the AE-L / AF-L button.

✦ **Picture Control indicator.** This icon shows which Picture Control setting is activated. For more information on Picture Controls, see Chapter 2.

✦ **Long exposure noise reduction indicator.** This lets you know if Long Exposure NR is activated.

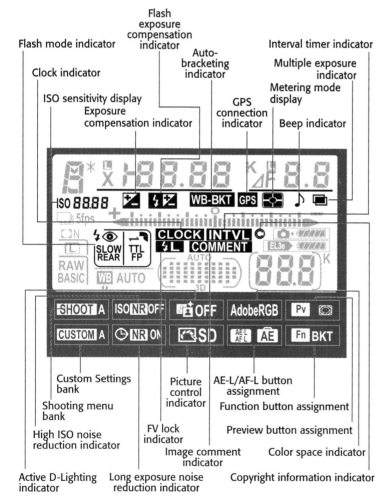

1.12 The Shooting info display 2

✦ **Custom Settings bank.** This item lets you know which Custom Settings bank you're using: A, B, C, or D. For more information on Custom Settings banks, see Chapter 3.

✦ **Shooting menu bank.** This item lets you know which Shooting menu bank you're using: A, B, C, or D. For more information on Shooting menu banks, see Chapter 3.

✦ **High ISO noise reduction.** This lets you know if the High ISO NR is activated. The options are HIGH, NORM (Normal), LOW, or OFF.

✦ **FV lock indicator.** This icon is shown when the FV lock is activated. FV lock can be assigned to the Preview, FUNC., or AE-L/AF-L button.

✦ **Flash mode indicator.** This area shows you the flash mode the camera is using. This option is shown only when the built-in flash is raised or an accessory Speedlight is attached. When an accessory Speedlight is attached, an icon is displayed in the top-right corner of this box. Additionally, this option shows you if the Speedlight is in Through-the-Lens mode (TTL), Repeating flash mode (RPT), Commander mode (CMD), and High Speed FP Sync mode (FP). For more detailed information on flash modes and Speedlights, see Chapter 6.

✦ **Clock indicator.** This icon flashes when the cameras internal clock is not set. You can set the clock in the Setup menu.

Nikon D700 Essentials

When you familiarize yourself with the basic layout of the D700 and all the various dials, switches, and buttons, you should find it much easier to navigate to and adjust the settings that allow you to control and fine-tune the way you capture images with your camera. In this chapter, I cover some of the most commonly changed settings of the camera such as the exposure modes, metering, autofocus (AF) settings, white balance, and ISO. All these settings combined create your image and you can tweak and adjust them to reflect your artistic vision or to simply be sure that you create the best possible images in complex scenes.

Exposure settings include the exposure modes that decide how the camera chooses the aperture and shutter speed and the metering modes that decide how the camera gathers the lighting information so that the camera can choose the appropriate settings based on the exposure mode. In this chapter, you also learn more about ISO, which also plays into exposure, and exposure compensation. Exposure compensation allows you to fine-tune the exposure to suit your needs or to achieve the proper exposure in situations where your light meter may be fooled.

In this chapter, I also explain the autofocus modes, which decide which areas of the viewfinder are given preference when the camera is deciding what to focus on. Discussions of white balance, Picture Controls, and Live View round out the chapter.

Exposure Modes

Unlike some of Nikon's entry-level digital single lens reflex (dSLR) cameras such as the D60, the D700 has no Scene modes. Scene modes are settings that are tailored for specific shooting scenarios like sports, landscapes, or portraits. With a

camera of this level, you are expected to know a little more about exposure settings for different types of photography rather than relying on the camera's scene modes; the D700 has four exposure modes: Programmed Auto, Aperture Priority, Shutter Priority, and Manual. They are all you need to achieve the correct exposure.

The D700 has four exposure modes to work with that allow you the ultimate in control. To switch among them, simply press the Mode button located next to the Shutter Release button and rotate the Main Command dial until the desired exposure mode appears in the control panel or in the viewfinder display.

Programmed Auto

Programmed Auto mode, or P, is a fully automatic mode that's best for shooting snapshots and scenes where you're not concerned about controlling the settings.

When the camera is in Programmed Auto mode, it decides all the exposure settings for you based on a set of algorithms. The camera attempts to select a shutter speed that allows you to shoot handheld without suffering from camera shake while also adjusting your aperture so that you get good depth of field to ensure everything is in focus. When the camera body is coupled with a lens that has a CPU built in (all Nikon AF lenses have a CPU), the camera automatically knows what focal length and aperture range the lens has. The camera then uses this lens information to decide what the optimal settings should be.

This exposure mode chooses the widest aperture possible until the optimal shutter speed for the specific lens is reached. Then the camera chooses a smaller f-stop and

increases the shutter speed as light levels increase. For example, when you're using a 24-70mm f/2.8 zoom lens, the camera keeps the aperture wide open until the shutter speed reaches about 1/40 second (just above minimum shutter speed to avoid camera shake). Upon reaching 1/40 second, the camera adjusts the aperture to increase depth of field.

The exposure settings selected by the camera are displayed in both the LCD control panel and the viewfinder display. Although the camera chooses what it thinks are the optimal settings, the camera does not know what your specific needs are. You may decide that your hands are not steady enough to shoot at the shutter speed the camera has selected or you may want a wider or smaller aperture for selective focus. Fortunately, you aren't stuck with the camera's exposure choice. You can engage what is known as flexible program. Flexible program allows you to deviate from the camera's selected aperture and shutter speed when you are in P mode. You can automatically engage this feature by simply rotating the Main Command dial until the desired shutter speed or aperture is achieved. This allows you to choose a wider aperture/faster shutter speed when you rotate the dial to the right, or a smaller aperture/slower shutter speed when you rotate the dial to the left. With flexible program, you can maintain the metered exposure while still having some control over the shutter speed and aperture settings.

A quick example of using flexible program would be if the camera has set the shutter speed at 1/60 second with an aperture of f/8, you're shooting a portrait, and you want a wider aperture to throw the background out of focus. By rotating the Main Command dial to the right, you can open the aperture

up to f/4, which causes the shutter speed to increase to 1/125 second. This is what is known as an equivalent exposure, meaning you get the same exact exposure but the settings are different.

When flexible program is on, an asterisk appears next to the P on the LCD control panel. Rotate the Main Command dial until the asterisk disappears to return to the default Programmed Auto settings.

Caution *Programmed Auto mode is not available when you're using non-CPU lenses. When you're in P mode with a non-CPU lens attached, the camera automatically selects Aperture Priority mode. The P continues to appear on the LCD control panel, but the A for Aperture Priority appears in the viewfinder display.*

Note *In Programmed Auto mode, if there is not enough light to make a proper exposure, the camera displays Lo in place of the shutter speed setting.*

Aperture Priority

Aperture Priority mode, or A, is a semiautomatic mode. In this mode, you decide which aperture to use and the camera sets the shutter speed for the best exposure based on your selection. Situations where you may want to select the aperture include when you're shooting a portrait and want a large aperture (small f-stop number) to blur out the background by minimizing depth of field, and when you're shooting a landscape and want a small aperture (large f-stop number) to ensure the entire scene is in focus by increasing the depth of field.

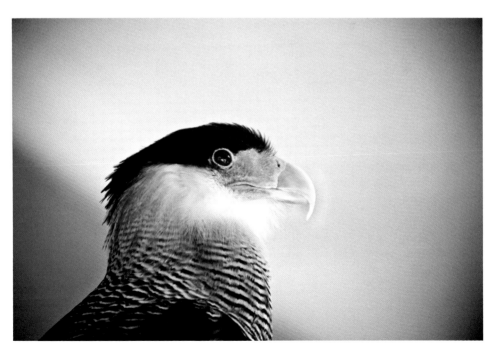

2.1 For this image, I used a wide aperture of f/2.8 to blur out the distracting elements of the background, drawing the eye to the most important part of the image.

Choosing the aperture to control depth of field is one of the most important aspects of photography and allows you to selectively control which areas of your image, from foreground to background, are in sharp focus and which areas are allowed to blur. Controlling depth of field enables you to draw the viewer's eye to a specific part of the image, which can make your images more dynamic and interesting to the viewer.

> **Note** In Aperture Priority mode, if there is not enough light to make a proper exposure, the camera displays Lo in place of the shutter speed setting.

Shutter Priority

Shutter Priority mode, or S, is another semi-automatic mode. In this mode, you choose the shutter speed and the camera sets the aperture.

Shutter Priority mode is generally used for shooting moving subjects or action scenes. Choosing a fast shutter speed allows you to freeze the action of a fast moving subject. A good example would be if you were shooting a horse race. Horses move extremely fast, so you'd need to be sure to use a fast shutter speed of about 1/1000 second to freeze the motion of the horse and prevent blur. This would allow you to capture most of the crisp details of the subject.

There are also times when you may want to use a slow shutter speed, and you can use this mode for that as well. When you're shooting scenes at night, a long exposure is often preferable and choosing your shutter speed can allow you to introduce many creative effects into your photography. I often like to shoot city skylines at night and more often than not the skyline is located near a river. Selecting a slow shutter speed of about

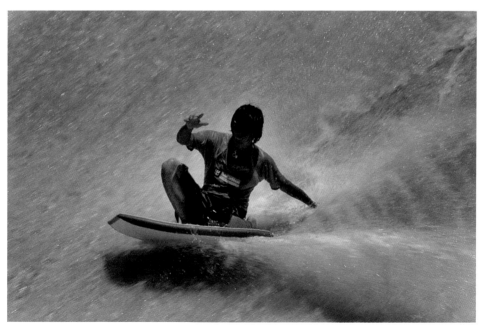

2.2 For this image I used a fast shutter speed to freeze the subject and the water drops, which also suggests action.

two to four seconds gives moving bodies of water a nice glass-like appearance that I find appealing. Be sure to bring along your favorite tripod for support.

Even when you're shooting action, you'll have times when you may want to use a slower shutter speed. Panning along with a moving subject at a slower shutter speed allows you to blur the background while keeping the subject in relatively sharp focus. The blur of the background is extremely effective in portraying motion in a still photograph. I use this technique extensively when shooting motorsports. Using a shutter speed that is too high (fast) when shooting race cars causes the vehicle to look as if it's parked on the track because it may potentially freeze the motion of the wheels. Selecting a relatively slow shutter speed of about 1/320 second and panning along with the car allows me to capture some blur in the tires, showing rotation so that the viewer can see that the car was actually moving.

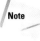 **Note** *In Shutter Priority mode, if there is not enough light to make a proper exposure, the camera displays Lo in place of the aperture setting.*

Manual

When in the Manual mode, or M, you set both the aperture and shutter speed settings. You can estimate the exposure, use a handheld light meter, or use the D700's electronic analog exposure display to determine the exposure needed.

 Cross-Reference *For more info on the electronic analog exposure display, see Chapter 1.*

You're probably wondering why you'd use Manual exposure when you have the other modes. There are a few situations where you may want to set the exposure manually:

2.3 For this image I used a relatively slow shutter speed and panning to show movement.

✦ **When wanting complete control over exposure.** Most times the camera decides the optimal exposure based on technical algorithms and an internal database of image information. Oftentimes, what the camera decides is optimal is not necessarily what is optimal in your mind. You may want to underexpose to make your image dark and foreboding, or you may want to overexpose a bit to make the colors pop (making colors bright and contrasty). If your camera is set to M, you can choose the settings and place your image in whatever tonal range you want without having to fool with exposure compensation settings.

✦ **When using studio flash.** When you're using studio strobes or external non-dedicated flash units, you don't use the camera's metering system. When using external strobes, you'll need a flash meter or manual calculation to determine the proper exposure. Using the Manual exposure mode, you can quickly set the aperture and shutter speed to the proper exposure; just be sure not to set the shutter speed above the rated sync speed of 1/250 second.

✦ **When using non-CPU lenses.** When you're using older non-CPU lenses, the camera is automatically set to Aperture Priority with the camera choosing the shutter speed. Switching to Manual allows you to select both the shutter speed and aperture while using the camera's analog light meter that appears in the viewfinder display.

Metering Modes

The D700 has three metering modes, Matrix metering, Center-weighted metering, and Spot metering, to help you get the best exposure for your image. You can change the modes by using the Metering Mode dial directly to the right of the viewfinder.

Metering modes determine how the camera's light sensor collects and processes the information used to determine exposure. Each of these modes is useful for different types of lighting situations.

Matrix

The default metering system that Nikon cameras use is a proprietary system called 3D Color Matrix Metering II, or Matrix metering for short. Matrix metering reads a wide area of the frame and sets the exposure based on the brightness, contrast, color, and composition. Then the camera runs the data through sophisticated algorithms and determines the proper exposure for the scene. When using a Nikkor D- or G-type lens, the camera also takes the focusing distance into consideration.

 For more info on lenses and lens specifications, see Chapter 4.

The D700 has a 1,005-pixel RGB (red, green, blue) sensor that measures the intensity of the light and the color of a scene. The camera then compares the information to information from 30,000 images stored in its database. The D700 determines the exposure settings based on the findings from the comparison. Simplified, it works like this: You're photographing a portrait outdoors, and the sensor detects that the light in the

center of the frame is much dimmer than the edges. The camera takes this information along with the focus distance and compares it to the ones in the database. The images in the database with similar light and color patterns and subject distance tell the camera that this must be a close-up portrait with flesh tones in the center and sky in the background. From this information, the camera decides to expose primarily for the center of the frame although the background may be over- or underexposed. The RGB sensor also takes note on the quantity of the colors and uses that information.

Image courtesy of Nikon, Inc.
2.4 The D700's 1,005-pixel RGB sensor

The Matrix meter of the D700 will perform several ways, automatically, based on the type of Nikon lens that is used.

✦ **3D Color Matrix Metering II.** As I mentioned earlier, this is the default metering system that the camera employs when a G- or D-type lens is attached to the camera. Most lenses made since the early to mid-90s are these types of lenses. The only difference between the G- and D-type lenses

is that on G-type lens there is no aperture ring. When using the Matrix metering method, the camera decides the exposure setting mostly based on the brightness and contrast of the overall scene and the colors of the subject matter as well as other data from the scene. It also takes into account the distance of the subject and which focus point is used, as well as the lens focal length to further decide which areas of the image are important to getting the proper exposure. For example, if you're using a wide-angle lens with a distant subject with a bright area at the top of the frame, the meter will take this into consideration when setting the exposure so that the sky and clouds don't lose critical detail.

✦ **Color Matrix Metering II.** This type of metering is used when a non-D- or G-type CPU lens is attached to the camera. Most AF lenses made from about 1986 to the early to mid-90s fit into this category. The Matrix metering recognizes this and the camera uses only brightness, subject color, and focus information to determine the right exposure.

✦ **Color Matrix Metering.** This type of metering is engaged when a non-CPU lens is attached to the camera and when the focal length and maximum aperture are specified using the non-CPU data in the D700 Setup Menu. The exposure is then calculated solely on the brightness of the scene and the subject color. If a non-CPU lens is attached and no lens information is entered, the camera's meter defaults to Center-weighted metering.

Matrix metering is suitable for use with most subjects especially when you're in a particularly tricky or complex lighting situation. Given the large amount of image data in the Matrix metering database, the camera can make a fairly accurate assessment about what type of image you are shooting and adjust the exposure accordingly. For example, with an image with a high amount of contrast and brightness across the top of the frame, the camera will try to expose for the scene so that the highlights retain detail. Paired with Nikon's Active D-Lighting, your exposures will have good dynamic range throughout the entire image.

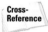 *For more information on Active D-Lighting, see Chapter 3.*

Center-weighted

When the camera's metering mode is switched to Center-weighted, the meter takes a light reading of the whole scene, but bases the exposure settings mostly on the light falling on the center of the scene. The camera determines about 75 percent of the exposure from a circular pattern in the center of the frame and 25 percent from the area around the center.

The D700 incorporates a variable Center-weighted meter so you can adjust the size of the center-weighted area based on the scene you are trying to meter. By default, the circular pattern is 12mm in diameter, but you can choose to make the circle bigger or smaller depending on the subject. Your choices are 8, 12, 15, or 20mm and are found in Custom Settings menu (CSM) b5. There is also a setting for Average. When set to Average, the camera takes a reading of the full frame and decides on an average

setting. I'm not sure why the Average option is included in the Center-weighted menu because it is not center-weighted at all, but I digress. Averaging meters were one of the first types of meters used in SLR cameras and although they worked okay in even moderately tricky lighting situations, you had to know when to use your exposure compensation or your image would come out flat and, well, average. An example of this would be a snowy landscape – the averaging meter takes a look at all that white and wants to make it an 18 percent gray, causing the snow to look dingy. You would have to know to adjust your exposure compensation +1 or 2 stops. Unless you're photographing something that is uniform in color and has very little contrast, I advise staying away from using the Average option.

On the other hand, true Center-weighted metering is a very useful option. It works great when shooting photos where you know the main subject will be in the middle of the frame. This metering mode is useful when photographing a dark subject against a bright background, or a light subject against a dark background. It works especially well for portraits where you want to preserve the background detail while exposing correctly for the subject.

With Center-weighted metering, you can get consistent results without worrying about the adjustments in exposure settings that can sometimes happen when using Matrix metering.

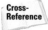 *You can change the center-weighted circle diameter in CSM b5, which I explain in more detail in Chapter 3.*

Spot

In Spot metering mode, the camera does just that: meters only a spot. This spot is only 4mm in diameter and only accounts for 1.5 percent of the entire frame. The spot is linked to the active focus point, which is good, so you can focus and meter your subject at the same time, instead of metering the subject, pressing AE-L (Auto Exposure Lock), and then recomposing the photo. The D700 has 51 focus points so it's like having 51 spot meters to choose from throughout the scene.

Choose Spot metering when the subject is the only thing in the frame that you want the camera to expose for. You select the spot meter to meter a precise area of light within the scene. This is not necessarily tied to the subject. For example, when you are photographing a subject on a completely white or black background, you need not be concerned with preserving detail in the background; therefore, exposing just for the subject works out perfectly. One example where this mode works well is concert photography where the musician or singer is lit by a bright spotlight. You can capture every detail of the subject and just let the shadow areas go black.

Note *When you use a non-CPU lens with Spot metering, the center spot is automatically selected.*

Focus Modes

The Nikon D700 has three different focus modes, two of which are AF modes: Continuous (C), Single (S), and Manual (M). Each of these modes is useful in its own

distinct way for different types of shooting conditions, from sports to portraits to still-life photographs. You can customize these modes to tailor them exactly to your specific shooting needs. To change the AF mode, simply flip the switch that's located near the base of the lens (labeled with an M, S, and C).

How the D700 autofocus works

The D700 has inherited the Multi-CAM 3500FX AF module from its bigger brother, the D3. This AF module is Nikon's newest and most sophisticated AF system to date. It features an impressive 51 focus points, 15 of which have cross-type sensors and 36 of which are horizontal sensors. The 15 cross-type sensors are located in the central focus points and the remaining 36 horizontal sensors are positioned with 18 sensors located on either side of the central 15 points.

Simplified, the Multi-CAM 3500FX AF works by reading contrast values from a sensor inside the camera's viewing system. As I mentioned earlier, the D700 employs two different sensor types, cross and horizontal. As you may have guessed, cross-type sensors are shaped like a cross while horizontal sensors are shaped like a horizontal line. You can think of them like plus and minus signs. Cross-type sensors are able to read the contrast in two directions, horizontally and vertically. Horizontal sensors can only interpret contrast in one direction. (When the camera is positioned in portrait orientation, the horizontal sensors are positioned vertically.)

Cross-type sensors can evaluate for focus much more accurately than horizontal sensors, but horizontal sensors can do it a bit

more quickly (provided that the contrast is running in the right direction). Cross-type sensors require more light to work properly so horizontal sensors are also included in the array to speed up the AF, especially in low-light situations.

Phase detection

The D700's AF system works by using phase detection, which employs a sensor in the camera's body. Phase detection is achieved by using a beam splitter to divert light that is coming from the lens to two optical prisms that send the light as two separate images to the D700's AF sensor. This creates a type of rangefinder where the base is the same as the diameter or aperture of lens. The larger the length of the base, the easier it is for the rangefinder to determine whether the two images are "in phase" or in focus. This is why lenses with wider apertures focus faster than lenses with smaller maximum apertures. This is also why the AF usually can't work with slower lenses coupled with a teleconverter, which reduces the effective aperture of the lens. The base length of the rangefinder images is simply too small to allow the AF system to determine the proper focusing distance. The AF sensor reads the contrast or phase difference between the two images that are being projected on it. This is the primary way that the D700 AF system works. This is also the same method that is used to autofocus while using the camera in handheld Live View mode. This type of focus is also referred to as SIR-TTL, or Secondary Image Registration-Through the Lens, given the AF sensor relies on a secondary image, as opposed to the primary image, that is projected into the viewfinder from the reflex mirror.

Contrast detection

Contrast detect focus is only used by the D700 in Live View mode in the Tripod mode setting. This is the same method that smaller compact digital cameras use to focus. Contrast detect focus is slower and uses the image sensor itself to determine whether the subject is in focus. It is a relatively simple operation in which the sensor detects the contrast between different subjects in the scene. The camera does this by moving the lens elements until sufficient contrast is achieved between the pixels that lie under the selected focus point. With contrast detection, a greater area of the frame can be focused upon.

Continuous

When the camera is set to Continuous AF (AF-C), the camera continues to focus as long as the shutter is pressed halfway (or the Autofocus-On [AF-ON] button is pressed). If the subject moves, the camera activates Predictive Focus Tracking. With Predictive Focus Tracking on, the camera will track the subject to maintain focus and will attempt to predict where the subject will be when the shutter is released. When in AF-C mode, the camera fires when the Shutter Release button is fully depressed, whether or not the subject is in focus. This custom AF setting is known as Release Priority. If you want to be sure that the camera is in focus before the shutter is released, you can change the setting to Focus Priority. When the Focus Priority option is selected, the camera will continue to focus while the Shutter Release button is pressed but the shutter will be released only when the subject is in focus. This may cause your frame rate to slow down. A third option

is Release + Focus. In this mode, you can take a picture whether or not the camera is in focus but the camera slows down the frame rate when there is low contrast or little light to allow the camera more time between shots to achieve focus. You can choose between Focus, Release, or Release + Focus Priority in CSM a1. This is the AF-C mode you want to use when shooting sports or any subject that may be moving erratically.

Single

In Single AF, or AF-S mode (not to be confused with the lens designation), the camera focuses when the Shutter Release button is pressed halfway. When the camera achieves focus, the focus locks. The focus remains locked until the shutter is released or the Shutter Release button is no longer pressed. By default, the camera does not fire unless focus has been achieved (Focus Priority), but you can change this to Release Priority in CSM a2. This allows you to take a photo whether the camera has achieved focus or not. I recommend sticking with Focus Priority for the AF-S, single servo mode and using Release Priority for AF-C, continuous servo. The AF-S mode is the best mode to use when shooting portraits, landscapes, or other photos where the subject is relatively static.

Using this mode helps ensure that you have fewer out-of-focus images.

Manual

When set to the Manual (M) mode, the D700 AF system is off. You achieve focus by rotating the focus ring of the lens until the subject appears sharp as you look through the viewfinder. You can use the manual focus setting when shooting still-life photographs or other nonmoving subjects, when you want total control of the focus, or simply when you are using a non-AF lens. You may want to note that the camera shutter will release regardless of whether the scene is in focus or not.

When using the manual focus setting, the D700 offers a bit of assistance in the way of an electronic rangefinder.

Autofocus Area Modes

The D700 has three different AF area modes to choose from: Single-point AF, Dynamic-area AF, and Auto-area AF. Each one is useful in different situations and can be modified to suit your needs for different shooting situations.

Selecting between the AF area modes is quite easy; you simply flip the AF Area Mode selector that lies right below the Multi-selector on the rear of the camera. This switch is easy to

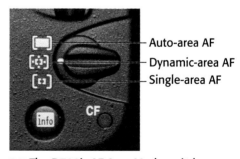

Auto-area AF
Dynamic-area AF
Single-area AF

2.5 The D700's AF Area Mode switch

find even when your eye is up to the view-finder, allowing you to quickly switch between modes as needed on the fly.

As discussed earlier in the chapter, the D700 employs an astounding 51 separate AF points. The 51 AF points can be used individually in Single-area AF mode or they can be set to use in groups of 9, 21, or 51 when in Dynamic-area AF mode.

The D700 can also be set to employ 3D-tracking, which enables the camera to automatically switch focus points and maintain sharp focus on a moving subject as it crosses the frame. 3D-tracking is made possible by the camera recognizing color and light information and using it to track the subject.

Nikon's Scene Recognition System uses the 1,005-pixel RGB sensor to recognize color and lighting patterns in order to determine the type of scene that you are photographing. This enables the AF to work faster than in previous Nikon dSLRs, and it also helps the D700 achieve more accurate exposure and white balance.

Single-area AF

Single-point AF area mode is the easiest mode to use when you're shooting slow-moving or completely still subjects. You can use the Multi-selector up, down, left, right, or diagonally to choose one of the AF points. The camera only focuses on the subject if it is in the selected AF area. Once the point is selected, in can be locked by rotating the AF Area Mode selector switch on the outside of the Multi-selector to the L position. The selected AF point is displayed in the viewfinder.

By default, Single-area AF allows you to choose from any one of the 51 AF area points. Sometimes selecting from this many points can slow you down; this is why the D700 also allows you to change the number of selectable points to a more widely spaced array of 11 focus points. Anyone who has used a D200 will be immediately familiar with the 11-point pattern. You can choose between 51 points and 11 points in CSM a8.

Switching from 51 points to 11 points can speed up your shooting process when using Single-area AF mode. I often use 11 points when shooting portraits; this allows me to move the focus point to the eye in less than half of the button pushes it takes when using 51 points.

Dynamic-area AF

Dynamic-area AF mode also allows you to select the AF point manually, but unlike Single-area AF, the remaining unselected points remain active; this way if the subject happens to move out of the selected focus area, the camera's highly sophisticated auto-focus system can track it throughout the frame. You can set the Dynamic-area AF to function with 9, 21, or 51 points in CSM a3.

When you set the focus mode to AF-S or Single AF (discussed earlier in the chapter), the mode operates exactly the same as if you were using Single-area AF. To take advantage of Dynamic-area AF, the camera must be set to the AF-C, or Continuous AF, mode.

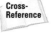 *For more information on the Custom Settings Menu, see Chapter 3.*

9 points

When your D700 is set to the 9-point option, you can select any one of the camera's 51 AF points to be the primary focus point. If your subject moves out of the selected point, the AF system uses the eight AF points immediately surrounding the selected point to achieve focus. This is the best setting to use when you want to focus on erratically moving subjects with greater accuracy.

21 points

As with the 9-point area AF mode, you can select the primary focus point from any one of the 51 points. The camera then uses information from the surrounding 20 points if the subject moves away from the selected focus area. The 21-point area gives you a little more leeway with moving subjects because the active AF areas are in a larger pattern. This mode is good for shooting subjects that are moving somewhat quickly or erratically especially when dealing with insufficient contrast.

51 points

The 51-point area AF mode gives you the widest area of active focus points. You can select the primary focus point the same way you do with the 9-point and 21-point options. The camera then keeps the surrounding 50 points active in case the subject leaves the selected focus area. This is the best mode to use when the subject is very unpredictable and moving around the frame quite a bit.

> **Note** When using Dynamic-area AF with 21 or 51 points you may notice that AF takes a little longer to work given the D700's processor has to sample more points.

51 points (3D-tracking)

This mode has all 51 AF points active. You select the primary AF point, but if the subject moves, the camera uses 3D-tracking to automatically select a new primary AF point. 3D-tracking is accomplished by the camera using distance and color information from the area immediately surrounding the focus point. The camera uses this information to determine what the subject is, and if the subject moves, the camera selects a new focus point. This mode works very well for subjects moving unpredictably; however, you need to be sure that the subject and the background aren't similar in coloring. When photographing a subject that is colored close to the background, the camera may lock focus on the wrong area, so use this mode carefully.

Auto-area AF

Auto-area AF is exactly what it sounds like: The camera automatically determines the subject and chooses one or more AF points to lock focus. Due to the D700's Scene Recognition System, when it is used with a Nikkor D- or G-type lenses, the camera is able to recognize human subjects. This means that the camera has a better chance of focusing where you want it than accidentally focusing on the background when shooting a portrait. Normally, I tend not to use a fully automatic setting such as this, but I've found that it works reasonably well and recommend using it when you're shooting candid photos. When the camera is set to Single AF mode, the active AF points light up in the viewfinder for about one second when the camera attains focus; when in Continuous AF mode, no AF points appear in the viewfinder.

Tip *If you're really curious about knowing which AF point was selected, you can view the AF point while reviewing the image on your LCD. To do this go to the Playback Menu, select Display mode and check Focus point under Basic photo info. Be sure to highlight Done and press OK to lock in the setting. When the image is played back, the active focus points will be overlayed.*

ISO Sensitivity

ISO, which stands for International Organization for Standardization, is the rating for the speed of film, or in digital terms, the sensitivity of the sensor. The ISO numbers are standardized, which allows you to be sure that when you shoot at ISO 100, you get the same exposure no matter what camera you are using.

The ISO for your camera determines how sensitive the image sensor is to the light that is reaching it through the lens opening. Increasing or reducing the ISO affects the exposure by allowing you to use faster shutter speeds or smaller apertures (raising the ISO), or use slower shutter speeds or wider apertures (lowering the ISO).

You can set the ISO very quickly on the D700 by pressing and holding the ISO button and rotating the Main Command dial until the desired setting appears in the LCD control panel. As with other settings for controlling exposure, the ISO can be set in 1/3-, 1/2-, or 1-stop increments. You can choose the ISO increments in CSM b1.

The D700 has a native ISO range of 200 to 6400. In addition to these standard ISO settings, the D700 also offers some settings that extend the available range of the ISO so you can shoot in very bright or very dark situations. These are labeled as H (high speed) and L (low speed). By default the H and L options are set in 1/3-stop adjustments up to H1. The options are as follows:

✦ **H0.3, H0.7, H1.0, and H2.0.** These settings are equivalent to approximately ISO 12,800, and 25,600.

✦ **L0.3, L0.7, and L1.0.** These settings are equivalent to approximately ISO 150, 125, and 100.

You can also set the ISO by going into the Shooting menu and choosing the ISO sensitivity settings option.

 Note *When CSM b1 is set to half step, you have the option of selecting H0.5 or L0.5.*

 Caution *Using the H and L settings will not produce optimal results. Using the L setting can result in images that are slightly lower in contrast, and using the H setting can cause your images to have increased amounts of digital noise.*

Auto ISO

The D700 also offers a feature where the camera adjusts the ISO automatically for you when there isn't enough light to make a proper exposure. Auto ISO is meant to free you up from making decisions about when to raise the ISO. You can set the Auto ISO in the Shooting menu under the ISO sensitivity settings option.

By default, when Auto ISO is on, the camera chooses an ISO setting from 200 up to 3200 whenever the shutter speed falls below 1/30 second. Basically what this means is that when Auto ISO is turned on, if you manually change the ISO, the camera cannot be set to a lower ISO than what the Auto ISO was set to in the Shooting menu. So, if you set it to ISO 800, then when you are shooting, Auto ISO will not lower the ISO below 800.

You can also limit how high the ISO can be set so you can keep control of the noise created when a higher ISO is used (although the amount of overall noise generated by the D700 is much lower than any of the preceding camera models with the exception of the D3).

On the opposite end of the spectrum, if you manually set the ISO to 400, the Auto ISO function will not allow the ISO to go lower than ISO 400, no matter how bright the scene is. So when using the Auto ISO feature, be sure to set your ISO to 200 to ensure that you can get the full range of ISO settings and avoid overexposing your images.

Using Auto ISO can yield questionable results because you can't be certain what ISO adjustments the camera will make. So if you're going to use it, be sure to set it to conditions that you deem acceptable to ensure your images will not be blurry or noisy.

Be sure to set the following options in the Shooting menu/ISO sensitivity settings:

✦ **Maximum sensitivity.** Choose an ISO setting that allows you to get an acceptable amount of noise in your image. If you're not concerned about noisy images, then you can set it all the way up to H2. If you need your images to have less noise, you can choose a lower ISO; the choices are 400, 800, 1600, 3200, 6400, H1, and H2.

✦ **Minimum shutter speed.** This setting determines when the camera adjusts the ISO to a higher level. At the default, the camera bumps up the ISO when the shutter speed falls below 1/30 second. If you're using a longer lens or you're photographing moving subjects, you may need a faster shutter speed. In that case you can set the minimum shutter speed up to 1/4000. On the other hand, if you're not concerned about camera shake, or if you're using a tripod, you can set a shutter speed as slow as one second.

> **Note** *The minimum shutter speed is only taken into account when using Programmed Auto or Shutter Priority modes.*

Noise reduction

Since the inception of digital cameras, they've been plagued with what is known as noise. Noise, simply put, is randomly colored dots that appear in your image. It's is basically caused by extraneous electrons that are produced when your image is being recorded. When light strikes the image sensor in your D700, electrons are produced. These electrons create an analog signal that is converted into a digital image by the Analog to Digital (A/D) converter in your camera (yes, digital cameras start with an analog signal). There are two specific causes of noise. The first is heat generated or thermal noise. While the shutter is open and

your camera is recording an image, the sensor starts to generate a small amount of heat. This heat can free electrons from the sensor, which in turn contaminate the electrons that have been created as a result of the light striking the photocells on your sensor. This contamination shows up as noise.

The second cause of digital noise is known as high ISO noise. Background electrical noise exists in any type of electronic device. For the most part, it's very miniscule and you never notice it. Cranking up the ISO amplifies the signals (photons of light) your sensor is receiving. Unfortunately, as these signals are amplified so is the background electrical noise. The higher your ISO, the more the background noise is amplified until it shows up as randomly colored specks.

Digital noise is composed of two different elements, chrominance and luminance. Chrominance refers to the colored specks and luminance refers mainly to the size and shape of the noise.

Fortunately with every new camera released, the technology gets better and better, and the D700 is no exception. The D700 has one of the highest signal-to-noise ratios of any camera on the market; thus you can shoot at ISO 6400 and not worry about excessive noise. In previous cameras, shooting at ISO 6400 produced a very noisy image that was not suitable for large prints.

Although it's very low in noise, noise does exist and starts appearing in images taken with the D700 when you're shooting above ISO 1600 or using long exposure times. For this reason, most camera manufacturers have built-in noise reduction (NR) features. The D700 has two types of NR: Long exposure NR and High ISO NR. Each one approaches the noise differently to help reduce it.

Long exposure NR

When this setting is turned on, the camera runs a noise reduction algorithm to any shot taken with a long exposure (one second or more). Basically, how this works is that the camera takes another exposure, this time with the shutter closed, and compares the noise from this dark image to the original one. The camera then applies the NR. The noise reduction takes about the same amount of time to process as the length of the shutter speed; therefore expect double the time it takes to make one exposure. While the camera is applying NR, the LCD control panel blinks a message that says "Job nr." You cannot take additional images until this process is finished. If you switch the camera off before the NR is finished, no noise reduction is applied.

You can turn Long exposure NR on or off by accessing it in the Shooting menu or the Quick Settings Display.

High ISO NR

When this option is turned on, any image shot at ISO 2000 or higher is run through the noise reduction algorithm.

This feature works by reducing the coloring in the chrominance of the noise and combining that with a bit of softening of the image to reduce the luminance noise. You can set how aggressively this effect is applied by choosing the High, Normal, or Low settings.

You may also want to be aware that High ISO NR slows down the processing of your images; therefore the capacity of the buffer can be reduced, causing your frame rate to slow down when you're in Continuous shooting mode.

When the High ISO NR is set to "off," the camera will still apply NR to images shot at H0.3 and higher, although the amount of NR is less than when the camera is set to the Low setting with NR on.

> **Note** *When shooting in NEF (RAW), no actual noise reduction is applied to the image.*

For the most part, I choose not to use either of these in-camera NR features. In my opinion, even at the lowest setting, the camera is very aggressive in the NR, and for that reason, there is a loss of detail. For most people, this is a minor quibble and not very noticeable; but for me, I'd rather keep all the available detail in my images and apply noise reduction in post-processing. This way I can decide how much to reduce the chrominance and luminance rather than letting the camera do it. The camera doesn't know whether you're going to print the image at a large size or just display it on-screen. I say it's better to be safe than sorry.

> **Note** *You can apply NR in Capture NX or NX 2, or by using Photoshop's Adobe Camera Raw or some other image-editing software.*

White Balance

Light, whether it is from sunlight, a light bulb, fluorescent light, or a flash, all has its own specific color. This color is measured using the Kelvin scale. This measurement is also known as color temperature. The white balance (WB) allows you to adjust the camera so that your images can look natural no matter what the light source. Given white is the color that is most dramatically affected by the color temperature of the light source,

this is what you base your settings on; hence the term white balance. The white balance can be changed in the Shooting menu or by pressing the WB button on the top of the camera and rotating the Main Command dial.

The term color temperature may sound strange to you. "How can a color have a temperature?" you might think. Once you know about the Kelvin scale, things make a little more sense.

What is Kelvin?

Kelvin is a temperature scale, normally used in the fields of physics and astronomy, where absolute zero (0 K) denotes the absence of all heat energy. The concept is based on a mythical object called a black body radiator. Theoretically, as this black body radiator is heated, it starts to glow. As it is heated to a certain temperature, it glows a specific color. It is akin to heating a bar of iron with a torch. As the iron gets hotter it turns red, then yellow, and then eventually white before it reaches its melting point (although the theoretical black body does not have a melting point).

The concept of Kelvin and color temperature is tricky as it is the opposite of what you likely think of as "warm" and "cool" colors. For example, on the Kelvin scale, red is the lowest temperature, increasing through orange, yellow, white, and to shades of blue, which are the highest temperatures. Humans tend to perceive reds, oranges, and yellows as warmer and white and bluish colors as colder. However, physically speaking, the opposite is true as defined by the Kelvin scale.

White balance settings

Now that you know a little about the Kelvin scale, you can begin to explore the white balance settings. The reason that white balance is so important is it helps ensure that your images have a natural look. When dealing with different lighting sources, the color temperature of the source can have a drastic effect on the coloring of the subject. For example, a standard light bulb casts a very yellow light; if the color temperature of the light bulb is not compensated for by introducing a bluish cast, the subject can look overly yellow and not quite right.

In order to adjust for the colorcast of the light source, the camera introduces a colorcast of the complete opposite color temperature. For example, to combat the green color of a fluorescent lamp, the camera introduces a slight magenta cast to neutralize the green.

The D700 has nine white balance settings:

AUTO **Auto.** This setting is best for most circumstances. The camera takes a reading of the ambient light and makes an automatic adjustment. This setting also works well when you're using a Nikon CLS compatible Speedlight because the color temperature is calculated to match the flash output. I recommend using this setting as opposed to the Flash WB setting.

 Incandescent. Use this setting when the lighting is from a standard household light bulb.

 Fluorescent. Use this setting when the lighting is coming from a fluorescent-type lamp. You can also adjust for different types of fluorescent lamps, including high-pressure sodium and mercury vapor lamps. To make this adjustment, go to the Shooting menu and choose White Balance, then fluorescent. From there, use the Multiselector to choose one of the seven types of lamps.

 Direct sunlight. Use this setting outdoors in the sunlight.

 Flash. Use this setting when using the built-in Speedlight, a hot-shoe Speedlight, or external strobes.

 Cloudy. Use this setting under overcast skies.

 Shade. Use this setting when you are in the shade of trees or a building or even under an overhang or a bridge — any place where the sun is out but is being blocked.

K **Choose color temp.** This setting allows you to adjust the white balance to a particular color temperature that corresponds to the Kelvin scale. You can set it between 2500K (red) to 10,000K (blue).

PRE **Preset manual.** This setting allows you to choose a neutral object to measure for the white balance. It's best to choose an object that is either white or light gray. There are some

accessories that you can use to set the white balance. One accessory is a gray card, which is fairly inexpensive. Simply put the gray card in the scene and balance off of it. Another accessory is the Expodisc. This attaches to the front of your lens like a filter; you then point the lens at the light source and set your WB. This setting (PRE) is best used under difficult lighting situations, such as when there are two different light sources lighting the scene (mixed lighting). I usually use this setting when photographing with my studio strobes.

Tip *By keeping your digital camera set to the Auto WB setting, you can reduce the amount of images taken with incorrect color temperatures. In most lighting situations, the Auto WB setting is very accurate. You may discover that your camera's capability to evaluate the correct white balance is more accurate than setting white balance manually.*

Figures 2.6 to 2.12 show the difference that white balance settings can make to your image. This particular image was shot under incandescent lighting.

2.6 Auto, 2850K

2.7 Incandescent, 2850K

2.8 Fluorescent, 3800K

2.10 Daylight, 5500K

2.9 Flash, 5500K

2.11 Cloudy, 6500K

2.12 Shade, 7500K

Picture Controls

With the release of the D3 and the D300, Nikon introduced their Picture Control System. The D700 has also been equipped with this handy option. This feature allows you to quickly adjust your image settings, including sharpening, contrast, brightness, saturation and hue based on your shooting needs. Another fantastic thing about the Picture Control System is that you can set it to emulate the color modes from other Nikon cameras (specifically, as of this writing, the D2XS). This is great for photographers who shoot more than one camera and do batch processing to their images. It allows both cameras to record the images the same so global image correction can be applied without worrying about differences in color, tone, saturation, and sharpening.

Picture Controls can also be saved to the CompactFlash (CF) card and imported into Nikon's image-editing software, Capture NX, Capture NX 2, or View NX. You can then apply the settings to RAW images or even to images taken with other camera models. You can also save and share these Picture Control files with other Nikon users, either by importing them to Nikon software or loading them directly to another camera.

The D700 comes with four standard Picture Controls already loaded on the camera, and you can custom modify up to nine Picture Control settings in camera. Nikon also offers Custom Picture Controls that are available for download on the Nikon Web site (http://nikonimglib.com/opc/). At the time of this writing, Nikon only offers five Custom Picture Controls. Three of the Picture Controls offer the same color mode settings that are available on D2XS cameras; they are called the D2XMODE1, D2XMODE2, and D2XMODE3. The other two Picture Controls available for download are Portrait and Landscape.

Original Picture Controls

Right out of the box the D700 comes with four Picture Controls installed:

✦ **SD.** This is the Standard setting. This applies slight sharpening and a small boost of contrast and saturation. This is the recommended setting for most shooting situations.

✦ **NL.** This is the Neutral setting. This setting applies a small amount of sharpening and no other modifications to the image. This setting is preferable if you do extensive post-processing to your images.

✦ **VI.** This is the Vivid setting. This setting gives your images a fair amount of sharpening, and the contrast and saturation is boosted highly, resulting in brightly colored images. This setting is recommended for printing directly from the camera or CF card as well as for shooting landscapes. Personally, I feel that this mode is a little too saturated and often results in unnatural color tones. This mode is not ideal for portrait situations, as skin tones are not typically reproduced with accuracy.

✦ **MC.** This is the Monochrome setting. As the name implies, this option makes the images monochrome. This doesn't simply mean black and white; you can also simulate photo filters and toned images such as sepia, cyanotype, and more. The settings for sharpening, contrast, and brightness can also be adjusted.

Optional Picture Controls

These Picture Controls are available for download from Nikon's Web site (http://nikonimglib.com/opc/):

✦ **PT.** This is the setting for Portraits. It gives you just a small amount of sharpening, which gives the skin a smoother appearance. The colors are muted just a bit to help with achieving realistic skin tones.

✦ **LS.** This is the Landscape setting. Obviously, this setting is for shooting landscapes and natural vistas. It appears to me that this is exactly the same as the Vivid Picture Control.

✦ **D2X.** There are three different D2X Picture Controls: Modes I, II, and III. The D2X Picture Controls simulate the three color modes used by the D2X and D2XS cameras. This allows you to obtain consistent image results when using different cameras. D2X Mode I is similar to PT Picture Control and is best for portraits, D2X Mode II is comparable to the NL Picture Control, and D2X Mode III is close to the VI Picture Control setting.

Custom Picture Controls

All the Original Picture Controls can be customized to fit your personal preferences. You can adjust the settings to your liking, giving the images more sharpening and less contrast or a myriad of other options.

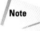

Note *Although you can adjust the Original Picture Controls, you cannot save over them, so there is no need to worry about losing them.*

There are a few different customizations to choose from:

✦ **Quick adjust.** This option works with SD, VI, PT, and LS. It exaggerates or de-emphasizes the effect of the Picture Control in use. Quick adjust can be set from ±2.

✦ **Sharpness.** This controls the apparent sharpness of your images. You can adjust this setting from 0 to 9, with 9 being the highest level of sharpness. You can also set this to Auto (A) to allow the camera's imaging processor to decide how much sharpening to apply.

✦ **Contrast.** This setting controls the amount of contrast your images are given. In photos of scenes with high contrast (sunny days), you may want adjust the contrast down; in low contrast scenes, you may want to add some contrast by adjusting the settings up. You can set this from ±3 or to A.

✦ **Brightness.** This adds or subtracts from the overall brightness of your image. You can choose 0 (default) + or −.

✦ **Saturation.** This setting controls how vivid or bright the colors in your images are. You can set this between ±3 or to A. This option is not available in the MC setting.

/Note *The Brightness and Saturation option is unavailable when Active D-Lighting is turned on.*

✦ **Hue.** This setting controls how your colors look. You can choose ±3. Positive numbers make the reds look more orange, the blues look more purple, and the greens look more blue. Choosing a negative number causes the reds to look more purple, the greens to look more yellow, and the blues to look more green. This setting is not available in the MC Picture Control setting. I highly recommend leaving this in the default setting of 0.

✦ **Filter Effects.** This setting is only available when you set your D700 to MC. The monochrome filters approximate the types of filters traditionally used with black-and-white film. These filters increase contrast and create special effects. The options are

• **Yellow.** Adds a low level of contrast. It causes the sky to appear slightly darker than normal and anything yellow to appear lighter. It is also used to optimize contrast for brighter skin tones.

• **Orange.** Adds a medium amount of contrast. The sky will appear darker, giving greater separation between the clouds. Orange objects appear light grey.

• **Red.** Adds a great amount of contrast, drastically darkening the sky while allowing the clouds to remain white. Red objects appear lighter than normal.

• **Green.** Darkens the sky and lightens any green plant life. This color filter can be used for portraits as it softens skin tones.

✦ **Toning.** Toning adds a color tint to your monochrome (black-and-white) images. Toning options are

• **B&W.** The black-and-white option simulates the traditional black-and-white film prints done in a darkroom. The camera records the image in black, white, and shades of gray. This mode is suitable when the color of the subject is not important. You can use it for artistic purposes or, as with the sepia mode, to give your image on antique or vintage look.

• **Sepia.** The sepia color option duplicates a photographic toning process that is done in a traditional darkroom using silver-based black-and-white prints. Sepia toning a photographic image requires replacing the

silver in the emulsion of the photo paper with a different silver compound, thus changing the color, or tone, of the photograph. Antique photographs were generally treated to this type of toning; therefore the sepia color option gives the image an antique look. The images have a reddish-brown look to them. You may want to use this option when trying to convey a feeling of antiquity or nostalgia to your photograph. This option works well with portraits as well as still-life and architecture images. You can also adjust the saturation of the toning from 1 to 7, with 4 being the default and the middle ground.

- **Cyanotype.** The cyanotype is another old photographic printing process; in fact it's one of the oldest. When the image is exposed to the light, the chemicals that make up the cyanotype turn a deep blue color. This method was used to create the first blueprints and was later adapted to photography. The images taken while in this setting are in shades of cyan. Because cyan is considered to a cool color, this mode is also referred to as cool. You can use this mode to make very interesting and artistic images. You can also adjust the saturation of the toning from 1 to 7, with 4 being the default setting.

- **Color toning.** You can also choose to add colors to your monochrome images. Although this is similar to the Sepia and Cyanotype toning options, this type of toning isn't based on traditional photographic processes. It is simply adding a colorcast to a black-and-white image. There are seven different color options you can choose from: red, yellow, green, blue-green, blue, purple-blue, and red-purple. As with Sepia and Cyanotype, you can adjust the saturation of these toning colors.

2.13 Black and White

2.14 Sepia

2.16 Green toning

To customize an Original Picture Control, follow these steps:

1. **Go to the Set Picture Control option in the Shooting Menu.** Press the Multi-selector right.

2. **Choose the Picture Control you want to adjust.** For small adjustments choose the NL or SD option. To make larger changes to color and sharpness, choose the VI mode. To make adjustments to monochrome images, choose MC. Press the Multi-selector right.

3. **Press the Multi-selector up or down to highlight the setting you want to adjust (sharpening, contrast, brightness, and so on).** When the setting is highlighted, press the Multi-selector left or right to adjust the settings. Repeat this step until you've adjusted the settings to your preferences.

2.15 Cyanotype

4. Press OK to save the settings.

> **Note** To return the Picture Control to the default setting, go to the Set Picture Control option in the Shooting Menu, choose the Picture Control you want to reset, and press the delete button. A dialog box appears asking for confirmation; select Yes to return to default or No to continue to use the Picture Control with the current settings.

> **Note** When the Original Picture Control settings have been altered, an asterisk is displayed with the Picture Control setting (SD*, VI*, and so on).

To save a Custom Picture Control, follow these steps:

1. **Go to the Manage Picture Control option in the Shooting Menu.** Press the Multi-selector right.

2. **Press the Multi-selector up or down to select Save/edit.** Press the Multi-selector right.

3. **Choose the Picture Control to edit.** Press the multi-selector right.

4. **Press the Multi-selector up or down to highlight the setting you want to adjust (sharpening, contrast, brightness, and so on).** When the setting is highlighted, press the Multi-selector left or right to adjust the settings. Repeat this step until you've adjusted the settings to your preferences.

5. **Press OK to save the settings.**

7. **Use the Multi-selector to highlight the Custom Picture Control you want to save to.** You can store up to nine Custom Picture Controls; they are labeled C-1 through C-9. Press the Multi-selector right.

8. **When the Rename Menu appears, press the Zoom in button and press the Multi-selector left or right to move the cursor to any of the 19 spaces in the name area of the dialog box.** New Picture Controls are automatically named with the Original Picture Control name and a two digit number (for example, STANDARD _02 or VIVID_03).

9. **Press the Multi-selector (without pressing the Zoom) to select letters in the keyboard area of the dialog box.** Press the Multi-selector center button to set the selected letter and press the Delete button to erase the selected letter in the Name area. Once you have typed in the name you want, press OK to save it. The Custom Picture Control is then saved to the Picture Control menu and can be accessed through the Set Picture Control option in the Shooting menu.

> **Note** To return the Picture Control to the default setting, go to the Manage Picture Control option in the Shooting Menu, use the Multi-selector to select Save/edit and to choose the Picture Control you want to reset, and press the delete button. A dialog box appears asking for confirmation; select Yes to return to default or No to continue to use the Picture Control with the current settings.

Your Custom Picture Controls can be renamed or deleted at any time by using the Manage Picture Control option in the Shooting menu. You can also save the Custom Picture Control to your memory card so that you can import the file to Capture NX, Capture NX 2, or View NX.

To save a Custom Picture Control to the memory card, follow these steps:

1. **Go to the Manage Picture Control option in the Shooting menu.** Press the Multi-selector right.

2. **Press the Multi-selector up or down to highlight the Load/save option.** Press the Multi-selector right.

3. **Press the multi-selector up or down to highlight the Copy to card option.** Press the Multi-selector right.

4. **Press the Multi-selector up or down to select the Custom Picture Control to copy.** Press the Multi-selector right.

5. **Select a destination on the memory card to copy the Picture Control file to.** Each CF card has 99 slots in which to store Picture Control files.

6. **Once you've chosen the destination, press the Multi-selector right.** A message will appear that the file is then stored to your CF card.

After you've copied your Custom Picture Control file to your card, you can then import the file to the Nikon software by mounting the CF card to your computer by your usual means (card reader or USB camera connection). See the software user's manual for instructions on importing to the specific program.

You can also upload Picture Controls that are saved to a CF card to your camera:

1. **Go to the Manage Picture Control option in the Shooting menu.** Press the Multi-selector right.

2. **Press the Multi-selector up or down to highlight the Load/save option.** Press the Multi-selector right.

3. **Press the Multi-selector up or down to highlight the Copy to camera option.** Press the Multi-selector right.

4. **Select the Picture Control to copy.** Press OK or the Multi-selector right to confirm.

5. **The camera then displays the Picture Control settings.** Press OK. The camera automatically displays the Save As menu.

6. **Select an empty slot to save to (C-1 through C-9).**

7. **Rename the file if necessary.** Press OK.

JPEG

JPEG, which stands for Joint Photographic Export Group, is a method of compressing photographic files and also the name of the file format that supports this type of compression. The JPEG is the most common type of file used to save images on digital cameras. Due to the small size of the file that is created and the relatively good image quality it produces, JPEG has become the default file format for most digital cameras.

The JPEG compression format came into being because of the immense file sizes that digital images produce. Photographic files contain millions upon millions of separate colors and each individual color is assigned a number, which causes the files to contain vast amounts of data, therefore making the

file size quite large. In the early days of digital imaging, the huge file sizes and relatively small storage capacity of computers made it almost impossible for most people to store images. Less than ten years ago, your standard laptop hard drive was only about 5GB. For people to efficiently store images, a file that could be compressed without losing too much of the image data during reconstruction was needed. Enter the Joint Photographic Export Group. This group of experts came in and designed what we now affectionately know as the JPEG.

JPEG compression is a very complicated process involving many mathematical equations, but it can be explained quite simply. The first thing the JPEG process does is break down the image into 8 by 8 pixel blocks. The RGB color information in each 8 by 8 block is then treated to a color space transform where the RGB values are changed to represent luminance and chrominance values. The luminance value describes the brightness of the color while the chrominance value describes the hue.

Once the luminance and chrominance values have been established, the data is run through what is known as the Discrete Cosine Transform, or DCT for short. This is the basis of the compression algorithm. Basically what the DCT does is take the information about the 8 by 8 block of pixels and assign it an average number because, for the most part, the changes in the luminance and chrominance values will not be very drastic in such a small part of the image.

The next step in the process is quantizing the coefficient numbers that were derived from the luminance and chrominance values by the DCT. Quantizing is basically the process of rounding off the numbers. This is where the file compression comes in. How much the file is compressed is dependent on the quantization matrix. The quantization matrix defines how much the information is compressed by dividing the coefficients by a quantizing factor. The larger the number of the quantizing factor, the higher the quality (therefore, the less compression). This is basically what is going on in Photoshop when you save as a JPEG and the program asks you to set the quality; you are simply defining the quantizing factor.

Once the numbers are quantized, they are run through a binary encoder that converts the numbers to the ones and zeros our computers love so well. You now have a compressed file that is on average about one-fourth of the size of an uncompressed file.

The one important consideration with JPEG compression is that it is what's known as a lossy compression. When the quantizing is put in effect, rounding off the numbers necessarily loses information. For the most part, this loss of information is imperceptible to the human eye. A bigger issue to consider with JPEGs comes from what is known as generation loss. Every time a JPEG is opened and resaved, a small amount of detail is lost. After multiple openings and savings, the image's quality starts to deteriorate, as less and less information is available. Eventually the image may start to look pixilated or jagged (this is known as a JPEG artifact). Obviously, this can be a problem, but the JPEG would have to be opened and resaved many hundreds of times before you'll notice a drop in image quality as long you save at high-quality settings.

TIFF

TIFF, or Tagged Image File Format, is another file format that is used primarily for digital images. When you save to TIFF, the camera applies no compression and there is no loss of image data when you open and close the files. TIFF files, being uncompressed, are very large. With the D700, which has a high-resolution sensor, the Large size TIFF file can sometimes be up to 40MB. An uncompressed RAW file will typically be less than half of this size. Using TIFF as your storage format can have some detrimental effects for shooting. First, these huge file sizes will fill up the cameras buffer, resulting in slower continuous shooting speeds. Second, you fill your flash cards a lot more quickly; a standard 4GB CF card can only store about 110 Large TIFFS. Using the same card, you can fit about twice that many uncompressed RAW files or almost six times as many Large JPEGS.

I find shooting TIFF files is the least effective way to go. The huge file sizes notwithstanding, you're better off to shoot RAW. In the next section, I'll go over some of the advantages of using RAW files. The only time I can imagine needing to shoot a TIFF is if I am going to upload a file straight from my camera to an art director.

Image Size

When saving to JPEG or TIFF format, the D700 allows you to choose an image size. Reducing the image size is like reducing the resolution on your camera; it allows you to fit more images on your card. The size you choose depends on what your output is going to be. If you know you will be printing your images

at a large size, then you definitely want to record large JPEGs. If you're going to print at a smaller size (8 × 10 or 5 × 7), you can get away with recording at the Medium or Small setting. Image size is expressed in pixel dimensions. When set to FX format, the large JPEG setting records your images at 4256 × 2832 pixels; this gives you a file that is equivalent to 12 megapixels. Medium size gives you an image of 3184 × 2120 pixels, which is in effect the same as a 6.7 megapixel camera. The small size gives you a dimension of 2128 × 1416 pixels, which gives you about a 3 megapixel image. Additionally, the D700 can record images in the DX format size, which gives you an even smaller file size and lower resolution. A large size JPEG in DX is 2784 × 1848, a medium one is 2080 × 1384, and a small one is 1392 × 920. These settings give you a resolution of about 5 megapixels, 2.8 megapixels, and 1.2 megapixels, respectively.

You can quickly change the image size by pressing the QUAL button and rotating the Sub-command dial on the front of the camera. You can also change the image size in the Shooting menu by selecting the image size menu option.

> **Note** *You can only change image size when using the JPEG or TIFF file format. RAW files are recorded only at the largest size.*

Image Quality

For JPEGs, other than the size setting, which changes the pixel dimension, you have the Quality setting, which is the setting that decides how much of a compression ratio is applied to your JPEG image. Your choices

are Fine, Normal, and Basic. JPEG Fine files are compressed to approximately 1:4, Normal are compressed to about 1:8, and Basic are compressed to about 1:16. To change the image quality setting, simply press the QUAL button and rotate the Main Command dial. Doing this scrolls you through all the file-type options available including RAW, TIFF, Fine (JPEG), Normal (JPEG), and Basic (JPEG). You will also be able to shoot RAW and JPEG simultaneously with all of the JPEG compression options available (RAW + Fine, RAW + Normal, or RAW + Basic.

NEF (RAW)

Nikon's RAW files are referred to as NEF in Nikon literature. NEF stands for Nikon Electronic File. RAW files contain all the image data acquired by the camera's sensor. When a JPEG is created, the camera applies different settings to the image, such as WB, sharpness, noise reduction, and so on. When the JPEG is saved, the rest of the unused image data is discarded to help reduce file size. With a RAW file, this image data is saved so it can be used more extensively in post-processing. In some ways the RAW file is like a digital negative, in which the RAW files are used in the same way as a traditional photographic negative; that is, you take the RAW information and process it to create your final image.

Although some of the same settings are tagged to the RAW file (WB, sharpening, saturation, and so on), these settings aren't fixed and applied as in the JPEG file. This way when you import the RAW into your favorite RAW converter you can make changes to these settings with no detrimental effects.

Capturing your images in RAW allows you to be more flexible when post-processing your images and generally gives you more control over the quality of the images.

The D700 offers a few options for saving NEF (RAW) files. They include compression and bit depth. Like JPEGs, RAW files can be compressed to save space so that you can fit more images on your CF card. You can also choose to save the RAW file with more bit depth, which can give you more available colors in your image file.

Type of compression

Under the NEF (RAW) recording option in the Shooting menu, you can choose the type of compression you wish to apply to the NEF (RAW) file or you can choose none at all. Keep in mind that with the D700 you can save a NEF file at 12 bits or 14 bits, which will affect the number of files you can capture.

You have three different options:

✦ **Lossless compressed.** Unlike JPEG compression, this algorithm loses no data information when the file is closed and stored. When the file is opened, the algorithm reverses the compression scheme and the exact same data that was saved is retrieved. This is the camera's default setting for storing RAW files. You will get a file size that is approximately 15 to 40 percent of the size of an uncompressed RAW file. You can fit about 200 of these files (often more) on a 4GB CF card in Compressed NEF (RAW) 12-bit capture.

✦ **Compressed.** Similar to JPEG compression, with this algorithm some of the image data is lost when these types of files are compressed. The complex algorithms they use to create these files actually run two different compression schemes to the same file. Given that our eyes perceive changes in the darker areas of images more than in the lighter areas, the image data for the shadow areas are compressed using a lossless compression while the mid-tones and lighter are compressed using a lossy method. This compression scheme has very little impact on the image data and allows you be sure that you retain all your shadow detail. Using this compression scheme, your file size will be about 30 to 60 percent of the size of an uncompressed file. You can fit about 276 of these files on a 4GB CF card in Compressed NEF (RAW) 12-bit capture.

✦ **Uncompressed.** Using this setting, the RAW file isn't compressed at all. I don't see any distinct advantage to using this setting over lossless compressed. There are a couple of disadvantages to recording uncompressed RAW files, though. Due to the larger file size, the camera buffer fills more quickly, slowing down your continuous shooting rate and your files take up a bit more space than compressed files. I'm not convinced that there is any real difference between compressed and uncompressed RAW files. In my opinion, using the lossless compressed RAW file is the way to go.

Bit depth

Simply put, bit depth is how many separate colors your sensor can record. The term bit depth is derived from digital terminology. A bit is the smallest unit of data; it is expressed in digital language as either a 1 or a 0. Most digital images saved as JPEG or TIFF are recorded in 8 bits or 1 byte per channel (each primary color being a separate color: red, green, and blue [RGB]), resulting in a 24-bit image. For each 8 bits there are 256 possible colors; multiply this by 3 channels and you get over 16 million different colors, which is enough information to create a realistic looking digital image. By default the D700 records its RAW files using a bit depth of 12 bits per channel, giving you a 36-bit image. What this means is that your sensor can recognize far more shades of color, which gives you a smoother gradation in tones, allowing the color transitions to be much smoother. In addition to the 12-bit setting, the D700 also offers the option of recording your NEF (RAW) files at 14 bits per channel, which gives you even more color information to deal with when processing your images.

All this comes with a cost: the higher the bit depth, the more information contained in the file. This makes your files bigger, especially when the camera is shooting 14-bit NEF (RAW) files. When shooting at 14 bits, the camera has much more image data to contend with, so your top frame rate is reduced by just a bit.

I find that for most applications, shooting NEF (RAW) files at 12 bits is more than enough color information. I only switch to 14 bits when shooting portraits, especially when the portraits are low-key. This helps me get much smoother transitions from the shadow areas to the highlights.

> **Note** *The Nikon D700 uses a 14-bit A/D converter, so its theoretical maximum dynamic range is 14 stops. High bit depth really only helps minimize image posterization because actual dynamic range is limited by noise levels. A high bit-depth image does not necessarily mean that the image contains more colors; it just means it has the capacity to store more color data. If a digital camera has a high precision A/D converter, it does not necessarily mean it can record a greater dynamic range. In reality, the dynamic range of a digital camera does not even come close to the A/D converter's theoretical maximum; 5 to 9 stops is generally all you can expect from the camera due to imaging sensor limitations.*

RAW vs. JPEG

This issue has caused quite a controversy in the digital-imaging world, with some people saying that RAW is the only way to go to have more flexibility in processing images, and others saying if you get it right in camera then you don't need to use RAW images. For what it's worth, both factions are right in their own way.

Choosing between RAW and JPEG basically comes down to the final output or what you're using the images for. Remember that you don't have to choose one file format and stick with it. You can change the settings to suit your needs as you see fit, or you can even choose to record both RAW and JPEG simultaneously.

Some reasons to shoot JPEGs include

✦ **Small file size.** JPEGs are much smaller in size than RAW files; therefore you can fit many more of them on your CF card and later on your hard drive. If space limitations are a problem, shooting JPEG will allow you to get more images in less space.

✦ **Printing straight from the camera.** Some people like to print their images straight from the camera or CF card. RAW files can't be printed without first being converted to JPEG.

✦ **Continuous shooting.** Given JPEG files are smaller than RAW files, they don't fill up the camera's buffer as quickly, allowing you longer bursts without the frame rate slowing down.

✦ **Less post-processing.** If you're confident in your ability to get the image exactly as you want it at capture, you can save yourself time by not having to process the image in a RAW converter and save straight to JPEG.

✦ **Snapshot quality.** If you're just shooting snapshots of family events or if you only plan to post your images on the Internet, saving as JPEG will be fine.

Some reasons to shoot RAW files include

✦ **16-bit images.** The D700 can capture RAW images in 12 or 14 bits. When converting the file using a RAW converter such as Adobe Camera RAW (ACR) or Capture NX or Capture NX 2, you can save your images with 16-bit color information. When the information is written to JPEG in camera, the JPEG is saved as an 8-bit file. This gives you the option of working with more colors in post-processing. This can be extremely helpful when you're trying to save an under- or overexposed image.

✦ **White Balance.** Although the WB that the camera was set to is tagged in the RAW file, it isn't fixed in the image data. Oftentimes, the camera can record a WB that isn't quite correct. This isn't always noticeable by looking at the image on the LCD screen. Changing the WB on a JPEG image can cause posterization and usually doesn't yield the best results. Because you have the RAW image data on hand, changing the WB settings doesn't degrade the image at all.

✦ **Sharpening and Saturation.** As with WB, these settings are tagged in the RAW file but not applied to the actual image data. You can add sharpening and saturation (or other options, depending on your software).

✦ **Image Quality.** Since the RAW file is an unfinished file, it allows you the flexibility to make many changes in the details of the image without any degradation to the quality of the image.

Live View

Live View is one of the newest innovations in dSLR technology. It allows you to use the LCD screen as a viewfinder. This can be very helpful when you are taking pictures where the camera is set up as a remote or when shooting at an awkward angle. For example, at a concert you could hold the camera over your head and use the screen to frame the shot.

There are two Live View options: Hand-held and Tripod. Obviously, the Hand-held mode is for when you are shooting the camera while handholding it. When the camera is in this mode, the camera functions more like a point-and-shoot camera. When the camera is in Hand-held mode, the camera uses phase detection focus which is discussed earlier in the chapter (this is the normal way the D700 determines the focus for the camera). There are some differences, though. In order for the camera to focus, the mirror must flip down, temporarily interrupting the Live View preview. You must also press the Shutter Release button multiple times to actually fire the shutter and get an exposure. I must admit, although I have found myself using the Hand-held option more frequently than I expected, it's kind of tricky to get it to work properly and can take some practice to get comfortable using it.

To operate the camera in Hand-held Live View mode:

1. **Turn the release mode dial to Lv (Live View).** Be sure that the Live View mode is set to Hand-held. You will find this setting in the Shooting menu under Live View.

2. **Press the Shutter Release button to raise the mirror.** The LCD then displays what the lens is seeing.

3. **Use the LCD to frame your subject.**

4. **Once your subject is framed, press the Shutter Release button halfway or press the AF-ON button.** The camera's mirror then flips down, interrupting the Live View. If the button is released, the mirror flips back up and Live View returns without taking a picture.

5. **To take the picture, press the Shutter Release button fully.**

The Tripod mode is used when shooting still subjects while the camera is mounted to a stationary object (tripod). Tripod mode functions a bit differently than Hand-held mode. When the camera's Live View is set to Tripod mode, the focusing is obtained by the contrast detection method. This is the same method that compact point-and-shoot digital cameras use to determine focus. This method works by reading data directly from the imaging sensor. The camera adjusts the lens until the sensor detects the greatest amount of contrast under the selected focus point in the image. This method takes longer to achieve proper focus; hence the shutter lag (delay) that occurs with most point-and-shoot cameras. Some of the benefits of using Tripod mode Live View is that you can move your focus point anywhere in the image frame as opposed to the limited area of the 51-point AF sensor area. You can also zoom into the image to check the focus. This a great advantage in studio photography where focusing accuracy is more important than focusing speed.

 For more on phase and contrast detection focus, see the section earlier in this chapter on how the D700 autofocus works.

To use Live View in Tripod mode:

1. **Attach the camera to a tripod or set the camera on a stable object.**

2. **Turn the Release Mode dial to Lv (Live View).**

3. **Use the viewfinder to frame the subject.**

4. **Press the Multi-selector button to navigate the AF point to the area of the frame that you want to focus on.** Be sure to choose a spot that has adequate contrast or the camera will not be able to achieve focus.

5. **Press the AF-ON button to focus.** The camera will not focus by pressing the Shutter Release button halfway.

6. **Press the Shutter Release button fully.** The mirror flips up and the image is displayed on the LCD monitor.

7. **Check the image on the LCD monitor.** You can use the Zoom in button to view the image closer to ensure that it's in focus. Use the Multi-selector to scroll around to areas that aren't in view when the image is zoomed in. Press OK to exit zoom. You can also press the AF-ON button to refocus, and you can use the Multi-selector to change AF points (as long as you are not zoomed in).

8. **Press the Shutter Release button to take the picture.**

Keep these details in mind when you're shooting in the Live View Tripod mode:

✦ **HDMI.** If the camera is connected to an HDTV, the LCD monitor is switched off and the TV can be used to preview the image.

✦ **Shooting info.** You can turn off the shooting information that is normally displayed on the image by pressing the INFO button.

✦ **Monitor brightness.** You can adjust the brightness of the LCD monitor by pressing the Play button and using the Multi-selector up and down buttons.

✦ **Remote release.** If using an optional remote release cable, you can activate the AF by pressing the button halfway for more than a second. If you fully depress the button without activating the AF, your image may be blurry.

Setting Up the Nikon D700

In the first few chapters of this book, I covered how to change the main settings of your D700. In this chapter, I go more in depth into the menu options. Here you can custom-tailor the D700 options to fit your shooting style, to help refine your workflow, or to make adjustments to refine the camera settings to fit different shooting scenarios.

The D700 is one of the most customizable cameras on the market. You can assign a number of buttons to the functions you find yourself using a lot. Using the My Menu feature, you can create your own personal list of menu options so that you don't have to scroll through all the menu options to get to those you access most frequently.

Some of these options are the same as the ones you can access and adjust by pushing a button and/or rotating a command dial. However, most are to change things that you don't need to change very often or quickly.

You access the menus by pressing the Menu button on the back of the camera. Use the Multi-selector to scroll through the toolbar on the right side of the LCD screen. When the desired menu is highlighted in yellow, press the OK button or Multi-selector right to enter the menu. Pressing the Menu button again or tapping the Shutter Release button exits the Menu mode screen and readies the camera for shooting.

Playback Menu

You manage the images stored on your CompactFlash (CF) card in the Playback menu. The Playback menu is also where you control how the images are displayed and what image information is displayed during review. Nine options are available from the Playback menu; I explain them in the following sections.

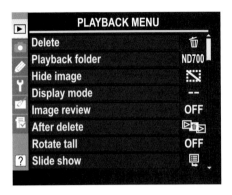

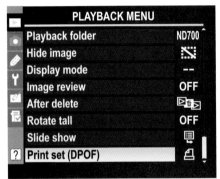

3.1 The Playback menu: the top image shows the first eight options; the bottom image is scrolled to show the last option, Print set (DPOF).

Delete

This option allows you to delete selected images from your memory card or to delete all of the images at once.

To delete selected images, follow these steps:

1. **Press the Multi-selector right, highlight Selected (default), and press the Multi-selector to the right again.** The camera displays an image selection screen. You can now select the image you want to delete.

2. **Use the Multi-selector left or right to choose the image.** You can also use the Zoom in button to review the image close up before deleting. Press the Multi-selector up or down to highlight the image you want to delete, press the center Multi-selector button to set the image for deletion; more than one image can be selected. When the image is selected for deletion, a small trash-can icon appears in the right-hand corner of the LCD screen.

3. **Press the OK button to erase the selected images.** The camera will ask you for confirmation before deleting the images.

4. **Select Yes, and then press the OK button to delete them.** To cancel the deletion, highlight No (default), and then press the OK button.

3.2 Selecting images to delete

To delete all images, follow these steps:

1. **Use the Multi-selector to high-light All, and then press the OK button.** The camera will ask you for confirmation before deleting the images.

2. **Select Yes, and then press the OK button to delete them.** To cancel deletion, highlight No (default), and then press the OK button.

Playback folder

The Nikon D700 automatically creates folders to store your images in. The main folder that the camera creates is called DCIM, and within this folder, the camera creates a subfolder to store the images. The first subfolder the camera creates is called 100ND700. After shooting 999 images, the camera automatically creates another folder called 101ND700, and so on. Use this menu to choose which folder or folders to display images from. Keep in mind that if you have used the CF card in another camera and have not formatted it, additional folders appear on the card (ND200, ND90, and so on). You have three choices:

✦ **ND700.** This is the default setting. The camera only plays back images from folders that the D700 created, ignoring folders from other cameras that may be on the CF card.

✦ **All.** This option plays back images from all folders that are on the CF card whether the D700 created them or not.

✦ **Current.** This option displays images only from the folder that the camera is currently saving to. This feature is useful when you have multiple folders from different sessions. Using this setting allows you to preview only the most current images. You can change the current folder using the Active folder option in the Shooting menu.

Hide image

This option is used to hide images so that they can't be viewed during playback. When the images are hidden, they are also protected from being deleted. To select images to be hidden, press the Multi-selector right, highlight Select/set (default), and then press the Multi-selector right. Use the Multi-selector to highlight the thumbnail images you wish to hide. Then press the OK button.

To allow the hidden images to be displayed, highlight Deselect all. The camera then asks you for confirmation before revealing the images. Select Yes and then press the OK button to display during playback. To cancel and continue hiding the images, highlight No (default) and then press the OK button.

Display mode

Quite a bit of image information is available for you to see when you review images. The Display mode settings allow you to customize the information that appears when you're reviewing the images that are stored

on your CF card. Enter the Display mode menu by pressing the Multi-selector right. Then use the Multi-selector to highlight the option you wish to set. When the option is highlighted, press the Multi-selector right or the OK button to set the display feature. The feature is set when a check mark appears in the box to the left of the setting. Be sure to scroll up to Done and press the OK button to set the feature. If you don't do this step, the info will not appear in the display.

The Display mode options are

✦ **Highlights.** When this option is activated, any highlights that are blown out will blink. If this happens, you may want to apply some exposure compensation or adjust your exposure to be sure to capture highlight detail. You can also view the highlight information in each separate color channel (RGB) by pressing the thumbnail button and pressing the Multi-selector left or right.

✦ **Focus point.** When this option is set, the focus point that was used is overlaid on the image you are reviewing. No focus point will be displayed if the camera did not achieve focus or if Continuous Autofocus (AF-C) was used in conjunction with Auto-area AF.

✦ **RGB Histogram.** When this option is turned on, you can view the separate histograms for the red, green, and blue channels along with a standard luminance histogram. The highlights are also displayed in this option and as with the standard highlights option, you can choose to view the highlights in each separate channel by pressing the thumbnail button and pressing the Multi-selector left or right.

✦ **Data.** This option allows you to review the shooting data (metering, exposure, lens focal length, and so on).

Generally, the only setting that I use is the RGB Histogram. This allows me to view the histograms and the highlight detail all at once.

Image review

This option allows you to choose whether the image appears on the LCD screen immediately after the image is taken. When this option is turned off (the default), you can view the image by pressing the Playback button. Most of the time, when you take a picture you want the image to automatically be displayed. This allows you a chance to preview the image, and check the exposure, framing, and sharpness. However, there are times when you may not want the images to be displayed. For example, when shooting sports at rapid frame rate, you may not need to check every shot. Turning this option off also serves to conserve battery power given the LCD is the biggest drain on your battery. I often turn off Image review when shooting weddings to deter people from asking to see the shots. (You could miss some good shots while the bridesmaids are looking at the images on your LCD.)

After delete

This allows you to choose which image is displayed after you have deleted an image during playback.

The options are

✦ **Show next.** This is the default setting. The next image taken is displayed after the selected image is deleted. If the image deleted is the last image, the previous image is displayed.

✦ **Show previous.** After the selected image is deleted, the one taken before it is displayed. If the first image is deleted, the following image is displayed.

✦ **Continue as before.** This option allows you to continue in the order that you were browsing the images. If you were scrolling through them as they were shot, the next image is displayed (Show next). If you were scrolling through them in reverse order, the previous image is shown (Show previous).

Rotate tall

The D700 has a built-in sensor that can tell whether the camera was rotated while the image was taken. This setting rotates images that are shot in portrait orientation so they display upright on the LCD screen. I usually turn this option off because the portrait orientation image appears substantially smaller when displayed upright on the LCD screen.

The options are

✦ **On.** The camera automatically rotates the image to be viewed while holding the camera in the standard upright position. When this option is turned on (and the Auto image rotation setting is set to On in the Setup menu), the camera orientation is recorded for use in image-editing software.

✦ **Off (default).** When the auto-rotating function is turned off, images taken in portrait orientation are displayed on the LCD screen sideways, in landscape orientation.

Slide show

This allows you to display a slide show of images from the current active folder. You can use this setting to review the images that you have shot without having to use the Multi-selector. This is also a good way to show friends or clients your images. You can even connect the camera to a standard or high-definition (HD) TV to view the slide show on a big screen. You can choose an interval of 2, 3, 5, or 10 seconds.

While the slide show is in progress, you can use the Multi-selector to skip forward or back (left or right), and view shooting info or histograms (up or down). You can also press the Menu button to return to the Playback menu, press the Playback button to end the slide show, or press the Shutter Release button lightly to return to the Shooting mode.

Pressing the OK button while the slide show is in progress pauses the slide show and offers you the option to restart the slide show, change the frame rate, or exit the slide show. Use the Multi-selector up and down to make your selection, and then press the OK button.

Print set (DPOF)

DPOF stands for Digital Print Order Format. This option allows you to select images to print directly from the camera. This can be used with PictBridge-compatible printers or DPOF-compatible devices such as a photo kiosk at your local photo printing shop. This is a pretty handy feature if you don't have a printer at home and want to get some prints made quickly, or if you do have a printer and want to print your photos without downloading them to your computer.

To create a print set, follow these steps:

1. **Use the Multi-selector to choose the Print set (DPOF) option, and then press the Multi-selector right to enter the menu.**

2. **Use the Multi-selector to highlight Select/set, then press the Multi-selector right to view thumbnails.** Press the Zoom in button to view a larger preview of the selected image.

3. **Use the Multi-selector right or left to highlight an image to print.** When you've highlighted the desired image, press the Protect (key) button and Multi-selector up to set the image and choose the number of prints you want. You can choose from 1 to 99. The number of prints and a small printer icon appears on the thumbnail. Continue this procedure until you have selected all of the images that you want to print. Press the Protect button and the Multi-selector down to reduce the number of prints and to remove it from the print set. You can also set the image to be printed by pressing the Multi-selector center button while the thumbnail is highlighted.

4. **Press the OK button.** A menu appears with three options:

 • **Done (default).** Press the OK button to save and print the images as they are.

 • **Data imprint.** Press the Multi-selector right to set the Data imprint option. A small check appears in the box next to the menu option. When this option is set, the shutter speed and aperture setting appear on the print.

 • **Date imprint.** Press the Multi-selector right to set the Date imprint option. A small check appears in the box next to the menu option. When this option is set, the date the image was taken appears on the print

5. **If you choose to set the imprint options, be sure to return to the Done option and press the OK button to complete the print set.**

Shooting Menu

The shooting controls that you find yourself using most often have dedicated buttons to access them. These are controls such as ISO, QUAL, and WB. You can also set these features in the Shooting menu. There are also other settings here that you will use quite often, such as Picture Controls, Active D-Lighting, and Noise Reduction.

Shooting menu bank

The Shooting menu bank allows you to store different combinations of settings for use during different shooting scenarios. If you shoot a variety of subjects and you change your settings depending on the subject, you can save your shooting settings so you can pull up the settings quickly rather than changing them all separately. For example, when you shoot landscapes, you may want to shoot RAW images at 14-bit, with your white balance set to Daylight, and the Picture Control set to Vivid; but when you shoot portraits, you like to shoot Large JPEG images, with the white balance set to Auto, and Picture Control set to Standard. You can save these groups of settings to separate banks and recall them when shooting that

particular type of subject. This can save you a lot of time because you don't have to change your settings every time you change your subject matter.

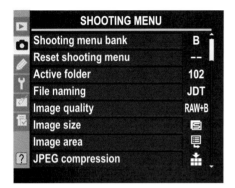

3.3 The Shooting menu is shown here in three sections so you can see all the available options.

The Shooting menu banks store only Shooting settings such as image quality, Picture Controls, Noise Reduction settings, and others. Be careful not to confuse the Shooting menu bank with the Custom Settings bank, which stores any changes made to the Custom Settings menu. (I cover this later in the chapter.)

Each Shooting menu bank operates separately from the other three, so any changes you make while in Bank A will not have any effect on Banks B, C, and D. One thing you need to remember is that any changes you make while in a particular shooting bank will be saved. If you are shooting in Bank B and you change the Noise Reduction setting, that setting will be saved until you change back. The Shooting menu bank does not reset when you turn the camera off. So if you modify certain settings, be sure to change them back after you're finished shooting or you may find yourself using the wrong settings.

You can rename each of the four available banks — A, B, C, and D —with a custom designation so you can easily remember which bank is for what subject. To rename the bank, follow these steps:

1. **Press the Menu button and use the Multi-selector to select the Shooting menu.**

2. **Select Shooting menu bank from the list of options.**

3. **Use the Multi-selector to scroll down to the Rename option.**

4. **Use the Multi-selector to choose the bank to rename.** Using the Multi-selector, choose from A, B, C, or D. Press the Multi-selector right. This brings up the text entry screen.

This screen allows you to choose up to 20 characters to name your Shooting menu bank.

5. **Enter the text.** Using the Multi-selector, you can scroll around within the set of letters, numbers, and punctuation marks. There are several buttons you can use to maneuver in the text entry screen.

- **Use the Multi-selector center button to insert the letter that is highlighted.**

- **Press the Thumbnail/Zoom out button and use the Multi-selector left or right to move the cursor within the text box.** You can use it to add spaces or to overwrite another character.

- **To erase a character you have inserted, move the cursor over the top of the character and press the Delete button (trash-can).**

6. **Once you've entered your text, press the OK button to save the changes.**

The only way to know which Shooting menu bank you're using is to check the Quick Settings menu (QSM). You can also change which bank you're using in the QSM. This setting appears on the LCD control panel of the D200 and D300 and it's one of the features that I wish they would have kept on the D700 because it's much quicker to glance at the top panel than it is to use the QSM.

Note *Remember the text entry screen: You will use it for various functions, including changing the filename, naming Custom Picture Controls, and Custom Shooting menu banks.*

3.4 Text entry screen

Reset shooting menu

Choosing this menu option resets the current Shooting menu bank (A, B, C, or D) to the camera default settings. Only use this option if you want to *start from scratch* so to speak. This option resets all of the Shooting values, including file naming, color space, and any exposure fine-tuning you may have set, so reset with caution.

Active folder

As I discussed earlier, the D700 automatically creates folders in which to store your images. The camera creates a folder named ND700, and then stores the images in sub-folders starting with folder 100. You can choose to change the folder that the camera is saving to from 100 up to 999. You can use this option to separate different subject into different folders. When I shoot Sports Car Club of America (SCCA) races, there are different groups of cars. I use a different folder for each group to make it easier to sort through the images later. If there are five groups, I start out using folder 101, then folder 102 for the second group, and so on. If you are on a road trip, you could save your

images from each destination to a separate folder. These are just a couple of different examples of how you can use this feature.

When selecting the active folder, you can choose a new folder number or you can select a folder that has already been created. When you format your CF card, all pre-existing folders are deleted, and the camera creates a folder with whatever number the active folder is set to. So if you set it to folder 105, when the card is formatted, the camera will create folder 105ND700; it does not start from the beginning with folder 100. If you want to start with folder 100, you need to be sure to change the active folder back to 100 and then format your card.

To change the Active folder setting, follow these steps:

1. **Go to the Shooting menu.** Using the Multi-selector, choose Active folder and then press the Multi-selector center button to view options.

2. **Select New folder number (default) to start a new folder.** Press the Multi-selector right. Use the Multi-selector up and down to change the numbers and left or right to change place in the number sequence.

3. **Press the OK button or the Multi-selector center button to save changes.**

File naming

When image files are created, the D700 automatically assigns a filename. The default filenames start with DSC_ followed by a four-digit number and the file extension

(DSC_0123.jpg) when you're using the sRGB color space. When you're using the Adobe RGB color space, the filenames start with _DSC followed by a four-digit number and the file extension (_DSC0123.jpg).

This menu option allows you to customize the filename by replacing the DSC prefix with any three letters of your choice. For example, I customized mine so that the filename reads JDT_0123.jpg.

To customize the filename, follow these steps:

1. **Highlight the File naming option in the Shooting menu.** Press the Multi-selector right to enter the menu. The menu shows a preview of the filename (sRGB: DSC_1234 / Adobe RGB: _DSC1234).

2. **Press the Multi-selector right to enter a new prefix within the text entry screen.** You will notice that this text entry screen doesn't have lowercase letters or any punctuation marks. This is because the file-naming convention only allows for files to be named using capital letters and the numbers 0 through 9.

3. **Use the Multi-selector to choose the letters and/or numbers.** Press the OK button when you finish.

Image quality

This menu option allows you to change the image quality of the file. You can choose from these options:

✦ **NEF (RAW) + JPEG fine.** This option saves two copies of the same image, one in RAW and one in JPEG with 1:4 ratio compression.

✦ **NEF (RAW) + JPEG normal.** This option saves two copies of the same image, one in RAW and one in JPEG with 1:8 ratio compression.

✦ **NEF (RAW) + JPEG basic.** This option saves two copies of the same image, one in RAW and one in JPEG with 1:16 ratio compression.

✦ **NEF (RAW).** This option saves the images in RAW format.

✦ **TIFF (RGB).** This option saves the images in TIFF format.

✦ **JPEG fine.** This option saves the images in JPEG with 1:4 compression.

✦ **JPEG normal.** This option saves the images in JPEG with 1:8 compression.

✦ **JPEG basic.** This option saves the images in JPEG with 1:16 compression.

You can also change these settings by pressing the QUAL button and rotating the Main Command dial to choose the file type and compression setting. You can view this setting on the LCD control panel on the top of the camera.

 For more detailed information on image quality, compression, and file formats, see Chapter 2.

Image size

This allows you to choose the size of the TIFF and JPEG files. The image sizes vary depending on whether you are in FX (full-frame) or DX mode. Change the image size depending on the intended output of the file.

The choices are

✦ **Large.** This setting gives you a full resolution image of 4256 × 2832 pixels or 12 megapixels in FX mode. In DX mode the image size is 2784 × 1848 or 5 megapixels

✦ **Medium.** This setting gives you a resolution of 3184 × 2120 pixels or 6.7 megapixels in FX mode. In DX mode the image size is 2080 × 1384 or 2.8 megapixels.

✦ **Small.** This setting gives your images a resolution of 2128 × 1416 pixels or 3 megapixels in FX mode. In DX mode the image size is 1392 × 920 or 1.2 megapixels.

 For more detailed information on image size, see Chapter 2

 You can also change the image size for JPEG and TIFF by pressing the QUAL button and rotating the Sub-command dial. The settings are shown on the LCD control panel on the top of the camera.

Image area

Some, if not most, of you have probably switched over from a Nikon DX-format dSLR such as the D300 or D80. This means you have likely invested some money in DX lenses. Nikon enables you to use these DX lenses on the D700 by allowing you to switch between FX and DX formats. You have two choices:

✦ **Auto DX crop.** This enables the camera to instantly recognize when a Nikkor DX lens is attached and automatically switch into DX mode. You should be aware that this is

only guaranteed to work with Nikkor DX lenses. With most third-party DX lenses, the camera probably won't recognize that the lens is DX. I know firsthand that the D700 didn't recognize the Tokina 12-24mm f/4 DX lens when I attached it to the camera. You can turn this option on or off. If you have Nikkor DX lenses that you want to use along with your FX lenses, you probably want to keep this option on. If you're using third-party DX lenses, you can safely turn this off. If you have both third-party and Nikkor lenses, then I suggest turning this on (just be sure to switch to DX when using non-Nikon lenses).

✦ **Choose image area.** This allows you to manually choose between FX and DX. This option is pretty self-explanatory. Select FX format (36 × 24) for a full-frame sensor size or DX format (24 × 16) for an APS-C sensor size.

 Cross-Reference *For more detailed information on using DX lenses, see Chapter 4*

JPEG compression

This menu allows you to set the amount of compression applied to the images when they're recorded in the JPEG file format.

The options are

✦ **Size Priority.** With this option the JPEG images are compressed to a relatively uniform size. Image quality can vary depending on the amount of image information in the scene you photographed. To keep the file sizes similar, some images must be compressed more

than others. The Nikon manual claims that a large fine JPEG file size is compressing to an approximate 5.7MB file. I have done some testing and even with Size Priority selected, my file sizes range anywhere between 2MB and 5MB.

✦ **Optimal Quality.** This option provides the best compression algorithm. The file sizes vary with the information contained in the scene recorded. Use this mode when image quality is a priority. With this mode I've found that my image sizes are more uniform, fluctuating between 5MB to 7MB.

When I contacted Nikon about this twist in the way that these functions are supposed to work, they assured me that it's normal.

NEF (RAW) recording

This option is for setting the amount of compression applied to RAW files. This menu is also where you choose the bit depth of the RAW file.

Use the Type sub-menu (accessed from the RAW recording menu) to choose the compression. The options are

✦ **Lossless compressed.** This is the default setting. The RAW files are compressed, reducing the file size from 20 percent to 40 percent with no apparent loss of image quality.

✦ **Compressed.** The RAW file is compressed by 40 percent to 55 percent. There is some file information lost.

✦ **Uncompressed.** The RAW file is saved to the card exactly as it was recorded. There is no compression. The file sizes can be very large.

Use the NEF (RAW) bit depth sub-menu to choose the bit depth of the RAW file. You have two options:

✦ **12 bit.** This records the RAW file with 12 bits of color information.

✦ **14 bit.** This records the RAW file with 14 bits of color information. The file size is significantly larger, but there is much more color information for smoother color transitions in your images.

 Cross-Reference *For more detailed information RAW on compression and bit depth, see Chapter 2.*

White balance

You can change the white balance (WB) options using this menu option. Changing the WB settings through this menu option allows you to fine-tune your settings with more precision and gives you a few more options than you get when using the dedicated WB button located on the top of the camera. You can select a WB setting from the standard settings (Auto, Incandescent, Fluorescent, Direct sunlight, Flash, Cloudy, Shade) or you can choose to set the WB according to color temperature by selecting a Kelvin temperature; you can choose between 2500K to 10,000K. A third option is to select from a preset WB that you have set.

 Cross-Reference *For detailed information on white balance settings and color temperature, see Chapter 2.*

Using standard WB settings

To select one of the standard WB settings, choose the White balance option from the Shooting menu, then use the Multi-selector button to highlight the preferred setting, and then press the Multi-selector right or the Multi-selector center button. This brings up

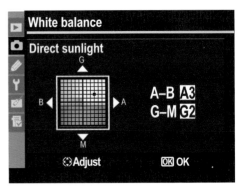

3.5 The WB fine-tuning grid

a new screen that gives you the option to fine-tune the standard setting. Displayed on this screen is a grid that allows you to adjust the color tint of the WB setting selected. The horizontal axis of the grid allows you to adjust the color from amber to blue, making the image warmer or cooler, while the vertical axis of the grid allows you to change the tint by adding a magenta or green cast to the image. Using the Multi-selector, you can choose a setting from 1 to 6 in either direction; additionally, you can add points along the horizontal and vertical axes simultaneously. For example, you can add 4 points of amber to give it a warmer tone and also add 2 points of green, shifting the amber tone more toward yellow.

Choosing the fluorescent setting brings up some additional menu options: You can choose between seven different non-incandescent lighting types. This is handy if you know what specific type of fixture is being used. For example, I was shooting a night football game recently. I had the camera set to Auto WB, but I was getting very different colors from shot to shot and none of them were looking right. Because I wasn't shooting RAW, I needed to get more consistent shots. I knew that most outdoor sporting arenas used mercury vapor lights to light

the field at night. I selected the fluorescent WB setting from the Shooting menu and chose the #7 option: High temp. Mercury vapor. I took a few shots and noticed I was still getting a sickly greenish cast, so I went back to the fine-tuning option and added 2 points of magenta to cancel out the green color cast. This gave me an accurate and consistent color.

There are seven lighting-type settings:

✦ **Sodium-vapor.** These types of lights often found in streetlights and parking lots. They emit a distinct deep yellow color.

✦ **Warm-white fluorescent.** These types of lights give a white light with a bit of an amber cast to add some warmth to the scene. They burn at around 3000K, similar to an incandescent bulb.

✦ **White fluorescent.** These lights cast a very neutral white light at around 5200K.

✦ **Cool white fluorescent.** As the name suggests, these types of lights are a bit cooler than a white fluorescent lamp and have a color temperature of 4200K.

✦ **Day white fluorescent.** These lights approximate sunlight at about 5500K.

✦ **Daylight fluorescent.** These types of lights give you about the same color as daylight. This lamp burns at about 6300K.

✦ **High temp. mercury-vapor.** These lights vary in temperature depending on the manufacturer and usually run between 4200K and 5200K.

 Note Sunlight and daylight are quite different color temperatures. Sunlight is light directly from the sun and is about 5500K. Daylight is the combination of sunlight and skylight and has a color temperature of about 6300K.

Choosing a color temperature

Using the K white balance option, you can choose a specific color temperature, assuming that you know the actual color temperature. Some light bulbs and fluorescent lamps are calibrated to put out light at a specific color temperature; for example full-spectrum light bulbs burn at a color temperature of 5000K.

As with the other settings, you get the option of fine-tuning the setting using the grid.

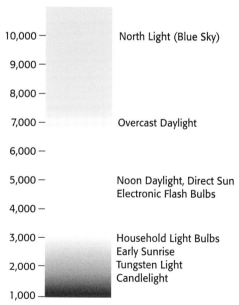

3.6 The Kelvin color temperature scale

Preset white balance

Preset white balance allows you to make and store up to five custom WB settings. You can use this option when shooting in mixed lighting: for example in a room with an incandescent light bulb and sunlight coming in through the window, or when the camera's auto white balance isn't quite getting the correct color.

You can set a custom white balance two ways: direct measurement, which is when you take a reading from a neutral-colored object (a gray card works the best for this) under the light source; or copy from an existing photograph, which allows you to choose a WB setting directly from an image that is stored on your memory card.

The camera can store up to five presets that are labeled d-0 through d-4. When taking a direct measurement, the camera automatically stores the preset image to d-0, so if you want to save a previous measurement, be sure to copy it over to one of the presets d-1 through d-4 before taking another measurement. I cover saving these presets later in this section.

Direct measurement

To take a direct measurement and save it to d-0 (default), follow these steps:

1. **Place a neutral object (preferably a gray card) under the light source you want to balance for.**

2. **Press the WB button located on the top left of the camera body and rotate the Main Command dial until the PRE in displayed on the LCD control panel.**

3. **Release the WB button for a moment, and then press and hold it until the LCD control panel shows a blinking PRE.** This will stay displayed for about six seconds.

4. **Looking through the viewfinder, frame the reference object.** Press the Shutter Release button as if you were taking a photo.

5. **If the camera was successful in recording the WB, GOOD flashes in the control panel.** If the scene is too dark or too bright, the camera may not be able to set the WB; in this case, No Gd flashes on the LCD control panel. You may need to change your settings to adjust the exposure settings on your camera. If the result was unsuccessful, repeat Steps 2 through 5 until you obtain results that are acceptable to you.

If you plan on using this preset to take pictures right away, be sure that your preset WB is set to d-0. Do this by pressing the WB button and rotating the Sub-command dial until d-0 is displayed on the LCD control panel.

If you want to save the current preset WB setting for future use, you'll need to copy the setting to another preset (d-1 through d-4). If you don't save this, the next time you make a preset, the d-0 slot will be overwritten.

To save a preset, follow these steps:

1. **Press the menu button.** Use the Multi-selector to choose White balance from the Shooting menu.

2. **Select Preset manual from the White balance menu.** Press the Multi-selector button right to view the preset choices.

3. **Use the Multi-selector to highlight one of the four available presets: d-1, d-2, d-3, or d-4.** Press the Multi-selector center button. This brings up a menu.

4. **Use the Multi-selector to highlight Copy d-0.** Press the OK button to copy the setting.

The D700 also allows you to add a comment to any of the presets. You can use this to remember the details of your WB setting. For example, if you have a set of photographic lights in your studio, you can set the WB for these particular lights and enter "photo lights" into the comment section. You can enter up to 36 characters (including spaces).

To enter a comment on a WB preset, follow these steps:

1. **Press the Menu button.** Use the Multi-selector to choose White balance from the Shooting menu.

2. **Select Preset manual from the White balance menu.** Press the Multi-selector button right to view the preset choices.

3. **Use the Multi-selector to highlight one of the presets you can choose from d-0 through d-4.** Press the Multi-selector center button. The preset menu is displayed.

4. **Use the Multi-selector to highlight Edit comment.** Press the Multi-selector right. This brings up the text entry screen I discussed earlier in the chapter.

5. **Enter your text and press the OK button to save the comment.**

Copy white balance from existing photograph

As I mentioned before, you can also copy the white balance setting from any photo saved on the CF card that's inserted into your camera. Follow these steps:

Tip *If you have particular settings that you like, you may consider saving the images on a small 256MB CF card. This way, you always have your favorite WB presets saved and don't accidentally erase them from the camera.*

1. **Press the Menu button.** Use the Multi-selector to choose White balance from the Shooting menu.

2. **Select Preset manual from the White balance menu.** Press the Multi-selector button right to view the preset choices.

3. **Use the Multi-selector to highlight one of the four available presets: d-1, d-2, d-3, or d-4.** Press the Multi-selector center button. This brings up a menu. Note that d-0 is not available for this option.

4. **Use the Multi-selector to highlight Select image.** The LCD screen displays thumbnails of the images saved to your CF card. This is similar to the Delete and DPOF thumbnail display. Use the Multi-selector directional buttons to scroll through the images. You can zoom in on the highlighted image by pressing the Zoom in button.

5. **Press the Multi-selector center button to set the image to the selected preset (d-1, d-2, and so on).** Press the OK button to save the setting. This brings up the fine-tuning graph. Adjust the colors if necessary. Press the OK button to save changes.

Once you have your presets in order, you can quickly choose between them by following these easy steps:

1. **Press the WB button located on top of the camera.**

2. **Rotate the Main Command dial until PRE appears on the LCD control panel.**

3. **Continue to press the WB button and rotate the Sub-command dial.** The top right of the LCD control panel displays the preset option from d-0 through d-4.

Set Picture Control

Nikon has included Picture Controls in the D700. These controls allow you to choose how the images are processed and you can also use them in Nikon's image-editing software Nikon View and Nikon Capture NX or NX 2. These Picture Controls allow you to get the same results when you use different cameras that are compatible with the Nikon Picture Control System.

Four standard Nikon Picture Controls are available in the D700:

✦ **Standard (SD).** This setting applies slight sharpening and a small boost of contrast and saturation. It is the recommended setting for most shooting situations.

✦ **Neutral (NL).** This setting applies a small amount of sharpening and no other modifications to the image. This setting is preferable if you often do extensive post-processing to your images.

✦ **Vivid (VI).** This setting gives your images a fair amount of sharpening. The contrast and saturation are boosted dramatically, resulting in brightly colored images. This setting is recommended for printing directly from the camera or CF card as well as for shooting landscapes. Personally, I feel that this mode is a little too saturated and often results in unnatural color tones. This mode is not recommended for portrait situations, as skin tones are not reproduced well.

✦ **Monochrome (MC).** As the name implies, this setting makes the images monochrome. This doesn't simply mean black and white; you can also simulate photo filters and toned images such as sepia, cyanotype, and more.

You can adjust all the standard Nikon Picture Controls to suit your specific needs or tastes. In the color modes — SD, NL, and VI — you can adjust the sharpening, contrast, brightness, hue, and saturation. In MC mode, you can adjust the filter effects and toning. After you have adjusted the Nikon Picture Controls, you can save them for later use. You can do this in the Manage Picture Control option described in the next section.

 For detailed information on customizing and saving Picture Controls, see Chapter 2.

Note *When saving to NEF, the Picture Controls are imbedded into the metadata. Only Nikon's software can use these settings. When opening RAW files using a third-party program, such as Adobe Camera RAW in Photoshop, the Picture Controls are not used.*

Manage Picture Control

This menu is where you can edit, save, and rename your Custom Picture Controls. There are four menu options:

✦ **Save/edit.** In this menu, you choose a Picture Control, make adjustments to it, and then save it. You can rename the Picture Control to help you remember what adjustments you made or to remind you of what you are using the Custom Picture Control for. For example, I have one named ultra-VIVID, which has the contrast, sharpening, and saturation boosted as high as it can go. I sometimes use this setting when I want crazy, oversaturated, unrealistic-looking images for abstract shots or light trails.

✦ **Rename.** This menu allows you to rename any of your Custom Picture Controls. You cannot, however, rename the standard Nikon Picture Controls.

✦ **Delete.** This menu gives you the option of erasing any Custom Picture Controls you have saved. This menu only includes controls you have saved or may have down-loaded from an outside source. The standard Nikon Picture Controls cannot be deleted.

✦ **Load/save.** This menu allows you to upload Custom Picture Controls to your camera from your memory card, delete any Picture Controls saved to your memory, or save a Custom Picture Control to your memory card to export to Nikon View or Capture NX or NX 2, or to another camera that is compatible with Nikon Picture Control.

Cross-Reference *For detailed information on creating and managing Picture Controls, see Chapter 2.*

The D700 also allows you to view a grid graph that shows you how each of the Picture Controls relate to each other in terms of contrast and saturation. Each Picture Control is displayed on the graph represented by a square icon with the letter of the Picture Control it corresponds to. Custom Picture Controls are denoted by the number of the custom slot it has been saved to. Standard Picture Controls that have been modified are displayed with an asterisk next to the letter. Picture Controls that have been set with one or more auto settings are displayed in green with lines extending from the icon to show you that the settings will change depending on the images.

To view the Picture Control grid, select the Picture Control option from the Shooting menu. Press the OK button and the Picture Control list is displayed. Press the Thumbnail/Zoom out button to view the grid. Once the Picture Control grid is displayed, you can use the Multi-selector to scroll though the different Picture Control settings. Once you have highlighted a setting, you can press the Multi-selector right to adjust the settings or press the OK button to set the Picture

Control. Press the Menu button to exit back to the Shooting menu or tap the Shutter Release button to ready the camera for shooting.

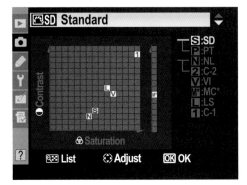

3.7 The picture control grid

Color space

Color space simply describes the range of colors, also known as the gamut, that a device can reproduce. You have two choices of color spaces with the D700: sRGB and Adobe RGB. The color space you choose depends on what the final output of your images will be.

✦ **sRGB.** This is a narrow color space, meaning that it deals with fewer colors and also less-saturated colors than the larger Adobe RGB color space. The sRGB color space is designed to mimic the colors that can be reproduced on most low-end monitors.

✦ **Adobe RGB.** This color space has a much broader color spectrum than is available with sRGB. The Adobe gamut was designed for dealing with the color spectrum that can be reproduced with most high-end printing equipment.

This leads to the question of which color space you should use. As I mentioned earlier, the color space you use depends on what the final output of your images is going to be. If you take pictures, download them straight to your computer, and typically only view them on your monitor or upload them for viewing on the Web, then sRGB will be fine. The sRGB color space is also useful when printing directly from the camera or memory card with no post-processing.

If you are going to have your photos printed professionally or you intend to do a bit of post-processing to your images, using the Adobe RGB color space is recommended. This allows you to have subtler control over the colors than is possible using a narrower color space like sRGB.

For the most part, I capture my images using the Adobe RGB color space. I then do my post-processing and make a decision on the output. Anything that I know I will be posting to the Web I convert to sRGB; anything destined for my printer, I save as Adobe RGB. I usually end up with two identical images saved with two different color spaces. Because most Web browsers don't recognize the Adobe RGB color space, any images saved as Adobe RGB and posted on the Internet will usually appear dull and flat.

Active D-Lighting

Active D-Lighting is a setting that is designed to help ensure that you retain highlight and shadow detail when shooting in a high-contrast situation, such as shooting a picture in direct bright sunlight, which can cause dark shadows and bright highlight areas. Active D-Lighting basically tells your camera to underexpose the image a bit; this underexposure helps keep the highlights from becoming blown out and losing detail. The

D700 also uses a subtle adjustment to avoid losing any detail in the shadow area that the underexposure may cause.

 Caution *Active D-Lighting is a separate and different setting than the D-Lighting option found in the Retouch menu. For more information on standard D-Lighting, see Chapter 8.*

Using Active D-Lighting changes all the Picture Control brightness and contrast settings to Auto; adjusting the brightness and contrast is how Active D-Lighting keeps detail in the shadow areas.

Active D-Lighting has five settings, which are pretty self-explanatory. These settings are Auto, High, Normal, Low, and Off. The Auto setting is a new option for Active D-Lighting that was introduced with the D700.

In my experience, using Active D-Lighting on both the D300 and the D700 works, but it's very subtle in the changes that it makes. For general shooting, I recommend setting Active D-Lighting to Auto and forgetting it. I prefer to shoot in RAW, and although the settings are saved to the metadata for use with Nikon software, I'd rather do the adjustment myself in Photoshop, so I turn this feature off.

When using Active D-Lighting, the camera takes some extra time to process the images, and your buffer will fill up quicker when you're shooting continuously, so expect shorter burst rates.

Vignette control

Some lenses, especially wide-angle lens, have a tendency to vignette, or darken, near the edges of the frame. This problem is more common on cameras with FX sensors

3.8 A wide-angle shot with pronounced vignetting

3.9 A wide-angle shot with the Vignette control set to High

than it is with DX cameras. The problem is due to the extremely oblique angle at which the light enters the lens. Vignetting is more pronounced with wide apertures; therefore, reducing the aperture size also reduces the amount of vignetting that occurs.

Although you can correct vignetting in post-processing, Nikon has included a Vignette control feature that lightens up the edges to make the exposure more uniform.

There are four Vignette control options: High, Normal, Low, and Off. I have tried this feature numerous times and I feel that it doesn't work as evenly as it should and still tends to leave a vignette even on the High setting. I tend to leave this option off given there are much better ways to control vignetting using image-editing software.

Long exp. NR

This menu option allows you to turn on noise reduction (NR) for exposures of one second or longer. When this option is on, after taking a long exposure photo, the camera runs a noise-reduction algorithm, which reduces the amount of noise in your image, giving you a smoother result.

High ISO NR

This menu option allows you to choose how much NR is applied to images that are taken at ISO 2000 or higher. There are four settings:

✦ **High.** This setting applies a fairly aggressive NR. A fair amount of image detail can be lost when you use this setting.

✦ **Normal.** This is the default setting. Some image detail may be lost when you use this setting.

✦ **Low.** A small amount of NR is applied when you select this option. Most of the image detail is preserved when you use this setting.

✦ **Off.** When you choose this setting, no NR is applied to images taken between ISO 100 (L 0.1) and 6400; however, a very small amount of NR is applied to images shot at H 0.3 and above.

ISO sensitivity settings

This menu option allows you to set the ISO. This is the same as pressing the ISO button and rotating the Main Command dial. You also use this menu to set the Auto ISO parameters.

 For more information on ISO settings and noise reduction, see Chapter 2.

Live view

This is where you can change the settings for the Live View feature of the D700. There are two settings:

✦ **Hand held.** This is the default setting. You use it when you are holding the camera. When set to this option, the camera uses a phase-detection focus, which is the same focus it uses when you're shooting normally (looking through the viewfinder). The image in the viewfinder is blacked out when the camera is focusing.

✦ **Tripod.** You use this option when the camera is attached to a tripod for shooting nonmoving subjects. When the option is activated, the camera uses contrast-detection to focus on the subject. The camera analyzes the data directly from the image sensor to determine the proper focus. This method takes a little longer to achieve focus; therefore, it is unsuitable for moving subjects.

You can also set the Release mode for shooting (Single, Continuous Low, or Continuous High) through the Release mode sub-menu.

 For more information on using Live View, see Chapter 2.

Multiple exposure

This menu option allows you to record multiple exposures in one image. You can record from two to ten shots in a single image. This is an easy way to get off-the-wall multiple images without using image-editing software like Photoshop.

To use this feature, follow these steps:

1. **Select Multiple exposure from the Shooting menu, and then press the Multi-selector right.**

2. **Select the Number of shots menu option, and then press the Multi-selector right.**

3. **Press the Multi-selector up or down to set the number of shots.** Press the OK button when the number of shots selected is correct.

4. **Select the Auto gain option, and then press the Multi-selector right.**

5. **Set the gain, and then press the OK button.** Using Auto gain enables the camera to adjust the exposure according to the number of images in the multiple exposures. This is the recommended setting for most applications. Setting the gain to Off does not adjust the exposure values and can result in an overexposed image. The Gain-off setting is recommended only in low-light situations. When the desired setting is chosen, press the OK button.

6. **Use the Multi-selector to highlight Done, then press the OK button.** This step is very important. If you do not select Done, the camera will not be in Multiple exposure mode.

7. **Take your pictures.** Once the selected amount of images has been taken, the camera exits Multiple exposure mode and returns to the default shooting setting. To do additional multiple exposures, repeat the steps.

Interval timer shooting

This menu option allows you to set the camera's time-lapse photography option. This allows you to set your camera to shoot a specified number of shots at specified intervals throughout a set period of time. You can use this interesting feature to record the slow movements of plants or animals, such as a flower opening or a snail crawling. Another option is to set up your camera with a wide-angle lens and record the movement of the sun or moon across the sky.

Naturally you'll need a tripod to do this type of photography and it's highly recommended that you use Nikon's EH-5a AC

power supply to be sure that your camera battery doesn't die in the middle of your shooting. At the very least you should use an MB-D10 with an extra battery.

After you record your series of images, you can use image-editing software to combine the images and create an animated GIF file.

You can set these options:

✦ **Starting time.** You can set the camera to start three seconds after the settings have been completed (Now) or to start photographing at a predetermined time in the future.

✦ **Interval.** This determines how much time is elapsed between each shot. You can set Hours, Minutes, and Seconds.

✦ **Number of intervals.** This sets how many times you want photos to be shot.

✦ **Shots per interval.** This sets how many shots are taken at each interval.

✦ **On or Off.** This starts or stops the camera from shooting with the current settings.

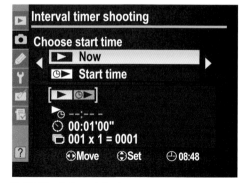

3.10 The Interval timing menu screen

Custom Settings Menu

The Custom Settings menu (CSM) is where you really start customizing your D700 to shoot to your personal preferences. You can also choose four banks in which to store your settings for different shooting situations, similar to the Shooting menu banks. Basically this is where you make the camera "yours." There are dozens of options that you can turn off or on to make shooting easier for you. The CSM is probably the most powerful menu in the camera.

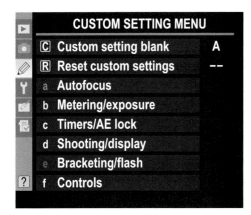

CUSTOM SETTING MENU

C	Custom setting blank	A
R	Reset custom settings	--
a	Autofocus	
b	Metering/exposure	
c	Timers/AE lock	
d	Shooting/display	
e	Bracketing/flash	
f	Controls	

3.11 The Custom Settings menu (CSM)

Custom setting bank

Like the Shooting menu banks, this option allows you to save your custom settings to four banks for easy recall. Simply select a bank — A, B, C, or D — and then change any of the custom settings to the option of your choice. The changed settings are stored until you choose to reset custom settings (described in the next section).

You can also select the Rename option in the Custom setting bank menu to add a descriptive name to your Custom setting bank to help you remember what it is to be used for.

The active Custom setting bank is shown in the Shooting info display on the main LCD screen when you press the Info button. You can quickly switch between Custom Settings banks by using the Quick Settings Display.

Reset custom settings

Use this option to restore the camera default settings for the active Custom shooting bank. So if the Custom setting bank is set to A, all the settings in bank A will return to camera default.

CSM a – Autofocus

The CSM sub-menu a controls how the camera performs its autofocus (AF) functions. Because focus is a very critical operation, this is a very important menu. You have 16 options to choose from.

a1 – AF-C priority selection

This chooses how the camera AF functions when in Continuous Autofocus (AF-C) mode. You can choose from three modes:

✦ **Release.** This is the default setting. It allows the camera to take a photo whenever you press the Shutter Release button regardless of whether the camera has achieved focus or not. This setting is best for fast action shots or for when it's imperative to get the shot whether it's in sharp focus or not.

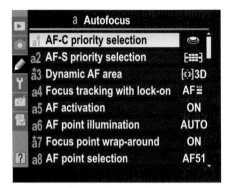

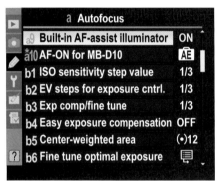

3.12 CSM a shown in two images so all options are visible

✦ **Release + focus.** This allows the camera to take pictures when the subject is not in focus, but slows the frame rate to allow the camera more time to focus on the subject. You can use this for action shots when you want to be sure that the subject is in focus and the frame rate is not important. You wouldn't want to use this option when attempting to take sequential shots at a high frame rate.

✦ **Focus.** This allows the camera to take photos only when the camera achieves focus and the focus indicator (green dot in the lower-left corner of the viewfinder) is lit. This is the best setting for slow moving subjects, where you want to be absolutely sure that your subject will be in focus.

a2 – AF-S priority selection

This sets how the camera AF functions when in Single-Servo Autofocus (AF-S) mode. You can choose from these two settings.

✦ **Release.** This is the default setting. It allows the camera to take a photo whenever you press the Shutter Release button, regardless of whether the camera has achieved focus or not.

✦ **Focus.** This allows the camera to take photos only when the camera achieves focus and the focus indicator (green dot in the lower-left corner of the viewfinder) is displayed.

a3 – Dynamic AF area

This allows you to set how many focus points to use when using Dynamic-area AF. Choose the amount of focus points by determining how much your subject may move. You can choose from four options — 9, 21, or 51 points, or 51 points with 3D-Tracking.

 For more information on Dynamic-area AF, see Chapter 2.

a4 – Focus tracking with lock-on

When you're photographing in busy environments, things can often cross your path, resulting in the camera refocusing on the wrong subject. Focus tracking with lock-on allows the camera to hold focus for a time before switching to a different focus point. This helps stop the camera from switching focus to an unwanted subject passing through your field of view.

You can choose Long, Normal, or Short delay times. You can also set the Focus tracking with lock-on to Off, which allows your camera to quickly maintain focus on a rapidly moving subject. Normal is the default setting.

a5 – AF activation

By default, you activate the camera's AF system by half-pressing the Shutter Release button or by pressing the Autofocus-On (AF-ON) button. This option allows you to set the D700 so that the AF is activated only when you're pressing the AF-ON button. If the camera is set to AF-ON, half-pressing the shutter only activates the camera's metering system. This is a personal preference, but I like to use the Shutter Release button to engage the AF. You can choose from these settings:

✦ **Shutter/AF-ON.** This allows you to engage the camera's AF system either by half-pressing the Shutter Release button or by using the AF-ON button (either on the camera body or on the MB-D10 grip).

✦ **AF-ON only.** With this option turned on, the camera's AF system is activated only when you press this button. Half-pressing the Shutter Release button only activates the D700 metering system.

a6 – AF point illumination

This menu option allows you to choose whether the active AF point is highlighted in red momentarily in the viewfinder when focus is achieved. When the viewfinder grid is turned on, the grid is also highlighted in red. When choosing Auto, which is the default, the focus point is lit only to establish contrast from the background when it is dark. When this option is set to On, the active AF point is highlighted, even when the background is bright. When this option is set to Off, the active AF point is not highlighted in red; it appears in black.

a7 – Focus point wrap-around

When using the Multi-selector to choose your AF point, this setting allows you to continue pressing the Multi-selector in the same direction and wrap around to the opposite side or stop at the edge of the focus point frame (no wrap).

a8 – AF point selection

This menu option allows you to choose the number of available focus points for you to choose from when using AF. You can set 51 points, which allows you to choose all of the D700's available focus points. You can also set it to 11 points, which allows you to choose from only 11 focus points similar to the D200. Use the 11-point option to select your focus points much more quickly than using 51 points. The 51-point option allows you to more accurately choose where in the frame the camera will focus on.

a9 – Built-in AF-assist illuminator

The AF-assist illuminator lights up when there isn't enough light for the camera to focus properly. In certain instances, you may

want to turn this option off, such as when shooting faraway subjects in dim settings (concerts or plays). When set to On, the AF-assist illuminator lights up in a low-light situation only when in AF-S mode and Auto-area AF is chosen. When in Single-point AF or Dynamic-area AF mode, the center AF point must be active.

When set to Off, the AF-assist illuminator does not light at all.

a10 – AF-ON for MB-D10

This menu option allows you to assign a specific function to the AF-ON button on the optional MB-D10 battery grip. You can choose from:

✦ **AF-ON.** This is the default setting. Pressing this button activates the camera's AF.

✦ **AE/AF Lock.** This locks the camera's focus and exposure while the button is pressed.

✦ **AE Lock only.** This only locks the exposure while the button is pressed.

✦ **AE Lock (Reset on release).** This locks the exposure. The exposure remains locked until you press the button again, the shutter is released, or you turn off the camera's exposure meter.

✦ **AE Lock (hold).** The exposure is locked when you press the button and remains locked until you press the button again or until the exposure meter turns off.

✦ **AF Lock only.** This locks the focus until the button is released.

✦ **Same as Func. button.** This sets the MB-D10 AF-ON button to the same settings as the camera's Function button. The Function button is set in CSM f5.

CSM b – Metering/ exposure

This is where you change the settings that control exposure and metering. These settings allow you to adjust the exposure, ISO, and exposure compensation adjustment increments. Setting the increments to 1/3 stops allows you to fine-tune the settings with more accuracy than setting them to 1/2 or 1 full stop. There are six options to choose from.

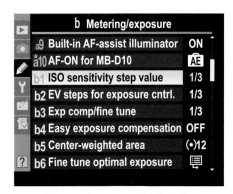

3.13 The CSM b menu, which follows the CSM a menu directly

b1 – ISO sensitivity step value

This is where you control whether the ISO is set in 1/3-, 1/2-, or 1-stop increments. Setting the ISO using smaller increments allows you to fine-tune your sensitivity with more precision, allowing you more control over keeping high ISO noise to a minimum.

b2 – EV steps for exposure cntrl.

This determines how the shutter speed, aperture, and auto-bracketing increments are set. The choices here are also 1/3, 1/2, or 1 stop. Choosing a smaller increment provides a much less drastic change in exposure and allows you to get a more exact exposure in critical situations.

b3 – Exp comp/fine tune

This allows you to choose whether the exposure compensation is set in 1/3-, 1/2-, or 1-stop increments. Again, choosing a lower increment setting allows you to fine-tune the exposure more precisely.

b4 – Easy exposure compensation

By default, to set the exposure compensation, you must first press the Exposure Value (EV) button and use the Main Command dial to add or subtract from the selected exposure. If you tend to use exposure compensation frequently, you can save yourself time by using Easy exposure compensation. When this function is set to On, it's not necessary to press the EV button to adjust the exposure compensation. Simply rotate the Main Command dial when in Aperture Priority mode or the Sub-command dial when in Programmed Auto or Shutter Priority mode to adjust the exposure compensation. The exposure compensation is then applied until you rotate the appropriate command dial until the exposure compensation indicator disappears from the LCD control panel.

If you choose to use Easy exposure compensation, probably the best setting to use is the On (Auto reset) setting. This allows you to adjust your exposure compensation while shooting, but returns the exposure compensation to default (0) when you turn

the camera off or the camera's exposure meter turns off. If you've ever accidentally left exposure compensation adjusted and ended up with incorrectly exposed images the next time you used your camera, you will appreciate this helpful feature.

When set to Off, exposure compensation is applied normally by pressing the Exposure Compensation button and rotating the Main Command dial.

b5 – Center-weighted area

This menu allows you to choose the size of your Center-weighted metering area. You can choose from four sizes: 8, 12, 15, or 20mm. You also have the option of setting the meter to Average.

Choose the spot size depending how much of the center of the frame you want the camera to meter for. The camera determines the exposure by basing 75 percent of the exposure on the circle.

 Cross-Reference *For more information on Center-weighted metering, see Chapter 2.*

b6 – Fine tune optimal exposure

If your camera's metering system consistently over- or underexposes your images, you can adjust it to apply a small amount of exposure compensation for every shot. You can apply a different amount of exposure fine-tuning for each of the metering modes: Matrix, Center-weighted, and Spot metering.

You can set the EV ±1 stop in 1/6 stop increments.

 Caution *When Fine tune optimal exposure is on, there is no warning indicator that tells you that exposure compensation is being applied.*

CSM c – Timers/AE lock

This small sub-menu controls the D700's various timers and also the Auto-Exposure lock setting. There are four options to choose from.

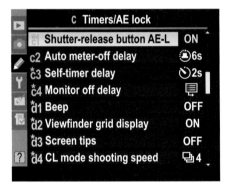

3.14 CSM c menu options

c1 – Shutter-release button AE-L

When this option is set to default (Off), the camera only locks exposure when you press the AE-L/AF-L button. When the option is set to On, the auto-exposure settings are locked when you half-press the camera's Shutter Release button.

c2 – Auto meter-off delay

The menu option determines how long the camera's exposure meter is active before turning off when no other actions are being performed. You can choose 4, 6, 8, 16, or 30 seconds; or 1, 5, 10, or 30 minutes. You can also specify for the meter to remain on at all times while the camera is on (no limit).

c3 – Self-timer delay

This menu option puts a delay on when the shutter is released after you press the Shutter Release button. This is handy when you want to do a self-portrait and you need

some time to get yourself into the frame. You can also use the self-timer to reduce the camera shake that happens when you press the Shutter Release button on long exposures. You can set the delay at 2, 5, 10, or 20 seconds.

c4 – Monitor off delay

This menu option controls how long the LCD screen remains on when no buttons are being pushed. Because the LCD screen is the main source of power consumption for any digital camera, choosing a shorter delay time is usually preferable. You can set the monitor to turn off after 10 or 12 seconds, or 1, 5, or 10 minutes.

CSM d – Shooting/display

CSM submenu d is where you make changes to some of the minor shooting and display details. You have 11 options to choose from.

d1 – Beep

When this option is on, the camera emits a beep when the self-timer is counting down or when the AF locks in Single Focus mode. You can choose High, Low, or Off. For most photographers, this option is the first thing they turn off when they take the camera out of the box. Although the beep can be kind of useful when in self-timer mode, it's a pretty annoying option, especially if you are photographing in a relatively quiet area.

d2 – Viewfinder grid display

This handy option displays a grid in the viewfinder (or in the LCD screen when in Live View) to assist you with composition of the photograph.

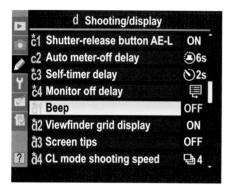

▶	d Shooting/display	
●	č1 Shutter-release button AE-L	ON
🖊	c2 Auto meter-off delay	6s
Y	č3 Self-timer delay	2s
🖼	č4 Monitor off delay	
	ð1 Beep	OFF
🗂	ð2 Viewfinder grid display	ON
	ð3 Screen tips	OFF
❓	ð4 CL mode shooting speed	4

▶	d Shooting/display	
●	d5 Max. continuous release	100
🖊	d6 File number sequence	ON
Y	d7 Shooting info display	AUTO
	d8 LCD illumination	OFF
🖼	d9 Exposure delay mode	OFF
🗂	ð10 MB-D10 battery type	NiMH
	ð11 Battery order	D700
❓	ê1 Flash sync speed	1/320*

3.15 CSM d shown in two images so all options are visible

d3 – Screen tips

When this menu option is turned on, the camera displays descriptions of the menu options available when using the Quick Settings Display. The menu options in the display are pretty self-evident so I have this option turned off. If you're unsure of any menu option, pressing the Protect/Help button displays a screen that describes the function.

d4 – CL mode shooting speed

This menu option allows you to set the maximum frame rate in the Continuous Low mode. You can set the frame rate between 1 and 7 frames per second (fps). This setting limits your burst rate for shooting slower

moving action. This is a handy option to use when you don't necessarily need the highest frame rate such as when you're shooting action that isn't moving very fast, but also isn't moving slow. I have this set to 4 fps, which is half of the frame rate I get when using the MB-D10 with AA batteries.

> **Note** The maximum continuous frame rate without the optional MB-D10 battery grip is 5 fps.

d5 – Max. continuous release

This menu option sets the maximum number of images that can be captured in a single burst when the camera is set to Continuous shooting mode. You can set this anywhere from 1 to 100. Setting this option doesn't necessarily mean that your camera is going to capture 100 frames at the full frame rate speed. When shooting continuously, especially at a high frame rate, the camera's buffer can get full and cause the frame rate to slow down or even stop while the buffer transfers data to the CF card. How fast the buffer fills up depends on the image size, compression, and the speed of your CF card. With the D700's large file sizes, I find it beneficial to use a faster card to achieve the maximum frame rate for extended periods.

d6 – File number sequence

The D700 names files by sequentially numbering them. This menu option controls how the sequence is handled. When set to Off, the file numbers reset to 0001 when a new folder is created, a new memory card is inserted, or the existing memory card is formatted. When set to On, the camera continues to count up from the last number until the file number reaches 9999. The camera then returns to 0001 and counts up from there. When this is set to Reset, the camera

starts at 0001 when the current folder is empty. If the current folder has images, the camera starts at one number higher than the last image in the folder.

d7 – Shooting info display

This controls how the Shooting info display on the LCD screen is colored. When set to Auto (default), the camera automatically sets it to White on Black or Black on White to maintain contrast with the background. The setting is automatically determined by the amount of light coming in through the lens. You can also choose for the information to be displayed consistently no matter how dark or light the scene is. You can choose B (black lettering on a light background) or W (white lettering on a dark background).

d8 – LCD illumination

When this option is set to Off (default), the LCD control panel (and on a Speedlight if attached) is lit only when the power switch is turned all the way to the right, engaging the momentary switch. When set to On, the LCD control panel is lit as long as the camera's exposure meter is active, which can be quite a drain on the batteries (especially for the Speedlight).

d9 – Exposure delay mode

Turning this option on causes the shutter to open about 1 second after you press the Shutter Release button and the reflex mirror has been raised. This option is for shooting long exposures with a tripod where camera shake from pressing the Shutter Release button and mirror slap vibration can cause the image to be blurry.

d10 – MB-D10 battery type

When using the optional MB-D10 battery pack with AA batteries, use this option to specify what type of batteries are being used to ensure optimal performance. Your choices are

✦ **LR6 (AA alkaline).** These are your standard everyday AA batteries. I don't recommend using them because they don't last very long for the D700.

✦ **HR6 (AA Ni-Mh).** These are your standard Nickel Metal Hydride rechargeable batteries available at most electronics stores. I recommend buying several sets of these. If you do buy these batteries, be sure to buy the ones that are rated at least 2500 MaH for longer battery life.

✦ **FR6 (AA Lithium).** These lightweight batteries are non-rechargeable, but last up to seven times longer than standard alkaline batteries. These batteries cost about as much as a good set of rechargeable batteries.

✦ **ZR6 (AA Ni-Mn).** These are Nickel Manganese batteries. These batteries are similar to standard Alkaline batteries but have a higher charge density, which allows them to last longer. These are the types of batteries that are usually advertised for use with digital cameras.

d11 – Battery order

You use this option to set the order in which the batteries are used when the optional MB-D10 battery grip is attached. Choose MB-D10 to use the battery grip first, or

choose D700 to use the camera battery first. If you're using the MB-D10 with AA batteries or an EN-EL4 battery to achieve a faster frame rate of 8 fps, you need to be sure that the battery order is set to use MB-D10 first. If you're using AA batteries in the MB-D10 only as a backup, set this option to use the camera battery first.

CSM e – Bracketing/ flash

This sub-menu is where you set the controls for the built-in Speedlight. Some of these options also affect external Speedlights. This menu is also where the controls for Bracketing images are located. There are seven choices.

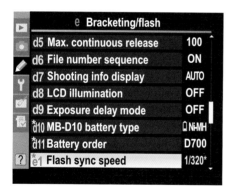

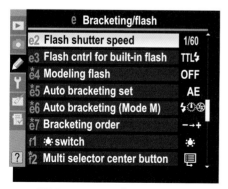

3.16 CSM e menu options

e1 – Flash sync speed

This is where you determine what shutter speed your camera uses to sync with the Speedlight. You can set the sync speed between 1/60 and 1/250 second. When using an optional SB-900, SB-800 or SB-600, you can also set the sync to 1/250 (Auto FP) or 1/320 (Auto FP); this allows you to use faster shutter speeds up to 1/8000 to maintain wider apertures in bright situations if needed.

> **Cross-Reference** *For more information on sync speed and Auto FP, see Chapter 6.*

e2 – Flash shutter speed

This option lets you decide the slowest shutter speed that is allowed when you do flash photography using Front-Curtain Sync or Red-Eye Reduction mode when the camera is in Programmed Auto or Aperture Priority exposure mode. You can choose from 1/60 second all the way down to 30 seconds.

When the camera is set to Shutter Priority or the flash is set to any combination of Slow Sync, this setting is ignored.

e3 – Flash cntrl for built-in flash

This sub-menu has other sub-menus nested within it. Essentially, this option controls how your built-in flash operates. The four submenus are

✦ **TTL.** This is the fully auto flash mode. You can make minor adjustments using FEC.

✦ **Manual.** You choose the power output in this mode. You can choose from Full power all the way down to 1/128 power.

✦ **Repeating flash.** This mode fires a specified number of flashes.

✦ **Commander mode.** Use this mode to control a number of off-camera Creative Lighting System (CLS) compatible Speedlights.

 Cross-Reference *For more information on flash photography, see Chapter 6 or pick up a copy of the* Nikon Creative Lighting System Digital Field Guide *(Wiley, 2007).*

e4 – Modeling flash

When using the built-in flash or an optional SB-600, SB-800, or SB-900 Speedlight, pressing the Depth-of-field preview button fires a series of low-power flashes that allow you to preview what the effect of the flash is going to be on your subject. When using CLS and Advanced Wireless Lighting with multiple Speedlights, pressing the button causes all the Speedlights to emit a modeling flash. You can set this to On or Off.

e5 – Auto bracketing set

This menu option allows you to choose how the camera brackets when Auto-bracketing is turned on. You can choose for the camera to bracket AE and flash, AE only, Flash only, or WB bracketing. WB bracketing is not available when the image quality is set to record RAW images.

e6 – Auto bracketing (Mode M)

This determines which settings the camera changes to adjust the exposure when using Auto-bracketing in Manual mode. The options are:

✦ **Flash/speed.** The camera varies the shutter speed and flash output (when set to AE + flash), or the shutter speed only (when set to AE only).

✦ **Flash/speed/aperture.** The camera varies the shutter speed, aperture, and flash output (when set to AE + flash), or the shutter speed and aperture (when set to AE only).

✦ **Flash/aperture.** The camera varies the aperture and flash level (when set to AE + flash) or the aperture only (when set to AE only).

✦ **Flash only.** The camera varies the flash level only (when set to AE + flash).

e7 – Bracketing order

This determines the sequence in which the bracketed exposures are taken. When set to default (N), the camera first takes the metered exposure, next the underexposures, and then the overexposures. When this option is set to (- ⇨ +), the camera starts with the lowest exposure increasing the exposure as the sequence progresses.

CSM f – Controls

This sub-menu allows you to customize some of the functions of the different buttons and dials of your D700. There are ten options to choose from.

f1 – Switch

You can rotate the On/Off button past the On setting that acts as a momentary switch. You can use this option to light up the LCD control panel (LCD backlight) or you can light up the LCD control panel and display the info screen on the rear LCD screen (Both).

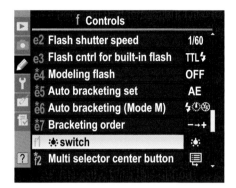

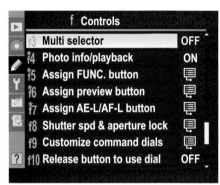

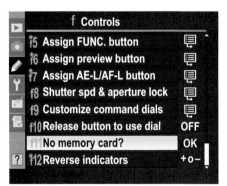

3.17 The CSM f menu options

f2 – Multi selector center button

This allows you to set specific options for pressing the center button of the Multi-selector. The options vary depending on whether the camera is in Shooting or Playback mode.

Shooting mode

In Shooting mode, the options are as follows:

✦ **Select center focus point.** This allows you to automatically select the center focus point by pressing the center button of the Multi-selector.

✦ **Highlight selected focus point.** This causes the active focus point to light up in the viewfinder when you press the center button of the Multi-selector.

✦ **Not used.** The center button has no effect when in Shooting mode.

Playback mode

In Playback mode, the options are as follows:

✦ **Thumbnail on/off.** This allows you to switch between full-frame Playback and Thumbnail view by pressing the center button of the Multi-selector.

✦ **View histogram.** This option displays the histogram of the current image selected when you press the center button of the Multi-selector.

✦ **Zoom on/off.** Pressing the center button of the Multi-selector allows you to automatically zoom in to the selected image to check focus. You can choose Low, Medium, or High magnification.

✦ **Choose folder.** Pressing the center button of the Multi-selector displays the list of folders currently on the flash card. You can then choose a folder to play back images from.

f3 – Multi selector

This allows you to set the Multi-selector to turn on the exposure meter when pressed. By default, the meter will not turn on when the Multi-selector is pressed in Shooting mode.

f4 – Photo info/playback

When in Playback mode, the left and right buttons on the Multi-selector scroll through the images while the up and down buttons display additional information such as histograms and shooting info. Using this option allows you to reverse the way these buttons function.

f5 – Assign FUNC. button

This button chooses what functions the Function button performs when you press it. Be aware that not all options are available depending on which particular setting you choose. You can choose from two Function button options: Fn. button press and Fn. button + command dials. You can also access this setting using the Quick Settings menu. The options are

✦ **Preview.** If you want to use the Depth-of-field preview button for another function, you can reassign it to this button. This option closes down the aperture so you can see in real time what effect the aperture will have on the image's depth of field. This function is cancelled when you select a function for Fn. button + command dials. If you choose this setting for button press only, the function for FN. button + command dials will be deactivated.

✦ **FV lock.** The camera fires a pre-flash to determine the proper flash exposure value and locks the setting, allowing you to meter the subject

and then recompose the shot without altering the flash exposure. This function is cancelled when you select a function for Fn. button + command dials. If you choose this setting for button press only, the function for Fn. button + command dials will be deactivated.

✦ **AE/AF Lock.** The focus and exposure locks when you press and hold the button.

✦ **AE Lock only.** The exposure locks when you press and hold the button. Focus continues to function normally.

✦ **AE Lock (reset on release).** The exposure locks when you press the button. The exposure remains locked until the shutter is released, the Function button is pressed again, or the exposure meter turns off. This function is cancelled when you select a function for Fn. button + command dials. If you choose this setting for button press only, the function for Fn. button + command dials will be deactivated.

✦ **AE Lock (hold).** The exposure locks until you press the button a second time or turn off the exposure meter.

✦ **AF Lock only.** The focus locks while you press and hold the button. The AE continues as normal.

✦ **Flash off.** With this option, the built-in flash (if popped up) or an additional Speedlight will not fire when the shutter is released as long as the Function button is pressed. This allows you to quickly take available light photos without having to turn of the flash. This is quite handy, especially when shooting weddings and events.

✦ **Bracketing burst.** The camera fires a burst of shots when you press and hold the Shutter Release button while in Single shot mode when Auto-bracketing is turned on. The number of shots fired depends on the Auto-bracketing settings. When in Continuous shooting mode, the camera continues to run through the bracketing sequence as long as you hold the Shutter Release button.

✦ **Matrix metering.** This allows you to automatically use Matrix metering no matter what the Metering Mode dial is set to.

✦ **Center-weighted.** This allows you to automatically use Center-weighted metering no matter what the Metering Mode dial is set to.

✦ **Spot metering.** This allows you to automatically use Spot metering no matter what the Metering Mode dial is set to.

✦ **Access top item in My Menu.** This brings up the top item set in the My menu option. You can use this to quickly access your most used menu option. This function is cancelled when you select a function for Fn. button + command dials. If you choose this setting for button press only, the function for Fn. button + command dials will be deactivated.

✦ **Live View.** This automatically turns on the Live View LCD screen preview, though this option will not work when the camera's Release Mode dial is set to Live View or Mirror up mode (Mup). This function is cancelled when you select a function for Fn. button + command dials. If you choose this setting for button press only, the function for Fn. button + dials will be deactivated.

✦ **+ NEF (RAW).** Pressing the Function button when this is activated and the camera is set to record JPEGs allows the camera to simultaneously record a RAW file and a JPEG. Pressing the button again allows the camera to return to recording only JPEGs. This function is cancelled when you select a function for Fn. button + command dials. If you choose this setting for button press only, the function for Fn. button + dials will be deactivated.

✦ **Virtual horizon.** When this option is selected, pressing the Function button switches the electronic analog exposure display in the viewfinder and on the LCD control panel to act as a level. When the camera is tilted to the right, the bars are displayed to the left of the 0; when the camera is tilted left, the camera displays bars to the right. When the camera is level, a single bar at the 0 position appears. This feature is useful when you want to be sure the horizon is straight and the camera is perfectly level. This function is cancelled when you select a function for Fn. button + command dials. If you choose this setting for button press only, the function for Fn. button + command dials will be deactivated.

✦ **None.** This is the default setting. No function is performed when the button is pressed.

A second subset in this menu is Func. + dials. This allows you to use the Function button in combination with the Main Command or Sub-command dial to perform certain functions. The options are

✦ **Choose image area.** Press the Function button and rotate either command dial to choose between FX and DX settings.

✦ **Shutter spd and aperture lock.** Press the Function button and rotate the Main command dial to lock the shutter speed when in Shutter Priority or Manual mode. Press the Function button and rotate the Sub-command dial when using Aperture Priority or Manual mode. To unlock it, press the Function button and rotate the appropriate dial again. You can use this setting to be sure you don't accidentally change your settings in a situation where you need a specific setting, such as when you're photographing a sporting event where you need a fast aperture or a portrait where you might want to keep the aperture wide open.

✦ **1 step spd / aperture.** When the Function button is pressed, the aperture and shutter speed are changed in 1-stop intervals.

✦ **Choose non-CPU lens number.** Press the Function button and rotate the Main Command dial to choose one of your presets for a non-CPU lens.

✦ **Auto-bracketing.** This is the default setting. Pressing and holding the Function button and rotating the Main Command dial changes the number of shots in the bracketing

series. Rotating the Main Command dial allows you to change the EV increments to 0.3, 0.7, or 1.0 stops.

✦ **Dynamic AF-area.** This allows you to choose the number of focus points when using Dynamic-area AF mode by pressing the Function button and rotating either the Main Command or Sub-command dial. Note that the camera must be in AF-C and Dynamic-area AF mode.

✦ **None.** No functions are performed.

f6 – Assign preview button

This allows you to assign a function to the Depth-of-field preview button. The choices are exactly the same as that of the Function button.

f7 – Assign AE-L/AF-L button

This allows you to assign a function to the AE-L/AF-L button. The choices are exactly the same as that of the Function button with the addition of an AF-ON setting.

f8 – Shutter spd & aperture lock

This option allows you to lock your exposure settings to avoid accidentally changing them; you can lock the shutter speed when using Shutter Priority mode, the aperture when using Aperture Priority mode. When in Manual mode, you can lock the aperture only, the shutter speed only, or both simultaneously. When using Programmed Auto mode, this feature is disabled.

f9 – Customize command dials

This menu allows you to control how the Main Command and Sub-command dials function. The options are

✦ **Reverse rotation**. This causes the settings to be controlled in reverse of what is normal. For example, by default, rotating the Sub-command dial right makes your aperture smaller. By reversing the dials, you get a larger aperture when rotating the dial to the right.

✦ **Change main/sub.** This switches functions of the Main Command dial to the front and the Sub-command dial to the rear of the camera.

✦ **Aperture setting.** This allows you to change the aperture only using the aperture ring of the lens. Note that most newer lenses have electronically controlled apertures (Nikkor G lenses) and do not have an aperture ring. When used with a lens without an aperture ring, the Sub-command dial controls the aperture by default.

✦ **Menus and playback.** This allows you to use the command dials to scroll the menus and images in much the same fashion the Multi-selector is used. In Playback mode, the Main Command dial is used to scroll through the preview images and the Sub-command dial is used to view the shooting information and/or histograms. When in Menu mode, the Main Command dial functions the same as the Multi-selector up and down and the Sub-command dial operates the same as the Multi-selector left and right.

f10 – Release button to use dial

When changing the Shooting mode, exposure compensation, Flash mode, WB, QUAL, or ISO, you must press and hold the corresponding button and rotate the command dial to make changes. This setting allows you to press and release the button, make changes using the command dials, and then press the button again to set.

f11 – No memory card?

This setting controls whether the shutter will release when no memory card is present in the camera. When set to Enable release, the shutter fires and the image is displayed in the LCD screen and will be temporarily saved. When set to Release locked, the shutter will not fire. If you happen to be using Camera Control Pro 2 shooting tethered directly to your computer, the camera shutter will release no matter what this option is set to.

f12 – Reverse indicators

This allows you to reverse the indicators on the electronic light meter displayed in the viewfinder and on the LCD control panel on the top of the camera. For some, the default setting showing the overexposure on the left and the underexposure on the right is counterintuitive. Reversing these makes more sense to some people (including me). This option also reverses the display for the Auto-bracketing feature.

Setup Menu

This menu contains a smattering of options, most of which aren't changed very frequently. Some of these settings include the time and date and the video mode. A couple other options are the Clean image sensor and Battery info, which you may want to access from time to time. There are 20 different options.

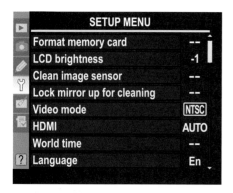

SETUP MENU

Format memory card	--
LCD brightness	-1
Clean image sensor	--
Lock mirror up for cleaning	--
Video mode	NTSC
HDMI	AUTO
World time	--
Language	En

SETUP MENU

Image comment	OFF
Auto image rotation	ON
Dust off ref photo	--
Battery info	--
Wireless transmitter	
Image authentication	OFF
Copyright information	ON
Save/load settings	--

SETUP MENU

Image authentication	OFF
Copyright information	ON
Save/load settings	--
GPS	--
Virtual horizon	--
Non-CPU lens data	No. 1
AF fine tune	--
Firmware version	--

3.18 The Setup Menu shown in three images so all options are visible

Format memory card

This allows you to completely erase everything on your CF card. Formatting your memory card erases all of the data on the card. It's a good idea to format your card every time you download the images to your computer (just be sure all of the files are successfully transferred before formatting). Formatting the card helps protect against corrupt data. Simply erasing the images leaves the data on the card and allows it to be overwritten; sometimes this older data can corrupt the new data as it is being written. Formatting the card gives your camera a blank slate on which to write.

You can also format the card using the much more convenient two-button method (pressing and holding the Delete and Mode buttons simultaneously).

LCD brightness

This menu sets the brightness of your LCD screen. You may want to make it brighter when viewing images in bright sunlight or make it dimmer when viewing images indoors or to save battery power. You can adjust the LCD ±3 levels. The menu shows a graph with 10 bars from black to gray on to white. The optimal setting is where you can see a distinct change in color tone in each of the 10 bars. If the last two bars on the right blend together, your LCD is too bright; if the last to bars on the left side blend together, your LCD is too dark.

Clean image sensor

This great new feature was released with the D300 and added to the D700. Even the higher-end D3 doesn't have this capability. With this feature, the camera uses ultrasonic vibration to knock any dust off the filter in front of the sensor. This helps keep most of the dust off of your sensor but is not going to keep it absolutely dust free forever. You may have to have the sensor professionally cleaned periodically.

You can choose Clean now, which cleans the image sensor immediately, or you have four separate options for cleaning that you access in the Clean at startup/shutdown option. They include

✦ **Clean at startup.** The camera goes through the cleaning process immediately upon turning the camera on. This may delay your startup time a little bit.

✦ **Clean at shutdown.** The camera cleans the sensor when you switch the camera off. This is my preferred setting because it doesn't interfere with the startup time.

✦ **Clean at startup and shutdown**. The camera cleans the image sensor when you turn it on and also when it is powered down.

✦ **Cleaning off.** This disables the dust reduction function when the camera is turned on and off. You can still use the Clean now option when this is set.

Lock mirror up for cleaning

This locks up the mirror to allow access to the image sensor for inspection or for additional cleaning. The sensor is also powered down to reduce any static charge that may attract dust. Although some people prefer to clean their own sensors, I recommend taking your camera to an authorized Nikon service center for any sensor cleaning. Any damage caused to the sensor by improper self-cleaning will not be covered by warranty and can lead to a very expensive repair bill.

Video mode

There are two options in this menu: NTSC (National Television System Committee) and PAL (Phase Alternating Line). Without getting into too many specifics, these are types of standards for the resolution of televisions. All of North America, including Canada and Mexico, use the NTSC standard, while most of Europe and Asia use the PAL standard. Check your television owner's manual for the specific setting if you plan to view your images on a TV directly from the camera.

HDMI

The D700 has an HDMI (High-Definition Multimedia Interface) output that allows you to connect your camera to an HD TV to review your images. There are five settings: 480p, 576p, 720p, 1080i, and Auto. The Auto feature automatically selects the appropriate setting for your TV. Before plugging your camera in to an HD TV I recommend reading your TV's owner's manual for specific settings. When the camera is attached to an HDMI device, the LCD screen on the camera is automatically disabled.

World time

This is where you set the camera's internal clock. You also select a time zone, choose the date display options, and turn the daylight-saving time options on or off.

Language

This is where you set the language that the menus and dialog boxes display.

Image comment

You can use this feature to attach a comment to the images taken by your D700. You can enter the text using the Input Comment menu. You can view the comments in Nikon's Capture NX, Capture NX 2, or View NX software or in the photo info on the camera. Setting the Attach comment option applies the comment to all images taken until this setting is disabled. Comments you may want to attach include copyright information or your name, or even the location where the photos were taken.

Auto image rotation

This tells the camera to record the orientation of the camera when the photo is shot (portrait or landscape). This allows the camera and also image-editing software to show the photo in the proper orientation so you don't have to take the time in post-processing to rotate images shot in portrait orientation.

Dust off ref photo

This option allows you to take a Dust off reference photo that shows any dust or debris that may be stuck to your sensor. Capture NX or NX 2 then uses the image to automatically retouch any subsequent photos where the specks appear.

To use this feature either select Start or Clean sensor and then start. Next you will be instructed by a dialog box to take a photo of a bright featureless white object that is about 10 centimeters from the lens. The camera automatically sets the focus to infinity. You can only take a Dust off reference photo when using a CPU lens. It's recommended to use at least a 50mm lens, and when using a zoom lens to zoom all the way in to the longest focal length.

Battery info

This handy little menu allows you to view information about your batteries. It shows you the current charge of the battery as a percentage and how many shots have been taken using that battery since the last charge. This menu also shows the remaining charging life of your battery before it is no longer able to hold a charge. I find myself accessing this menu quite a bit to keep a real-time watch on my camera's power levels. Most of these info options only work with EN-EL3e or EN-EL4/EN-EL4a batteries. AA batteries cannot provide the camera with data. The menu options are as follows:

✦ **Bat. meter.** This tells you the percentage of remaining battery life from 100% to 0%. When the MB-D10 is attached and loaded with AA batteries, a percentage is not shown but there is a battery indicator that shows full, 50%, and 0% power levels.

✦ **Pic. meter.** This tells you how many shutter actuations the battery has had since its last charge. This option is not displayed for the MB-D10 when you're using AA batteries.

✦ **Calibration.** This option is only displayed when an EN-EL4 or EN-EL4a battery is inserted into the MB-D10. This tells you when to recalibrate the battery so that the remaining charge can be shown more accurately.

✦ **Charging life.** This is a gauge that goes from 0 to 4 that tells you how much working life you have left in your battery given Li-Ion batteries have a finite life. This option is not shown for AA batteries. When shooting outside in temperatures below 41° F (5° C), this gauge may temporarily show that the battery life has lost some of its charging life. The battery will show normal when brought back to normal operating temperature of about 68° F.

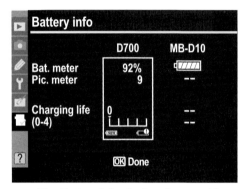

3.19 The Battery info display shown with MB-D10 and AA batteries

Wireless transmitter

This option is used to change settings of the optional WT-4 wireless transmitter. You cannot access this menu option when the WT-4 is not attached. See the WT-4 wireless transmitter for more information.

Image authentication

This allows you to embed information to your images while they are being captured. Any subsequent altering of the images can be detected using Nikon's optional Image Authentication Software. Police and government agencies usually use this option to verify that an image hasn't been manipulated and, therefore, can be used as evidence in court.

Copyright information

This is a great feature that allows you to imbed your name and copyright information directly into the EXIF (Exchangeable Image File Format) data of the image as it is being recorded. Enter the information using the text entry screen. You can turn this option on or off without losing the actual information. You may want to turn this option off when doing "work for hire," where you get paid to take the photos but relinquish all copyright and ownership to the person who hired you.

Save/load settings

This allows you to save the current camera settings to a CF card. You can then store this CF card somewhere or transfer the file to your computer. You can also load these settings back to your camera in case of an accidental reset or load them onto a second D700 to duplicate the settings quickly.

GPS

This menu is used to adjust the settings of an optional GPS (Global Positioning System) unit, which can be used to record longitude and latitude to the images EXIF data. The GPS is connected to the camera's 10-pin remote terminal using an optional MC-35 GPS adapter.

Virtual horizon

Virtual horizon is a new feature that appeared with the D700 and was simultaneously added to the D3 via a firmware update. This view is similar to a heads-up display in a fighter plane that allows you to see whether your camera is level or not. The feature uses a sensor inside the camera to determine whether it's level or not. When the camera is completely level, the Virtual horizon is displayed in green. If you shoot a lot of landscapes and your tripod doesn't have a level, you're in luck: This is the perfect tool for you. You can view the Virtual horizon display directly overlaid on the Live View screen by pressing the Info button twice when using Live View mode.

Non-CPU lens data

Non-CPU lenses are manual focus lenses that don't have a CPU chip built in so that the lens and camera can communicate data back and forth. This menu option enables you to enter focal length and aperture data for up to nine different lenses.

There are different features within the camera that require focal length and aperture information to function properly. First off, if information about the lens isn't entered, it won't show in the EXIF data. Second, when a non-CPU lens is attached to the camera, the metering mode automatically defaults to Center-weighted. Entering the lens data enables you to use Color Matrix metering (3D Color Matrix Metering II requires a D- or G-type CPU lens). Third, entering the lens data allows the Auto zoom feature to work with the SB-600, SB-800, or SB-900. Finally, you also need to enter the lens data for the SB-800 or SB-900 flash to function properly using the Auto Aperture setting.

To set the lens data when using a non-CPU lens, follow these steps:

1. **Use the Multi-selector to select non-CPU lens data from the Setup menu, and then press the Multi-selector right.**

2. **Use the Multi-selector left or right button to select a lens number from 1 to 9 to set the information.** Press the Multi-selector down button.

3. **Select the focal length of your non-CPU lens.** You can use a lens from as wide as 6mm to as long as 4000mm. Press the Multi-selector down.

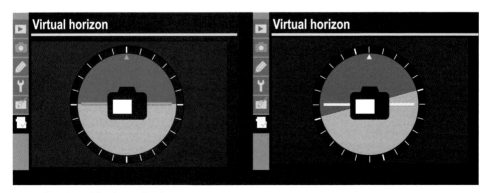

3.20 The Virtual horizon display

4. **Choose the maximum aperture of your lens.** You can choose from f/1.2 to f/22.

5. **Use the Multi-selector to highlight Done, and then press the OK button to save the lens data.**

AF fine tune

This option allows you to adjust the AF to fit a specific lens. Lenses are manufactured to tight specifications, but sometimes lens elements can shift a few microns due to impact or general wear and tear. These small abnormalities can cause the lens to shift its plane of focus behind or in front of the imaging sensor. I would say that this is usually a rare occurrence, but it's a possibility.

You can now fine-tune the camera's AF to correct for any focusing problems. This feature can save you the time and hassle of sending your lens in for calibration. Another good thing about this feature: If you're using a CPU lens, the camera remembers the fine-tuning for that specific lens and adjusts it for you automatically.

Here's a brief rundown on how to adjust the AF fine-tuning:

1. **Using the Multi-selector, choose AF fine tune from the Setup menu and press the OK button.**

2. **Turn AF fine tune On by selecting AF fine tine (On/Off) in the menu, Highlight On, and then press the OK button.**

3. **Highlight Saved value and press the OK button.**

4. **Use the Multi-selector up and down to adjust the plane of focus.** You'll have to use a little guesswork. Determine if the camera is focusing behind the subject or in front of it and, if so, how far?

5. **Once it's adjusted, press the OK button.**

6. **Set the Default.** This should be set to 0. Press the OK button.

Note *The saved value stores separate tuning values for each individual lens. This is the value that will be applied when the specific lens is attached and the AF fine tune is turned on.*

Note *When the AF fine tune is on and a lens without a stored value is attached, the camera will use the default setting. This is why I recommend setting the default to 0 until you can determine whether the lens needs fine-tuning or not.*

Each CPU lens you fine-tune is saved into the menu. To view them, select List Saved Values. From there you can assign a number to the saved values from 0 to 99 (although the camera only stores 12 lens values). I'm not sure what the reasoning is behind this odd numbering system. Possibly you could use the number to denote what lens you're using; for example, use the number 50 for a 50mm lens, the number 85 for an 85mm lens, and so on.

The best thing to do when attempting to fine-tune your lenses is to set them up one by one and do a series of test shots. You need to do your test shots in a controlled manner so there are no variables to throw off your findings.

The first thing to do is to get an AF test chart. You can find these on the Internet or you can send me an e-mail through my Web site (http://deadsailorproductions.com) and I can send you one that you can print out. An AF test chart has a spot in the center that you focus on and a series of lines or marks set at different intervals. Assuming you focus on the right spot, the test chart can tell you

whether your lens is spot on, back focusing, or front focusing. The test chart needs to be lit well for maximum contrast. Not only do you need the contrast for focus, but also it makes it much easier to interpret the test chart. Using bright continuous lighting is best, but flash can work as well. Lighting from the front is usually best.

Next, set your camera Picture Control to ND, (Neutral). Ensure that all in-camera sharpening is turned off and contrast adjustments are at zero. This is to be sure that you are seeing actual lens sharpness, not sharpness created by post-processing.

Lay the AF test chart on a flat surface. This is important: There must be no bumps or high spots on the chart or your results won't be accurate. Mount the camera on a tripod and adjust the tripod head so that the camera is at a 45-degree angle. Be sure that the camera lens is just about at the minimum focus distance to ensure the narrowest depth of field. Set the camera to Single-servo AF mode and use Single-area AF and use the center AF point. Focus on the spot at the center of the AF test chart. Be sure not to change the focus point or move the tripod while making your tests. Set the camera to Aperture Priority and open the aperture to its widest setting to achieve a narrow depth of field. (This makes it easier to figure out where the focus is falling — in the front or the back.) Use a Nikon MC-30 remote control release or the self-timer to be sure there is no blur from camera shake. The first image should be shot with no AF fine-tuning.

Look at the test chart. Decide whether the camera is focusing where it needs to be or if it's focusing behind or in front of where it needs to be.

Next, you can make some large adjustments to the AF fine-tuning (+5, -5, +10, -10, +15, −15, +20, −20), taking a shot at each setting. Be sure to defocus and refocus after adjusting the settings to ensure accurate results. Compare these images and decide which setting brings the focus closest to the selected focus point. After comparing them you may want to do a little more fine-tuning, to −7 or +13, for example.

This can be a tedious and time-consuming project. That being said, most lenses are already spot on and it probably isn't necessary to run a test like this on your lens unless it is extremely noticeable that the lens is consistently out of focus.

Firmware version

This menu option displays which firmware version your camera is currently operating under. Firmware is a computer program that is embedded in the camera that tells it how to function. Camera manufacturers routinely update the firmware to correct for any bugs or to make improvements on the camera's functions. Nikon posts firmware updates on its Web site at www.nikonusa.com.

Retouch Menu

The Retouch menu allows you to make changes and corrections to your images using imaging-editing software. As a matter of fact, you don't even need to download your images. You can make all of the changes in-camera using the LCD screen (or hooked up to a TV if you prefer).

The options include D-Lighting, Red-eye correction, Trim, Monochrome, Color effects, Color balance, and Image overlay.

 Cross-Reference *The Retouch menu is discussed at length in Chapter 8.*

My Menu

This is a great new menu option that was introduced with the D300. It is much better than the Recent Settings menu in the D200. (You can also choose the replace the My Menu tab with the Recent Settings tab.) The My Menu option allows you to create your own customized menu by choosing the options. You can also set the different menu options to whatever order you want. This allows you to have all the settings you change the most right at your fingertips, without your having to search through all the menus and sub-menus. For example, I have the My Menu option set to display all of the menu options I frequently use, including Set Picture Control, Battery info, CSM e3, and Active D-Lighting among a few others. This saves me an untold amount of time because I don't have to go through a lot of different menus.

To set up your custom My Menu, follow these steps:

1. **Select My Menu, and press the OK button.**

2. **Select Add items, and press the OK button.**

3. **Use the Multi-selector to navigate through the menus to add specific menu options, and press the OK button.**

4. **Use the Multi-selector to position where you want the menu item to appear, and press the OK button to save the order.**

5. **Repeat Steps 2 to 4 until you have added all the menu items you want.**

3.21 This figure shows the My Menu options I have set on my camera.

To reorder the items in My Menu, follow these steps:

1. **Select My Menu, and press the OK button.**

2. **Select Rank items, and press the OK button.** This brings up a list of all the menu options that you have saved to the My Menu.

3. **Use the Multi-selector to highlight the menu option you want to move, and press the OK button.**

4. **Using the Multi-selector, move the yellow line to where you want to move the selected item.** Press the OK button to set the option. Repeat this step until you have moved all of the menu options that you want.

5. **Press the menu button or tap the Shutter Release button to exit.**

To delete options from My Menu, simply press the Delete button when the option is highlighted. The camera will ask for confirmation that you indeed want to delete the setting. Press the Delete button again to confirm or press the Menu button to exit without deleting the menu option.

As I mentioned earlier, you can replace the My Menu option with the Recent Settings option. The Recent Settings menu stores the last 20 settings you have adjusted. To switch from My Menu to Recent Settings:

1. **Select My Menu from the Menu tab. Press the OK button to view My Menu.**

2. **Use the Multi-selector to scroll down to the Choose tab menu option, and press the OK button.**

3. **Select Recent settings and press the OK button or the Multi-selector right to change the setting.**

4. **Press the menu button or tap the Shutter Release button to exit.**

Quick Settings Display

The Quick Settings Display, believe it or not, is inherited from Nikon's entry-level camera, the D60. It allows you access to several of the most commonly changed menu items. To access the Quick Settings Display, press the Info button. This displays the Shooting info screen on the rear LCD. While the shooting info is displayed press the Info button again. This grays out the shooting info and highlights the settings shown at the bottom of the Shooting info screen. Use the Multi-selector directional buttons to highlight the setting you want to change then press the OK button. This takes you straight to the specific menu option. The Quick Settings Display options are

✦ Shooting menu bank

✦ Custom Settings bank

✦ High ISO Noise Reduction

✦ Long exposure Noise Reduction

✦ Active D-Lighting

✦ Picture Control

✦ Color space

✦ Assign AE-L/AF-L button

✦ Assign Preview button

✦ Assign Function button

High ISO Noise
Reduction

Active
D-Lighting

Assign Preview
button

Color space

Shooting menu
bank

Custom Settings
menu bank

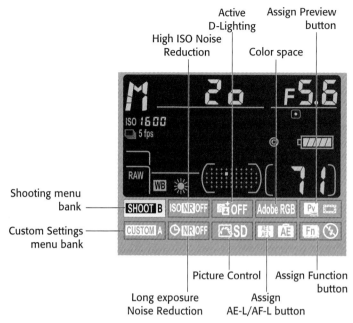

Long exposure
Noise Reduction

Picture Control

Assign
AE-L/AF-L button

Assign Function
button

3.22 The Quick Settings Display

Capturing Great Images with the Nikon D700

Selecting and Using Lenses

The lens that you put on your camera is almost as important as the camera body itself, and some may argue that the lens is more important than the camera itself. There are many different types of lenses, from ultrawide-angle lenses to super-telephoto lenses. The lens that you use depends on the subject you're photographing as well as how you want your image to be perceived.

The build and optical quality of a lens can have a serious impact on your image quality. Lower-quality lenses often have undesirable characteristics that will show up in your images. Often low-priced lenses will have problems such as softness, lack of contrast, chromatic aberration, and vignetting (darkening of the edges). Chromatic aberration is characterized by fringing on the edges of certain areas of the image, particularly in areas of high contrast. This is caused by the inability of the lens to focus all wavelengths of light on the same optical axis. In order to take full advantage of your D700, I recommend buying the best lenses that you can afford.

One of the great things about photography is that through your lens choice you can show things in a way that the human eye can't perceive. The human eye is basically a fixed focal length lens. We can only see a certain set angular distance. This is called our field of view (or angle of view). Our eyes have about the same field of view as a 50mm lens on an FX-format Nikon dSLR camera. Changing the focal length of your lens, whether by switching lenses or zooming, changes the field of view, allowing the camera to "see" more or less of the scene you are photographing. In the following sections, I discuss the different types of lenses and how they can influence the subjects that you're photographing.

Wide-Angle and Ultrawide Lenses

Wide-angle lenses, as the name implies, provide a very wide angle of view of the scene you are photographing. Wide-angle lenses are great for photographing a variety of subjects, but they are really excellent for subjects such as landscapes and group portraits, where you need to capture a wide area of view.

The focal length range of wide-angle lenses starts out at 12mm (ultrawide) and extends to about 35mm (wide-angle). Most of the more common wide-angle lenses on the market today are zoom lenses although there are quite a few prime lenses available. Wide-angle lenses are generally rectilinear (also known as aspherical), meaning that

there are lens elements built into the lens to correct the distortion that is common with wide-angle lenses; this way, the lines near the edges of the frame appear straight. Fisheye lenses, which are also a type of wide-angle lens, are curvilinear; the lens elements are not corrected, resulting in severe optical distortion. I discuss fisheye lenses in more depth later in the chapter.

In recent years, lens technology has grown by leaps and bounds, making high-quality ultra-wide lenses affordable. In the past, ultra-wide lenses were rare, prohibitively expensive, and out of the reach of most amateur photographers. These days, it's very easy to find a relatively inexpensive ultra-wide lens. Ultra-wide lenses usually run in focal length from about 12mm to 20mm. Most wide-angle zoom lenses run the gamut from ultra-wide to wide angle. Some of the ones that work with the D700 include

Image courtesy of Nikon, Inc.
4.1 Nikkor 14-24mm f/2.8

✦ **Nikkor 14-24mm f/2.8.** This is Nikon's newest ultra-wide zoom and probably the best on the market. This lens gives you a field of view of 114 degrees at 14mm to 84 degrees at 24mm. It also gives you excellent image sharpness from corner to corner at all apertures. It has a fast constant aperture and is great for low-light shooting. It is a truly spectacular lens.

✦ **Sigma 12-24mm f/4.5-5.6.** This third-party lens is currently the widest FX-compatible lens available. It's also one of my favorite lenses. The field of view is an incredible 122 degrees at 12mm. There are a couple of drawbacks to this lens. First, it's not nearly as fast as the Nikon 14-24mm. At more than a stop slower at 12mm and 2 stops slower at 24mm, you really need to crank up the ISO in low light (not really a problem with the D700). This lens is also lacking in sharpness when it's wide open and it isn't really completely sharp until you get to f/11. Personally, I think the extreme wideness of this lens

is worth the tradeoff in image sharpness. I sharpen a bit in post-processing and everything looks fine.

✦ **Nikkor 17-35mm f/2.8.** This is a great standard (meaning not ultra-wide) wide-angle lens that is very versatile. It's sharp, it's fast, and it's quiet. The 17-35mm is a work-horse of a lens. This lens is pretty popular, so finding one used at a decent price is nearly impossible. If you're willing to give up a few millimeters and AF-S, the Nikon 20-35mm f/2.8D is a great, affordable alternative.

Of course, Nikon and other manufacturers make wide-angle prime lenses as well. Today's wide-angle zoom lenses are just as sharp (if not sharper in the case of the 14-24mm) as the prime lenses. I find that a wide-angle zoom gives you more bang for your buck, but prime lenses are more affordable, smaller, and lighter. The standard wide-angle primes are 14, 20, 24, 28, 30, and 35mm. All of these prime lenses are sharp and come in apertures of at least f/2.8 or faster.

Deciphering Nikon's Lens Codes

When shopping for lenses, you may notice all sorts of letter designations in the lens name. For example, the kit lens is the Nikkor 24-120mm f/3.5-5.6G IF-ED AF-S VR. So, what do all those letters mean? Here's a simple list to help you decipher them:

✦ **AI/AIS.** These are auto-indexing lenses that automatically adjust the aperture diaphragm down when the Shutter button is pressed. All lenses made after 1977 are AI lenses. They are all manual focus lenses.

✦ **E.** These lenses were Nikon's budget series lenses, made to go with the lower-end film cameras the EM, FG, and FG-20. Although these lenses are compact and are often constructed with plastic parts, some of theses lenses, especially the 50mm f/1.8, are of quite good quality. These lenses are also manual focus only.

Continued

Continued

✦ **D.** Lenses with this designation convey distance information to the camera to aid in metering for exposure and flash.

✦ **G.** These are newer lenses that lack a manually adjustable aperture ring. You must set the aperture on the camera body.

✦ **AF, AF-D, AF-I, and AF-S.** All of these denote that the lens is an autofocus lens. The AF-D represents a distance encoder for distance information, the AF-I is for internal focusing motor type, and the AF-S is for an internal Silent Wave Motor.

✦ **DX.** This lets you know the lens was optimized for use with Nikon's DX-format sensor (all Nikon dSLRs, with the exception of the D700 and D3). These lenses can be used on the D700 (or D3) when set to DX-format mode. This effectively decreases your image resolution to 5.1 megapixels.

✦ **VR.** This code denotes the lens is equipped with Nikon's Vibration Reduction image stabilization system.

✦ **ED.** This indicates the glass in the lens is Nikon's Extra-low Dispersion glass, which means the lens is less prone to lens flare and chromatic aberrations.

✦ **Micro-NIKKOR.** Even though they are labeled as micro, these are Nikon's macro lenses.

✦ **IF.** IF stands for internal focus. The focusing mechanism is inside the lens, so the lens doesn't change length and the front of the lens doesn't rotate when focusing. This feature is useful when you don't want the front of the lens element to move; for example, when you use a polarizing filter. The internal focus mechanism also allows for faster focusing.

✦ **DC.** DC stands for Defocus Control. Nikon only offers a couple of lenses with this designation. These lenses make the out-of-focus areas in the image appear softer by using special lens elements to add spherical aberration. The parts of the image that are in focus aren't affected. Currently the only Nikon lenses with this feature are the 135mm and the 105mm f/2. Both of these are considered portrait lenses.

✦ **CRC.** CRC stands for Close Range Correction. Lenses that have this feature have floating elements inside that allow the images to retain sharpness when focusing at close distances.

When to use a wide-angle lens

You can use wide-angle lenses for a broad variety of subjects, and they are great for creating dynamic images with interesting results. Once you get used to "seeing" the world through a wide-angle lens, you'll find that your images will start to be more creative and you'll look at your subjects differently. There are many different considerations to think about when you use a wide-angle lens. Here a few examples:

✦ **More depth of field.** Wide-angle lenses allow you to get more of the scene in focus than you can when you're using a mid-range or telephoto lens at the same aperture and distance from the subject.

✦ **Wider field of view.** Wide-angle lenses allow you to fit more of your subject into your images. The shorter the focal length, the more you can fit in. This can be especially beneficial when you're shooting landscape photos where you want to fit an immense scene into your photo or when you're shooting a large group of people.

✦ **Perspective distortion.** Using wide-angle lenses causes things that are closer to the lens to look disproportionately larger than things that are farther away. You can use this to your advantage if you want the subject to stand out in the frame.

✦ **Handholding.** At shorter focal lengths, it's possible to hold the camera steadier than at longer shutter speeds (remember the reciprocal rule for focal length?). At 14mm, it's entirely possible to hand hold your camera at 1/15 without worrying about camera shake.

✦ **Environmental portraits.** Although using a wide-angle lens isn't the best choice for standard close-up portraits, wide-angle lenses work great for environmental portraits where you want to show a person in his or her surroundings.

Understanding limitations

Wide-angle lenses are very distinctive when it comes to the way they portray your images, and they also have some limitations that you may not find in lenses with longer focal lengths. There are also some pitfalls that you need to be aware of when using wide-angle lenses:

✦ **Soft corners.** The most common problem that wide-angle lenses, especially zooms, have is they soften the images in the corners. This is most prevalent at wide apertures such as f/2.8 and f/4 and the corners usually sharpen up by f/8 (depending on the lens). This problem is greatest in lower-priced lenses.

✦ **Vignetting.** This is the darkening of the corners in the image. This occurs because the light that is needed to capture such a wide angle of view must come from a very oblique angle. When the light comes in at such an angle, the aperture is effectively smaller. The aperture opening no longer appears as a circle, but as a cat's eye shape. Stopping down the aperture reduces this effect and reducing the aperture by 3 stops fully eliminates the vignetting.

✦ **Perspective distortion.** Perspective distortion is a double-edged sword: It can make your images look very interesting or make them look terrible. One of the reasons that a wide-angle lens isn't recommended for close-up portraits is that it distorts the face, making the nose look too big and the ears too small. This can make for a very unflattering portrait.

✦ **Barrel Distortion.** Wide-angle lenses, even rectilinear lenses, are often plagued with this specific type of distortion that causes straight lines outside of the image center to appear to bend outward (similar to a barrel). This can be unwanted when doing architectural photography. Fortunately Photoshop and other image-editing software allow you to fix this problem relatively easily.

Mid-Range or Standard Zoom Lenses

Mid-range, or standard, zoom lenses fall in the middle of the focal-length scale. Zoom lenses of this type usually start at a moderately wide angle of around 24-28mm and zoom in to a short telephoto of about 70mm.

4.2 An environmental portrait shot at 12mm

These lenses work great for most general photography applications and can be used successfully for everything from architectural to portrait photography. Basically, this type of lens covers the most useful focal lengths and will probably spend the most time on your camera. For this reason, I recommend buying the best quality lens you can afford.

Some of the options for mid-range lenses include

✦ **Nikkor 24-70mm f/2.8.** This is Nikon's newest addition to its standard zoom line. It is a professional lens; it has a fast aperture of f/2.8 over the whole zoom range and is extremely sharp at all focal lengths and apertures. The build quality of this lens is excellent as most of Nikon's pro lenses are. The 24-70mm has Nikon's super-quiet and fast-focusing Silent Wave Motor, and Nikon's new Nano Crystal Coat to help deal with flare and ghosting. This lens is top-notch all around and is worth every penny of the price tag.

✦ **Nikkor 28-70mm f/2.8.** This lens has essentially been replaced by the Nikon 24-70mm f/2.8. This lens is an excellent option and a more affordable choice to those who need a fast pro lens. You can usually find this lens used for just over half the price of a new 24-70mm. This lens is extremely sharp and has the fast and quiet Silent Wave Motor. It's a bit bulkier than the 24-70mm, but weighs about the same. If you're looking for a bargain on a fast pro lens, I recommend checking out one of these.

Image courtesy of Nikon, Inc.
4.3 Nikkor 24-70mm f/2.8

✦ **Nikkor 24-120mm f/3.5-5.6 VR.** This is the kit lens option that is available with the D700. This lens covers a very wide range of focal lengths, but it doesn't have a fast constant aperture. To make up for this, Nikon has added Vibration Reduction (VR) to this lens to help when you're shooting in low-light situations. When lens manufacturers opt to go the route of these extreme focal lengths, they have to make some concessions that usually come in the form of image quality. That being said, if you need a lightweight, versatile lens for just walking around and shooting, this lens is perfectly suited for that. As usual, the VR system works like a charm and is great for shooting still objects in low-light conditions that typically call for slower shutter speeds.

✦ **Nikkor 24-85mm f/2.8-4D.** This is a nice lightweight option. This lens is based on Nikon's older designs, but is still listed on their current roster. This lens is small, light, and also has the added benefit of a macro setting that allows you to get a decent 1:2 reproduction ratio. Although this lens lacks VR and the extra reach of the 24-120mm, I recommend looking into it as an everyday walking-around lens. It's faster and sharper than the 24-120mm and the macro function allows it to truly be a great all-around lens.

There are also some good third-party lens options from Sigma and Tamron in this focal length range. I recommend doing some research on the Internet to find the best lens for the best deal.

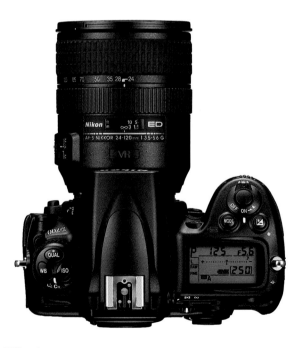

Image courtesy of Nikon, Inc.
4.4 The D700 with 24-120mm kit lens

The only prime lens that fits into this category is the 50mm. This is considered a normal lens on FX-format (35mm-sized) sensors and film cameras given it approximates the normal field of view that human eyes can see. There are two different lenses of this focal length on Nikon's current list, the 50mm f/1.8 and the 50mm f/1.4. Both of these lenses are fast and perfect for low-light photography. They are great lenses to use as an ultra-lightweight walking-around lens. They aren't the most versatile lenses, but they can get the job done and done well. They are two of the sharpest lenses available, especially at the price range. The 50mm f/1.8 is a great deal; you can usually find it for about $100 new and even less than that used.

Telephoto Lenses

Telephoto lenses are lenses with very long focal lengths that are used to get closer to distant subjects. They provide a very narrow field of view and are handy when you're trying to focus on the details of a subject. Telephoto lenses have a much shallower depth of field than wide-angle and mid-range lenses and you can use them effectively to blur out background details to isolate the subject.

Telephoto lenses are commonly used for sports and wildlife photography. The shallow depth of field makes them one of the top choices for photographing portraits, as well.

As with wide-angle lenses, telephoto lenses also have their quirks, such as perspective distortion. As you may have guessed, telephoto perspective distortion is the opposite

of the wide-angle variety. Because everything in the photo is so far away with a telephoto lens, the lens tends to compress the image. Compression causes the background to look too close to the foreground. Of course, you can use this effect creatively. For example, compression can flatten out the features of a model, resulting in a pleasing effect. Compression is another reason why photographers often use a telephoto lens for portrait photography.

4.5 Portrait shot with a telephoto lens

A standard telephoto zoom lens usually has a range of about 70-200mm. If you want to zoom in close to a subject that is very far away, you may need an even longer lens. These super-telephoto lenses can act like telescopes, really bringing the subject in

close. They range from about 300mm up to about 800mm. Almost all super-telephoto lenses are prime lenses, and they are very heavy, bulky, and expensive to buy. A lot of these lenses are a little slower than your normal telephoto zoom lens, usually having a maximum aperture of about f/4 or smaller.

Some of the most common telephoto lenses include

✦ **Nikkor 70-200mm f/2.8 VR.** This is Nikon's top-of-the-line standard telephoto lens. The VR makes this lens useful when photographing far-off subjects, handheld. This is a great lens for sports, portraits, and wildlife photography.

✦ **Nikkor 80-200 mm f/2.8D.** This is a great affordable alternative to the 70-200mm VR lens. This lens is sharp with a fast constant f/2.8 aperture.

✦ **Nikkor 80-400mm f/4.5-5.6 VR.** This is a high-power, VR image stabilization zoom lens that gives you quite a bit of reach. Its versatile zoom range makes it especially useful for wildlife photography where the subject is far away. As with most lenses with a very broad focal length range, you make concessions with fast apertures and a moderately lower image quality when compared to the 70-200mm or 80-200mm f/2.8 lenses.

When using a camera with a high-resolution sensor, such as the D700, you need to spend the extra money on quality lenses to be sure your images look as good as they can; otherwise, you may as well be shooting with a lower-resolution camera. Budget priced lenses such as the Nikkor 70-300mm f/4-5.6 will show a lower image quality due to the lower quality of the lens elements.

Image courtesy of Nikon, Inc.
4.6 Nikkor 300mm f/2.8 VR

That being said, Nikon offers many high-quality telephoto zoom lenses, and the most expensive one is not necessarily going to be the best one for the job. I have owned both the nearly $2,000 Nikkor 70-200 f/2.8G AF-S VR and the just under $1,000 Nikkor 80-200mm f/2.8D. I ended up reselling the more expensive lens because the image quality was about the same as the other lens. The bells and whistles, such as the VR and the Silent Wave Motor, aren't necessarily worth the extra money, depending on where and what you shoot. When I compared the two, they were nearly identical.

The only difference seems to be that the 80-200mm focuses a little slower than the 70-200mm with the VR off.

When I'm using a telephoto lens of this size, I'm usually at a racetrack photographing cars or at a concert or other sporting event, so the quiet AF isn't important. As for the VR, for my needs, I haven't been convinced it works well enough to justify the extra money. The moral is, don't be too budget-minded when buying a lens, but also don't be taken in by added features you may not need.

Zoom versus Prime Lenses

A little more than a decade ago, zoom versus prime would have been a very hotly debated topic. In the past, zoom lenses had a very bad rap for good reason. They were heavy, badly designed, and slow. However, with the advent of new, more precise lens manufacturing technology — and new lightweight composites — zoom lenses today are almost if not as good as prime lenses.

One of the main advantages of the zoom lens is its versatility. You can attach one lens to your camera and use it in a wide variety of situations. Gone is the need for constantly changing out lenses, which is a very nice feature because every time you take the lens off of your camera, the sensor is vulnerable to dust and debris.

Although today's zoom lenses can be just as sharp as a prime lens, you do have to pay for this quality. A $150 zoom lens is not going to give you nearly the same quality as a $1,500 zoom lens. These days you can easily find a fast zoom lens, one with an aperture of at least f/2.8. However, because you can easily change the ISO on a digital camera and the noise created from using a high ISO is lessening, a fast zoom lens is not a complete necessity. I prefer a zoom lens with a wider aperture — not so much for the speed of the lens, but for the option of being able to achieve a shallower depth of field, which is very important in shooting portraits.

Before zoom lenses were available, the only option a photographer had was using a prime lens. Because each lens is fixed at a certain focal length, such as 50mm, when the photographer wants to change the angle of view, he has to either physically move farther away from or closer to the subject or swap out the lens with one that has a focal length more suited to the range.

Continued

Continued

Prime lenses still offer some advantages over zoom lenses. For example, prime lenses don't require as many lens elements as zoom lenses do, and this means prime lenses are almost always sharper than zoom lenses. The differences in optical quality are not as noticeable as they were in the past, but with digital camera resolutions getting higher, the differences are definitely becoming more noticeable.

The most important features of the prime lens are that they can have a faster maximum aperture, they are far lighter, and they cost much less. The standard prime lenses aren't very long, so the maximum aperture can be faster than with zoom lenses. Standard primes also require fewer lens elements and moving parts, so the weight can be kept down considerably. And because there are fewer elements, the overall cost of production is less; therefore you pay less.

Special Purpose Lenses

Nikon has a few options when it comes to lenses that are designed specifically to handle a certain task. Nikon's special purpose lenses are the Perspective Control (PC) and Micro-NIKKOR (macro) lenses. They even have a lens that combines both of these features! These lenses, especially the PC lenses, aren't typically designed for everyday use and are pretty specific in their applications.

Perspective Control lenses

PC lenses are designed to control apparent distortion and to maximize depth of field throughout the subject area. One of the most common uses for PC lenses is architectural photography. Shooting tall buildings with a standard lens usually requires tilting the camera lens up to fit the whole building in the frame. Tilting the lens up causes perspective distortion and converging lines in the image. The result is that the bottom of the building looks big and the top of the building looks small, which can cause the building in the image to appear as if it is tipping over. The only way too avoid this problem is to keep the cameras lens on axis, or on the same plane as the front of the building. Given buildings are usually pretty tall, keeping the camera on axis to the building front usually only allows you to get the bottom of the structure in the frame. The PC lens allows you to shift the lens elements up to capture the whole structure while keeping the camera and lens on axis with the building, thus ridding the image of converging lines.

Nikon's early PC lenses provide a shift and allow you to rotate the lens to adjust the shift where you need it, but their newest lenses also provide another movement called a tilt. These lenses are also known as tilt-shift lenses. Tilt allows you to change the plane of focus to achieve sharp focus with multiple subjects that lie at different distances, without having to resort to using a smaller aperture. These lenses are used not

only for architectural photography but also for serious product photography: They enable you to keep the whole product in sharp focus while still allowing you to use a relatively wide aperture.

Recently, Nikon has seriously ramped up their PC lens arsenal and they have four tilt-shift PC lenses in their current lineup. These lenses are expensive: All of them retail at well over $1,000. All the current lenses with the exception of one are designated what Nikon terms PC-E. The E designation specifies that these lenses have an electromagnetic diaphragm that allows you to control the aperture from the camera (D3, D700, and D300 cameras only). With other PC lenses (with a PC designation, not PC-E), you must control the aperture manually given that the shifting of the lens prevents the standard Auto-Indexing feature from functioning properly.

Some of the most common PC lenses include

✦ **Nikkor PC-E 24mm f/3.5D.** This is a wide-angle lens that is perfectly suited for architecture and interior shots of buildings. It provides tilt, shift, and rotation.

✦ **Nikkor PC-E 45mm f/2.8D.** This lens has a normal focal length lens that you can use for a wide variety of applications, from architecture to nature photography and products. It provides tilt, shift, and rotation.

✦ **Nikkor PC-E 85mm f/2.8D.** This is a medium telephoto focal length lens that also has macro capability for close-up shots. This lens is best suited for taking photos of small products where attention to detail is important. It provides tilt, shift, and rotation. Nikon also offers a non-PC-E version of this lens that lacks the electromagnetic aperture control.

Image courtesy of Nikon, Inc.
4.7 Nikkor PC-E 24mm f/3.5D

You can still find Nikon's older PC lenses used and available for much less than the newer versions. As I mentioned before, the older PC lenses offer a somewhat more limited functionality given they only provide shift and rotation, but if you're seriously into architectural photography, you may want to give one of these lenses a look. Some of your options include the 28mm f/3.5 and the 35mm f/2.8. Both are wide-angle lenses, and you can find them used for relatively reasonable prices.

 Caution *Due to the nature of the mechanics of these lenses, all Nikon PC shift lenses are manual focus only.*

Macro (Micro-NIKKOR) lenses

A macro lens is a special-purpose lens used in macro and close-up photography. It allows you to have a closer focusing distance than regular lenses, which in turn allows you get more magnification of your subject, revealing small details that would otherwise be lost. True macro lenses offer a magnification ratio of 1:1; that is, the image projected onto the sensor through the lens is the exact same size as the actual object being photographed. Some lower-priced macro lenses offer a 1:2 magnification ratio, which is half the size of the original object.

One major concern with a macro lens is the depth of field. When focusing at such a close distance, the depth of field becomes very shallow; so often it is advisable to use a small aperture to maximize your depth of field and ensure everything is in focus. Of course, as with any downside, there's an upside: You can also use the shallow depth of field creatively. For example, you can use it to isolate a detail in the subject.

Macro lenses come in a variety of different focal lengths, and the most common is 60mm. Some macro lenses have substantially longer focal lengths, which allow more distance between the lens and the subject. This comes in handy when the subject needs to be lit with an additional light source. A lens that is very close to the subject while focusing can get in the way of the light source, casting a shadow.

When buying a macro lens, you'll want to consider a few things: How often are you going to use the lens? Can you use it for other purposes? Do you need AF? Because newer dedicated macro lenses can be pricey, you may want to consider some cheaper alternatives.

The first thing you should know is that it's not absolutely necessary to have an AF lens. When shooting very close up, the depth of focus is very small, so all you need to do is move slightly closer or farther away to achieve focus. This makes an AF lens a bit unnecessary. You can find plenty of older Nikon manual focus (MF) macro lenses that are very inexpensive, and the good thing is the lens quality and sharpness are still superb.

Note *Some other manufacturers also make very good quality MF macro lenses. The lens I use is a 50mm f/4 Macro-Takumar made for early Pentax screw-mount camera bodies. I bought this lens for next to nothing, and I found an inexpensive adapter that allows it to fit the Nikon F-mount. The great thing about this lens is that it's super-sharp and allows me to focus close enough to get a 4:1 magnification ratio, which is 4X life size.*

4.8 A shot taken with a 50mm macro lens with a magnification ratio of 4:1, or 4X the original size.

Nikon currently offers three different focal length macro lenses under the Micro-NIKKOR designation:

✦ **60mm f/2.8.** Nikon offers two versions of this lens, one with a standard AF drive and one with an AF-S version with the Silent Wave Motor. The AF-S version also has the Nikon new Nano Crystal Coat lens coating to help eliminate ghosting and flare.

✦ **105mm f/2.8 VR.** This is a great lens that not only allows you to focus extremely close but also enables you to back off and still get a nice close-up shot. This lens is equipped with VR. This can be invaluable with macro photography because it allows you to hand hold at slower shutter speeds, a necessity when stopping down to maintain a good depth of field. This lens also can double as a very impressive portrait lens.

✦ **200mm f/4.** This telephoto macro lens provides a longer working distance, which can be beneficial when you're photographing small animals or insects. This is a good lens for nature and wildlife photography and gives you a true 1:1 macro shot.

Fisheye lenses

Fisheye lenses are ultra-wide-angle lenses that aren't corrected for distortion like standard rectilinear wide-angle lenses. These lenses are what is known as curvilinear, meaning that straight lines in your image, especially near the edge of the frame, will be curved. Fisheye lenses have extreme barrel distortion, but that is what makes them fisheye lenses.

Fisheye lenses cover a full 180-degree field of view, allowing you to see everything that is immediately to the left and right of you in the frame. Special care has to be taken so that you don't get your feet in the frame as so often happens when you're using a lens with a field of view this extreme.

Fisheye lenses aren't made for everyday shooting, but with their extreme perspective distortion, you can achieve interesting, and sometimes wacky, results. You can also "de-fish" or correct for the extreme fisheye using software, such as Photoshop, Capture NX or NX2, and DxO Optics. The end result of de-fishing your image is that you get a reduced field of view. This is akin to using a rectilinear wide-angle lens.

4.9 An image taken with a Zenitar 16mm fisheye lens

There are two types of fisheye lenses available, circular and full-frame. A circular fisheye projects a complete 180-degree hemispherical image onto the frame, resulting in a circular image surrounded by black in the rest of the frame. A full-frame fisheye completely covers the frame with an image. Nikon's 16mm fisheye is a full-frame fisheye lens while the 10.5mm DX Nikkor fisheye is a full-frame fisheye on a DX-format dSLR and projects circular fisheye on an FX-format camera. Sigma also makes a series of fisheye lenses that are both circular and full-frame. There are a couple of Russian companies that also manufacture high-quality but affordable MF fisheye lenses. AF is not truly a necessity on fisheye lenses given their extreme depth of field and short focusing distance. Zenitar makes a 16mm f/2.8 full-frame fisheye that functions well with the D700. Peleng makes an 8mm circular fisheye that also works with the D700. Both lenses are fairly soft wide open, but the images are sharp when you stop them down to 5.6. You can find these lenses on eBay for reasonable prices.

Using VR Lenses

Nikon has an impressive list of lenses that offer Vibration Reduction (VR). This technology is used to combat image blur caused by camera shake, especially when you're handholding the camera at long focal lengths. The VR function works by detecting the motion of the lens and shifting the internal lens elements. This allows you to shoot up to 3 stops slower than you would normally. If you're an old hand at photography, you probably know this rule of thumb: To get a reasonably sharp photo when handholding the camera, you should use a shutter speed that corresponds to the reciprocal of the lens's focal length. In simpler terms, when shooting at a 200mm zoom setting, your shutter speed should be at least 1/200 second. When shooting with a wider setting, such as 28mm, you can safely hand hold at around 1/30 second. Of course, this is just a guideline; some people are naturally steadier than others and can get sharp shots at slower speeds. With the VR enabled, you should be

4.10 The NIKKOR 70-200 f/2.8 ED-IF AFS with VR

able to get a reasonably sharp image at a 200mm setting with a shutter speed of around 1/30 second.

Although the VR feature is good for providing some extra latitude when you're shooting with low light, it's not made to replace a fast shutter speed. To get a good, sharp photo when shooting action, you need to have a fast shutter speed to freeze the action. No matter how good the VR is, nothing can freeze a moving subject but a fast shutter speed.

Another thing to consider with the VR feature is that the lens's motion sensor may overcompensate when you're panning, causing the image to actually be blurrier. So, in situations where you need to pan with the subject, you may need to switch off the VR. The VR function also slows down the AF a bit, so when catching the action is very important, you may want to keep this in mind. However, Nikon's newest lenses have been updated with VR II, which Nikon claims can tell the difference between panning motion and regular side-to-side camera movement.

While VR is a great advancement in lens technology, few things can replace a good exposure and a solid monopod or tripod for a sharp image.

Using DX Lenses

For those of you who have updated from a previous Nikon dSLR, you may own one (or several) DX NIKKOR lenses. Have no fear: You can still use these lenses on your D700. The camera recognizes when the Nikon DX lens is attached and automatically sets the image area from FX to DX. The DX image area can also be set manually through the Shooting menu.

The DX image applies what is known as a 1.5X crop factor. Crop factor is a ratio that describes the size of a camera's imaging area as compared to another format; in the case of SLR cameras, the reference format is 35mm film.

Photographers use lenses of a certain focal length to provide a specific field of view. The field of view, also called

the angle of view, is the amount of the scene that is captured in the image and is usually described in degrees. For example, when you use a 16mm lens on a 35mm camera, it captures the scene almost 180 degrees horizontally. Conversely, when you use a 300mm focal length, the field of view is reduced to a mere 6.5 degrees horizontally, which is a very small part of the scene. The field of view was consistent from camera to camera because all SLRs used 35mm film, which had an image area of 24 x 36mm.

With the advent of dSLRs and because the sensors were more expensive to manufacture, the sensor was made smaller than a frame of 35mm film to keep costs down. This sensor size was called APS-C, or in Nikon terms, the DX format. The lenses that are used with DX-format dSLRs have the same focal length they've always had, but because the sensor doesn't have the same amount of area as the film, the field of view is effectively decreased. This causes the lens to provide the field of view of a longer focal lens when compared to 35mm film images. Of course with the full-frame or FX-format sensor of the D700, you don't need to worry about crop factor unless you intentionally switch to DX crop image area.

Early on, when dSLRs were first introduced, all lenses were based on 35mm-format film. The crop factor effectively reduced the coverage of these lenses, causing ultrawide-angle lenses to act like wide-angles, wide-angle lenses like standard lenses, standard lenses like short telephotos, and so on. Because Nikon created specific lenses for dSLRs with digital

sensors, they called them DX-format lenses. The focal length of these lenses was shortened to fill the gap to allow true super-wide-angle lenses. These DX-format lenses were also redesigned to cast a smaller image inside the camera so that the lenses could actually be made smaller and use less glass than conventional lenses. The byproduct of designing a lens to project an image circle to a smaller sensor is that these same lenses can't be used with 35mm film cameras because the image won't completely fill an area the size of the film sensor.

There is an upside to this crop factor. Lenses with longer focal lengths now provide a bit of extra reach. A lens set at 200mm provides the same amount of coverage as a 300mm lens, which can be a great advantage for sports and wildlife photography or when you simply can't get close enough to your subject.

 When using non-Nikon DX lenses, the Auto DX crop feature does NOT work. This feature only works with Nikkor DX lenses,

The byproduct of using DX lenses on the D700 is that when you're shooting in DX mode, the camera's effective sensor resolution is reduced to 5.1 megapixels.

Note *When using DX lenses, you still benefit from the larger pixel pitch of the sensor, which enables you to get lower noise from high ISO images and better overall image quality.*

Lately DX lenses have been a pretty widely debated topic among D700 users. Some people are of the opinion that you're "wasting"

4.11 This image shows the difference in the field of view between FX and DX at a 40mm setting.

your D700 by not taking advantage of the FX sensor. I'm of the opinion that you should use whatever setting gets the shot. I'm sure that most of the people who buy the D700 are doing so to take advantage of the full-frame sensor, but for those who aren't as concerned with the FX aspect, here are a few reasons why you may want to consider using DX lenses on your FX camera:

✦ **Portability.** DX lenses are almost always smaller and lighter than FX lenses. Since they cast a smaller image circle the lens elements are necessarily not as large. This can be a great feature when traveling and you're limited to the amount of accessories that you can carry.

✦ **Wider AF point coverage.** The wider frame allows most of the edges to be outside of where the AF points lie. Using a DX lens (or simply switching to DX mode) allows more of the frame to be covered by the 51-point AF system. This can be extremely helpful when you're photographing subjects that are moving erratically across the frame.

✦ **Wider zoom range.** Because DX lenses are smaller, they are capable of achieving wider zoom ranges than FX lenses. The 18-200mm DX compares to a 27-300mm lens when crop factor is figured in. The only current NIKKOR lens that Nikon offers that has a wide zoom range is the 24-120mm, which

doesn't even come close to offering the same type of range (although Tamron offers an FX 28-300mm).

✦ **Affordability.** All of Nikon's newest standard NIKKOR lenses are pro lenses. These lenses are very expensive. If you are looking for a lower-priced lens with excellent image quality and don't mind using the D700 in DX crop mode, you may want to check into buying a DX lens.

✦ **Optimized for digital sensors.** All of Nikon's DX lenses were designed from the ground up with the digital sensor in mind. Digital sensors are more prone to showing things like chromatic aberrations (CA) and moiré patterns (a wavy pattern that appears in scenes with repetitive patterns). DX lenses are designed to better control these problems. Although Nikon's brand-new FX lenses also control these problems, most of the FX lenses available are relics from the age of film photography and don't offer the optimal image quality when used with a digital sensor. This isn't to say the older designed lenses don't work great with dSLRs, they do, they just weren't designed to deal with the specific imaging problems that digital sensors have.

Using FX Lenses in DX Crop Mode

One interesting technique that is possible with an FX-format camera such as the D700 is using an FX lens in DX crop mode. This crops into the image area and gives you a narrower field of view. This applies the same 1.5X crop factor that is present on such APS-C sensor dSLRs like the D300. This gives your lens a field of view that is equivalent to the focal length of your lens multiplied by 1.5.

The main advantage of this technique is that it gives you extra "reach" by zooming into the image area. Of course, you can achieve the same result in post-processing by cropping the image, but for me, it's preferable to frame the subject and shoot in real time than to go back to the image and crop later.

I find that switching back and forth between FX and DX modes is similar to having two lenses on my camera at once. Using my 28-70mm lens, I can get wide-angle to short telephoto coverage in FX and an equivalent normal to medium telephoto (42-105mm) when I switch to the DX crop mode. Similarly, when I use my 80-200mm lens, I can get the same coverage as a 120-300mm f/2.8 without using a teleconverter and losing a stop of light.

I have found myself using this technique so frequently (much to my surprise) that I have programmed the AE-L / AF-L button (Custom Setting Menu, CSM, f7) to allow me to switch between the two formats effortlessly.

The only qualm that I have about using DX mode with the D700 is that the FX part of the viewfinder is not *grayed* out when the camera is in DX mode. The D3 does this to make it easier to compose when in DX mode. The D700 only provides you with a black rectangle that shows you the approximate image area of the DX frame.

Third-Party Lenses

Nikon is by no means the only manufacturer of lenses that fit the D700. There are quite a few different companies that make lenses that work flawlessly with Nikon cameras. In the past, third-party lenses had a bad reputation of being, at best, cheap knock-offs of the original manufacturers' lenses. This is not the case anymore as a lot of third-party lens makers have stepped up to the plate and started releasing lenses that rival some of the originals (usually at half the price).

Although you can't beat Nikon's professional lenses, there are many excellent third-party lens choices available. The three most prominent third-party lens manufacturers are Sigma, Tokina, and Tamron. Each company makes lenses that cover the entire zoom range.

Sigma

Sigma is a company that has been around for more than 40 years and was the first lens manufacturer to make a wide-angle zoom lens. They make good lenses with a great build quality.

Unlike some companies, about two-thirds of Sigma's lenses are designed around the FX-format (35mm-sized sensors) and optimized for use with digital sensors. I'd say that Sigma had one eye to the future when designing these lenses, knowing that FX-format sensors would indeed be coming. The Sigma lenses are also available with what they call HSM, or Hyper-Sonic Motor. This is an AF motor that is built inside the lens and operates in a similar fashion to Nikon's AF-S or Silent Wave Motor. It allows very fast and

quiet AF. Sigma lenses have won many awards and are considered a viable and affordable alternative to Nikon's offerings.

Sigma makes a multitude of different lenses; here are a couple of my personal favorites:

✦ **12-24mm f/4.5-5.6 HSM.** So far, this is the absolute widest full-frame rectilinear lens available on the market. This is one of the most fun lenses that I own. It gives you an extreme 122-degree angle of view. It's definitely not for everyday use (unless you're a professional landscape photographer) due to the extreme angles and crazy perspective distortion you get. The crazy perspective is what I love about this lens though. It does have its drawbacks, however. The corners are quite soft, especially wide open, and aren't much better when stopped down. I usually have to sharpen in post-processing a bit, which makes the images very good. It's not a fast lens, but at this focal length, it's entirely possible to hand hold the camera at fairly long shutter speeds; and if you need some speed, crank up your ISOs — the D700 can handle it. If you're looking for a super-sharp fast lens, you might want to pass this one up, but for what I do, I find that this lens is perfect.

✦ **17-35mm f/2.8-4 DG HSM.** I initially bought this lens to use as a faster alternative to the Nikkor 18-55mm that came with the D60. I expected to sell it once I sold the D60. However, I found it was such a solid performer that I couldn't get rid of it. It's reasonably sharp, has

an acceptably fast aperture, and is super-quiet and light. I generally use it as a walking-around lens. It's perfect for photojournalism-type shots and street photography. This lens is not to be confused with the original version that lacks the digitally integrated (DG) designation. DG lenses are designed for use with digital sensors. The original lens suffered from very soft images; the DG version is better.

4.12 The Sigma 12-24mm f/4.5-5.6

Tamron

Tamron is another lens manufacturer that has been making lenses for the Nikon F-mount for some time. Tamron's offerings are somewhat slimmer for FX cameras, but

they do make a few full-frame lenses that are designated Di, or Digitally Integrated, to better suit the needs of digital sensors. The one thing that Tamron offers is FX super-zooms that cover a wide range of focal lengths. Tamron is currently the only manufacturer to offer a wide-angle to super-telephoto lens of 28-300mm with Vibration Compensation (VC) that can be compared to Nikon's VR. Here are a couple good options:

✦ **Tamron 28-300 f/3.5-6.3 Di XR VC.** This is pretty much a cover-all lens. For an FX camera, it covers all the focal lengths you're likely to need. Of course, with this huge zoom range, you make concessions with quality. It's a pretty good performer when it comes to image sharpness, but you will definitely need some additional sharpening in post-processing (or you can add sharpness in a Custom Picture Control). The lens also has some barrel distortion at 28mm, but it's gone by the 50mm setting. At 100-300mm, you see pronounced pincushion distortion. Again, you can fix all this in post-processing. This lens is by no means fast with a variable aperture, but the VC can help with that. The main problem is that at longer focal lengths, the camera tends to hunt for focus due to the light fall-off. If you're looking for an all-in-one lens and you don't mind a few quirks, then this lens isn't too bad — especially for its low price.

✦ **Tamron 200-500mm f/5-6.3 Di LD.** This a super-telephoto lens with a pretty good zoom range. The 200-500mm makes a perfect lens for wildlife or sports photographers

(as long as you have ample light). For the most part, I've found this lens almost excellent. It's relatively sharp and has good contrast — a great performer for a lens in this price range. The only major problem with it is that it tends to have a lot of CA in the corners of the frame. (CA is generally more noticeable in the corners.) If you're shooting sports or wildlife professionally, you may want to use one of Nikon's pro super-telephoto primes, but for most general applications, this lens performs extremely well.

Tokina

Tokina manufactures mostly DX lenses at this time, but that's likely to change in the near future with full-frame cameras being produced by more manufacturers. That being said, Tokina does offer a few FX lenses. Currently, Tokina offers a 100mm f/2.8 macro, an 80-400mm super-zoom, a 28-70mm and 28-80mm f/2.8, and a wide-angle 19-35mm f/3.5-4.5. I've only used two Tokina lenses in my career, the 12-24mm f/4 DX, and the 19-35mm f/3.4-4.5. I've had mixed luck with Tokina. I loved the 12-24mm lens on my D200 and D300. It was very sharp with little CA — an excellent lens. On the other hand, the Tokina 19-35mm was a complete disappointment. The build quality was abysmal: The first day I had it one of the screws from the switch on the side fell out. A couple of days later, the rubber grip on the zoom ring came loose and would slide all around. The images I shot were plagued with massive CA and lots of flare, and they were unbelievably soft and lacked contrast all

around. To be fair, this lens isn't considered to be a "pro" grade lens and I only paid $200 for it, but for not much more than $200, you can get a Sigma 17-35mm that's faster and better all around.

While I have had limited exposure to them, Tokina's DX lenses are reputed to be some of the best. You'll find many reviews of Tokina lenses on the Internet, and if you're considering buying a Tokina, do some research.

Lens Accessories

Many types of accessories are available for your lenses. Some are as simple as a lens cap that keeps the dust off of your lens and protects it from scratches. Others are more important, such as a lens hood that blocks light from the front element of the lens, helping to reduce ghosting and flare while also supplying a modicum of protection for your lens.

Other accessories can allow you to do things with your lens that aren't normally possible, such as making the focusing distance closer and extending the range. This isn't meant to be a comprehensive guide to all of the lens accessories available, but a short list to let you know about some of the most useful accessories out there.

Teleconverters

In some cases, you may need a lens that has a longer focal length than the lenses you own. You may want a 600mm lens to really get close up to a faraway subject, but you don't necessarily want to spend the money

on an expensive 600mm prime lens. Fortunately, Nikon, as well as some other lens manufacturers, offer teleconverters. A teleconverter attaches to your camera between the lens and the camera body and extends the focal length, giving you extra zoom and magnification. There are different sizes of teleconverters: Nikon offers a 1.4X, a 1.7X, and 2X. Some other manufacturers offer different sizes, including and up to 3X.

There are some drawbacks to using teleconverters. With the extended range you gain in focal length, you lose some light. The teleconverter effectively makes your lens anywhere from 1 to 3 stops slower than normal. The 1.4X teleconverter causes you to lose 1 stop of light, while using a 3X model causes you to lose a very noticeable 3 stops of light. This will cause your f/2.8 lens to function with an effective f/8 aperture. While this may not be a problem during a bright sunny day, in a low-light condition, you may run into some problems.

Additionally, the AF systems on most cameras need a specific amount of light to function. Attaching a teleconverter to a lens with a maximum aperture of less than f/2.8 can cause the AF function to not work properly or to not work at all. Within Nikon's autofocus system, the threshold for the AF sensor is f/5.6.

Finally, with the inclusion of additional lens elements and the longer focal length, teleconverters cause you to lose some sharpness in your image. The higher-priced teleconverters, like the ones offered by Nikon, give you sharper overall images than the lower-priced teleconverters offered by third-party manufacturers. Teleconverters are available in both AF and MF versions.

 Caution *Not all teleconverters work with all lenses and some lenses cannot work with a teleconverter at all. Additionally, some teleconverters can cause damage to the lens or camera if they're used improperly. Check with a reputable camera shop before using a teleconverter.*

Extension tubes

Extension tubes also attach between the camera body and the lens, similar to a teleconverter, but they function completely differently. While the teleconverter allows you to increase the focal length of your lens, an extension tube simply moves the lens farther from the image sensor. Extension tubes give you a closer focusing distance so your lens can get more magnification of the subject, making it possible to take macro photos with a regular lens and giving you increased magnification when used with a macro lens.

As with teleconverters, when you add an extension tube, you effectively reduce your maximum aperture and lose some light. Unlike teleconverters, extension tubes have no optical elements in them; they are simply open tubes. Additionally, extension tubes are offered in both AF and MF options.

Filters

In the days before Photoshop, when photographers needed to add a special effect to their photographs, they often would add a filter to the lens. Filters provide a wide range of effects; some add a color tint to the

photograph while others neutralize a color cast. (For example, you might use a filter to compensate for the color of a tungsten light bulb.) Other filters block certain wavelengths of light or add a special effect, such as a star pattern in the highlight areas of a photograph. You can now replicate many traditional photo filters using Photoshop or some other image-editing software. However, you cannot replicate a few filters with software, such as the following:

Cross-Reference *For more info on color casts and white balance, see Chapter 2.*

✦ **UV (ultraviolet) filters.** This is by far the most common filter found on camera lenses these days. UV filters block UV light, resulting in a sharper image. These filters can also reduce the effect of atmospheric haze in landscape photos of distant subjects. Most people also use these filters to protect the front element of the lens from getting scratched or damaged. To be fair, there are those people who doubt the validity of using these filters because, at lower elevations, UV light is not abundant enough to adversely affect the image. In addition, the sensors on dSLR cameras usually already have some sort of UV filter built in. Some people also claim that putting a lower-quality glass filter on an expensive lens lessens the quality of the images. I have a UV filter on almost all of my lenses at all times (mostly for protection). Ultimately, the decision is yours. When selecting a UV filter for your lens, I recommend buying the best one you can afford. Filters that are multi-coated and designated

for use with digital cameras are usually the best bet. I use a Rodenstock HR Digital Multi-coated UV filter on most of my lenses.

✦ **ND (neutral density) filters.** This is another commonly used filter. ND filters reduce the amount of light that reaches the sensor without changing the color. They're used to prevent blown-out highlights caused by extremely bright lighting conditions, such as when you're at a beach with white sand on a bright sunny day. You can also use these filters to achieve a slower shutter speed when you need a long exposure, there is too much light on the subject, and reducing the ISO is out of the question. And you can use these filters to increase the shutter speed and use a wider aperture to achieve a shallow depth of field. ND filters normally come in three versions: ND-2, which absorbs 1 stop of light; ND-4, which absorbs 2 stops of light; and ND-8, which absorbs 3 stops of light. You can also find an ND-400 filter, which effectively reduces the amount of light by 9 stops.

✦ **Graduated ND filters.** These filters are similar to standard ND filters except that the ND coating of the filters is faded out, covering only about half of the filter. These filters are used mostly for landscape photography, to even out the exposure between the sky and the land (or water) area.

✦ **Polarizing filters.** When light is reflected off any surface, it tends to scatter randomly, and the

polarizing filter takes these random scattered light rays and makes them directional, thereby reducing or even eliminating the glare from reflective surfaces. Polarizing filters are almost invaluable when photographing landscapes; they can cut down the atmospheric haze and add contrast and increased saturation to the image. The effect of a polarizer on skies is most evident; it increases the contrast between the clouds and the sky. Many people also use the polarizer as a type of ND filter because it reduces the exposure by 1/2 to 1 stop of light. Polarizing filters are mounted on a rotating ring that allows you to rotate the filter to achieve the maximum effect of the filter. Polarization works the best when your subject is at a 90-degree angle to the sun (side lit). When photographing a subject where the sun is 180 degrees to your subject (front lit), the polarizing filter will have almost no effect. When composing your image, rotate the filter element until you see maximum contrast; this should be easily noticeable. Using polarizing filters on ultra-wide-angle lenses can cause uneven results due to the change of the angle of the sun over the entire image area. For the best effect, use a lens of 28mm or longer. It is important to note that as there are two types of polarizing filters, linear and circular, if your camera has Through-the-Lens metering and/or autofocus, as almost all do today, you will need a circular polarizer.

✦ **IR (infrared) filters.** These filters block almost the entire visible light spectrum, allowing only IR light, which is invisible to the naked eye, to pass through to the sensor. The resulting images are very ethereal, dreamlike, and often surreal. In IR photography, the skies are very dark and vegetation glows a ghostly white. Because almost all of the light is being blocked, IR photography requires long shutter speeds and a tripod.

There are many more types of filters available (warming filters, cooling filters, star filters, and so forth). A quick search on the Web will yield many more results.

Essential Photography Concepts

For some of you, this chapter contains well-known concepts, while for others, it is a good refresher. Some of this information may even be brand-new if you are just stepping into the world of dSLR photography. If you are an advanced user, you may choose to skip this chapter, although you may discover some new information or something you may have forgotten. This chapter covers information on exposure, the effects aperture has on depth of field, and some tips and hints on how to use histograms, bracketing, and exposure compensation.

Exposure

The exposure is the basis of photography. In basic terms, exposure is the amount of light that falls on your sensor (or film). Note that the term exposure doesn't necessarily mean the amount of light that's needed to expose your image properly. There are good exposures and bad exposures. Whether an exposure is good or bad also depends on the subject and the photographer's artistic vision. Underexposures and overexposures are usually considered "bad," unless the effect it has on the image is good — then it falls into the good exposure category. Basically, it boils down to the fact there is no such thing as a bad exposure so long as the exposure works for the image in question.

An exposure is made of three elements that are all interrelated. Each depends on the others to create a good exposure. If one of the elements changes, the others must increase or decrease proportionally.

The following are the elements you need to consider:

✦ **Shutter speed.** The shutter speed determines the length of time the sensor is exposed to light.

✦ **ISO sensitivity.** The ISO setting you choose influences your camera's sensitivity to light.

✦ **Aperture/f-stop.** The aperture, or f-stop, controls how much light reaches the sensor of your camera. Each camera has an adjustable opening on the lens. As you change the aperture (the opening), you allow more or less light to reach the sensor.

Shutter speed

Shutter speed is the amount of time light entering from the lens is allowed to expose the image sensor. Obviously, if the shutter is open longer, more light can reach the sensor. The shutter speed can also affect the sharpness of your images. When using a longer focal length lens, a faster shutter speed is required to counteract camera shake, which can cause blur. When taking photographs in low light, a slow shutter speed is often required, which can also cause blur from camera shake or fast moving subjects.

D700 shutter speeds appear as whole numbers on the displays but they are actually fractions of a second. The D700 shutter speeds range from a very long 30 seconds to an extremely short 1/8000 second (fast enough to freeze almost any type of action). As with aperture settings, you can use shutter speeds creatively to make your images more dynamic or even ethereal, as you will see.

Using fast shutter speeds

Any shutter speed from about 1/500 to 1/8000 second is a fast shutter speed, meaning that the time your sensor is exposed to the light is very brief. To achieve a fast shutter speed (while still getting a proper exposure), you will need a lot of light. To get this light, you will need to open up your aperture or raise your ISO setting to make the most of the available light. First and foremost, the reason to use a fast shutter speed is to stop the motion of fast moving objects. A fast shutter speed shows you a moment frozen in time. One of the cool things about high-speed photography is that it allows you to see things your eyes can't detect.

Sports photos are a prime candidate for fast shutter speeds. It doesn't matter what sport you're photographing; there is usually fast movement involved, and using a slow to moderate shutter speed is going to introduce blur into your image (although you can use this creatively, as I discuss later). Freezing the motion often gives a sense of action to the image.

The next most useful application of a fast shutter speed is to prevent blur from camera shake. As most of you know, longer lenses tend to accentuate any shaking that is caused by handholding the camera. This can cause your images to look blurry even though your focus was spot on. The cure for camera shake is to use a fast shutter speed. The rule of thumb is that you want to use a shutter speed that has a reciprocal that's near to the focal length of the lens (1/60 second for a 50mm lens, 1/100 second for a 105mm lens, and so on). When using extremely long telephoto lenses, especially at 200mm and longer, the camera shake is magnified even

5.1 In this image, a fast shutter speed of 1/3200 second freezes the motion of the skateboarder in mid-air.

greater. At 1/200 second using a 200mm, you're going to have to be pretty steady to get a sharp shot (without Vibration Reduction, or VR), or crank up that shutter speed. Using a faster shutter speed may also free you up from needing a tripod.

Using slow shutter speeds

The real creative stuff starts when you slow the shutter speed down. You can create many cool effects simply by doing a long exposure. You can show action with panning and motion blur, and can make interesting light trails. You can shoot fireworks and much more. Here's how to do some of these effects:

✦ **Show action.** Just as you can use a fast shutter speed to catch action, you can use a slow one to show it. The best way is to pan, or move your lens, in the same direction as the subject is moving. When you do this properly, the subject will be in sharp focus, but the background will have motion blur, giving the still photo the illusion of movement. The shutter speed you use depends on how fast the subject is actually moving. For fast moving subjects such as racecars or motorcycles, you can get away with using a shutter speed up to 1/320 second. For slower moving subjects

5.2 This panning shot was taken at 1/60 second, allowing the wheels and the background to blur out to give a sense of speed to the shot.

like football or soccer players, you can use a much slower shutter speed. A little bit of experimentation is usually in order to figure out exactly what shutter speed works for your shot.

✦ **Create light trails.** Using an extra-long shutter speed can cause moving light sources to create trails in your image. For the most part, it's best to use a tripod in this situation, but sometimes holding the camera in your hand can result in some pretty interesting effects.

✦ **Capture fireworks.** Setting your camera up on a tripod and opening the shutter up for a few seconds allows you to capture fireworks in full bloom. Using a shutter of about 4 seconds and an aperture between f/8 and f/11 is generally recommended for fireworks photography.

✦ **Blur water.** This is a very common technique that has grown in popularity, especially since the advent of digital photography. Using a slow shutter speed gives the moving water a glassy and ethereal look that is quite interesting. This is also a situation where you'd want to use a tripod.

There are a few pitfalls that you may come across when doing long exposures; long exposure noise and camera shake are the most common.

5.3 Using a shutter speed of 1/2 second allowed me to capture light trails to add some interest to this shot.

5.4 A shutter speed of 8 seconds allowed the water to blur.

ISO

The ISO (International Organization for Standardization) setting is how you can determine how sensitive your camera is to light. The higher the ISO number, the less light you need to take a photograph, meaning the more sensitive the sensor is to light. For example, you might choose an ISO of 200 on a bright, sunny day when you are photographing outside because you have plenty of light. However, on a dark, cloudy day, you want to consider an ISO of 400 or higher to make sure your camera captures all the available light. This allows you to use a faster shutter speed should it be appropriate for the subject you are photographing.

It is helpful to know that each ISO setting is twice as sensitive to light as the previous setting. For example, at ISO 400, your camera is twice as sensitive to light as it is at ISO 200. This means it needs only half the light at ISO 400 that it needs at ISO 200 to achieve the same exposure.

Additionally, the D700 allows you to adjust the ISO in 1/3-stop increments (100, 125, 160, 200, and so on), which enables you to fine-tune your ISO to reduce the noise inherent with higher ISO settings.

5.5 This image shows digital noise resulting from using a high ISO. Notice that the noise is more prevalent in the darker areas of the image.

Aperture

Aperture is the size of the opening in the lens that determines the amount of light that reaches the image sensor. The aperture is controlled by a metal diaphragm that operates in a similar fashion to the iris of your eye. Aperture is expressed as f-stop numbers, such as f/2.8, f/5.6, and f/8. A few important things to know about aperture include

✦ **Smaller f-stop numbers equal wider apertures.** A small f-stop such as f/2.8, for example, opens the lens so more light reaches the sensor. If you have a wide aperture (opening), the amount of time the shutter needs to stay open to let light into the camera decreases.

✦ **Larger f-stop numbers equal narrower apertures.** A large f-stop such as f/11, for example, closes the lens so less light reaches the sensor. If you have a narrow aperture (opening), the amount of time the shutter needs to stay open to let light into the camera increases.

Deciding what aperture to use depends on what kind of photo you are going to take. If you need a fast shutter speed to freeze action, and you don't want to raise the ISO, you can use a wide aperture to let more available light in to the sensor. Conversely, if the scene is very bright, you may want to use a small aperture to avoid overexposure.

Understanding Depth of Field

Depth of field is the distance range in a photograph in which all included portions of an image are acceptably sharp. It is heavily affected by aperture, but how far your camera is from the subject can also have an effect. Here's how it works.

When you focus your lens on a certain point, everything that lies on the horizontal plane of that same distance is also in focus. This means everything in front of the point and everything behind it is technically not in focus. Because our eyes aren't acute enough to discern the

minor blur that occurs directly in front of and directly behind the point of focus, it still appears sharp. This is known as the zone of acceptable sharpness, or depth of field.

This zone of acceptable sharpness is based on the circle of confusion. The circle of confusion simplified is the largest blurred circle that is perceived by the human eye as acceptably sharp.

> **Note** *A few factors go into determining the size of the circle of confusion, such as visual acuity, viewing distance, and enlargement size.*

Circles of confusion are formed by light passing through the body of a lens. Changing the size of the circle of confusion is as easy as opening up or closing down your aperture. Therefore, when you open up the aperture,

the circle of confusion is larger, resulting in decreased depth of field and a softer, more blurred background (and foreground). When the aperture is closed down, the circle of confusion is smaller, resulting in increased depth of field and causing everything in the image to appear sharp.

There are two types of depth of field:

✦ **Shallow depth of field.** This results in an image where the subject is in sharp focus, but the background has a soft blur. You likely have seen it used frequently in portraits. Using a wide aperture, such as f/2.8, results in a subject that is sharp with a softer background. Using a shallow depth of field is a great way to get rid of distracting elements in the background of an image.

5.6 An image with a shallow depth of field has only the main subject in focus.

5.7 An image with a deep depth of field has most of the image in focus.

✦ **Deep depth of field.** This results in an image that is reasonably sharp from the foreground to the background. Using a narrow aperture, such as f/11, is ideal to keep photographs of landscapes or groups in focus throughout.

Tip *Remember, to enlarge your depth of field, you want a large f-stop number; to shrink your depth of field, you want a small f-stop number.*

Subject distance also plays an important part when considering depth of field. When focusing on a subject that is close to the lens, the depth of field is reduced. This explains why when you're doing macro photography, the depth of field is extremely shallow, even when you're using relatively small apertures. Conversely, when the subject you are focusing on is farther away, the depth of field is increased.

Exposure Compensation

Your camera's meter may not always be completely accurate. There are a lot of variables in most scenes, and large bright or dark areas can trick the meter into thinking a scene is brighter or darker than it really is, causing the image to be over- or underexposed. Exposure compensation is a feature of the D700 that allows you to fine-tune the amount of exposure to vary from what is set by the camera's exposure meter. Although you can usually

adjust the exposure of the image in your image-editing software (especially if you shoot RAW), it's best to get the exposure right in the camera to be sure that you have the highest image quality. If after taking the photograph, you review it and it's too dark or too light, you can adjust the exposure compensation and retake the picture to get a better exposure. Exposure Compensation is adjusted in EV (Exposure Value), 1 EV is equal to 1 stop of light. You adjust exposure compensation by pressing the Exposure Compensation button, next to the Shutter Release button, and rotating the Main Command dial to the left for more exposure (+EV) or to the right for less exposure (–EV). Depending on your settings, the exposure compensation is adjusted in 1/3, 1/2, or 1 stop of light. You can change this setting in the Custom Settings menus (CSM b3).

You can adjust the exposure compensation up to +5 EV and down to –5 EV, which is a large range of 10 stops. To remind you that exposure compensation has been set, the exposure compensation indicator is displayed on the top LCD control panel and the viewfinder display. It also appears on the rear LCD screen when the shooting info is being displayed.

 Caution *Be sure to reset the exposure compensation to 0 after you're done to avoid unwanted over- or underexposure.*

There are a few different ways to get the exact exposure that you want. You can use the histogram to determine whether you need to add or subtract from your exposure; you can also use bracketing to take a number of exposures and choose from the one that you think is best; or you can combine the bracketed images with different exposures to create one image using post-processing software.

Histograms

The easiest way to determine if you need to adjust the exposure compensation is to simply preview your image. If it looks too dark, add some exposure compensation; if it's too bright, adjust the exposure compensation down. This, however, is not the most accurate method of determining how much exposure compensation to use. To accurately determine how much exposure compensation to add or subtract, look at the histogram. A histogram is a visual representation of the tonal values in your image. Think of it as a bar graph that charts the lights, darks, and mid-tones in your picture.

The histogram charts a tonal range of about 5 stops, which is about the limit of what the D700's sensor can record. This range is broken down into 256 separate brightness levels from 0 (absolute black) to 255 (absolute white), with 128 coming in at middle or 18 percent gray. The more pixels there are at any given brightness value, the higher the bar. If there are no bars, then the image has no pixels in that brightness range.

The D700 offers four separate histogram views, the luminance histogram, which shows the brightness levels of the entire image, and three separate histograms for each color channel — red, green, and blue.

The most useful histogram for determining if your exposure needs adjusting is the luminance histogram. To display the luminance histogram, simply press the Multi-selector

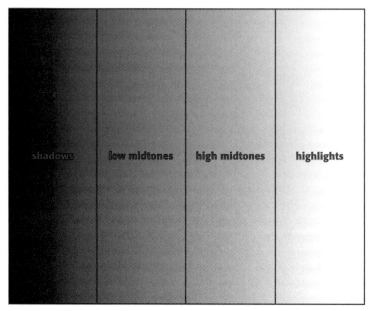

shadows low midtones high midtones highlights

5.8 A representation of the tonal range of a histogram

up while viewing the image on the LCD. This displays a thumbnail of the current image, the shooting info, and a small luminance histogram. You can also view a larger version of the luminance histogram directly overlaid on the current image. You can set this up in the CSM f2 assigning this function to the Multi-selector center button when in Playback mode.

To view the luminance histogram using the Multi-selector center button, follow these steps:

1. **Press the Menu button.**

2. **Use the Multi-selector to select the Custom Settings Menu (CSM).**

3. **Use the Multi-selector to highlight CSM f, Controls.** Press OK or the Multi-selector right to view CSM f options.

4. **Use the Multi-selector to highlight menu option f2 Multi-selector center button.** Press OK or the Multi-selector right.

5. **Choose Playback mode from the menu options by pressing the Multi-selector down.** Press OK or the Multi-selector right.

6. **Choose Playback mode from the menu options.** Press the Multi-selector right to view options.

7. **Select View histograms.** Press OK or the Multi-selector center button to save the setting.

Once you've followed these steps, press the Playback button to view an image, and press the Multi-selector center button to view the histogram.

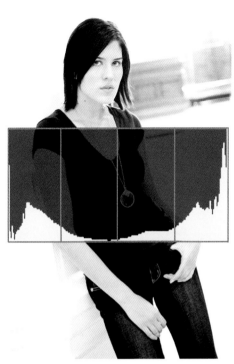

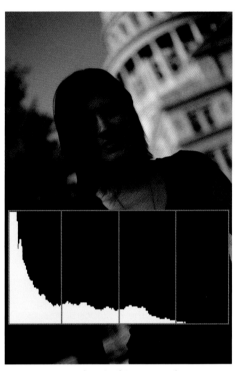

5.9 An example of a histogram from an overexposed image (no highlight detail). Notice the spikes at the far right of the graph.

5.10 An example of a histogram from an underexposed image (no shadow detail). Notice the spikes at the far left of the graph.

Ideally, you want to expose your subject so that it falls right about in the middle of the tonal range, which is why your camera's meter exposes for 18 percent gray. If your histogram graph has most of the information bunched up on the left side, then your image is probably underexposed; if it's bunched up on the right side, then your image is probably overexposed. Ideally, with most average subjects that aren't bright white or extremely dark, you want to try to get your histogram to look sort of like a bell curve, with most of the tones in the middle range, tapering off as they get to the dark and light ends of the graph. But, this is only

for most average types of images. As with almost everything in photography, there are exceptions to the rule. If you take a photo of a dark subject on a dark background (a low-key image), then naturally your histogram will have most of the tones bunched up on the left side of the graph. Conversely, when you take a photograph of a light subject on a light background (a high-key image), the histogram will have most of the tones bunched up to the right.

The most important thing to remember is that there is no such thing as a perfect histogram. A histogram is just a factual representation of the tones in the image. The other

important thing to remember is that although it's okay for the graph to be near one side or the other, you usually don't want your histogram to have spikes bumping up against the edge of the graph; this indicates your image has blown-out highlights (completely white, with no detail) or blocked-up shadow areas (completely black, with no detail).

Now that you know a little bit about histograms, you can use them to adjust exposure compensation. Here is a good set of steps to follow when using the histogram as a tool to evaluate your photos:

1. **After taking your picture, review its histogram on the LCD.** To view the histogram in the image preview, press the Playback button to view the image. Press the Multiselector up, and the histogram appears directly to the right of the image preview.

2. **Look at the histogram.** An example of an ideal histogram can be seen in figure 5.11.

3. **Adjust the exposure compensation.** To move the tones to the right to capture more highlight detail, add a little exposure compensation by pressing the Exposure Compensation button and rotating the Main Command dial to the left. To move the tones to the left, press the Exposure Compensation button and rotate the Main Command dial to the left.

4. **Retake the photograph if necessary.** After taking another picture, review the histogram again. If needed, adjust the exposure compensation more until you achieve the desired exposure.

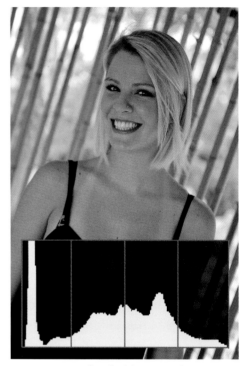

5.11 An example of a histogram from a properly exposed image. Notice that the graph does not spike against the edge on the left or the right, but tapers off.

When photographing brightly colored subjects, it may sometimes be necessary to refer to the RGB histograms. Sometimes it's possible to overexpose an image only in one single color channel, even though the rest of the image looks to be properly exposed. To view the separate RGB histograms, you need to set the display mode in the Playback menu.

5.12 An example of a histogram from a low-key image.

5.13 An example of a histogram from a high-key image.

To view RGB histograms:

1. **Press the Menu button.**

2. **Use the Multi-selector to select the Playback menu.**

3. **Use the Multi-selector to high-light Display mode.** Press the OK button or the Multi-selector right to view the menu options.

4. **Use the Multi-selector to scroll down to Menu option Detailed photo info RGB histogram.** Pressing the Multi-selector right sets the option to on. This is confirmed by a small check mark in a box next to the option.

5. **When the option is set, use the Multi-selector to scroll up to the Done option.** If you fail to select Done, the setting will not be saved.

It's possible for any one of the color channels to become overexposed, or blow out, as some photographers call it, although the most commonly blown-out channel is the red channel. Digital camera sensors seem to be more prone to overexposing the red channel because these sensors are generally more sensitive to red colors. When one of these color channels is overexposed, the histogram is similar to the luminance histogram of a typical overexposed image.

Typically, the best way to deal with an image that has an overexposed color channel is to reduce exposure by using exposure compensation. Although this a quick fix, reducing the exposure can also introduce blocked up shadows; you can deal with this by shooting RAW or, to a lesser extent, by using Active D-Lighting. Ideally, adding a bit of fill light to the shadow areas with a reflector or flash is the way to go.

Bracketing

Another way to ensure that you get the proper exposure is to bracket your exposures. Bracketing is a photographic technique in which you vary the exposure of your subject over three or more frames. By doing this, you are able to get the proper exposure in difficult lighting situations where your camera's meter can be fooled. Bracketing is usually done with at least one exposure under and one exposure over the metered exposure.

You can bracket your images manually or you can choose to use the D700's auto-bracketing function. To use the auto-bracketing function, you must set the Function button to Auto-bracketing. To do this, follow these steps:

1. **Press the Menu button.**

2. **Use the Multi-selector to enter the CSM.** Scroll down to CSM f / Controls. Press the Multi-selector right

3. **Scroll down to CSM f5, Assign FUNC. button.** Press the Multi-selector right to choose the FUNC. button options.

4. **Use the Multi-selector button to choose the FUNC. button + dials option.** Press the Multi-selector right.

5. **Choose Auto-bracketing from the FUNC. button + dials options menu.**

6. **Press the OK button.** The Function button is now assigned to be used for auto-bracketing.

 Note *You can assign Auto-bracketing to the Preview button. To set Auto-bracketing to the Preview button, use CSM f6.*

The D700 offers a few different types of bracketing:

✦ **Auto-exposure and flash.** This bracketing option varies both the exposure compensation and the flash output.

✦ **Auto-exposure only.** This bracketing option varies the exposure compensation.

✦ **Flash only.** This bracketing option adjusts the flash output.

✦ **White Balance bracketing.** White Balance bracketing takes an image and saves multiple copies of the same image with small adjustments to the white balance (WB). This ensures that you get the proper WB. This option cannot be used when shooting RAW files.

To set the exposure or WB bracketing:

1. **Press the Menu button to display menu options.** Use the Multi-selector to enter the CSM.

2. **Scroll down to CSM.** Press the Multi-selector right.

3. **Use the Multi-selector up or down to highlight CSM e5 (Auto-bracketing set).** Press the Multi-selector right to display options.

4. **Use the Multi-selector to high-
light the type of bracketing you
want.** This can be AE only, Flash,
WB, and so on. Press the OK but-
ton or Multi-selector right to set.

Once auto-bracketing is set to the Function
button, you can choose from a number of
different options:

✦ **Choose 3, 5, 7, or 9 frames.** This
option gives you more variations of
the exposure or WB.

✦ **Vary the exposure increments
from 0.3, 0.7, and 1.0 stops.**
Choosing a higher exposure incre-
ment gives you a wider variation
than choosing a lower increment.
For example, choosing a 5-frame
bracket at 0.3 EV gives you a series
of exposures where your images
range only ± 2/3 stop over and
under the original exposure. The
series of exposure compensation
will range as follows: −0.7, −0.3, 0,
+0.3, +0.7. Choosing a 5-frame
bracket at 1.0 EV gives a much
wider series of exposures. This
gives you a 5 stop range: 2 stops
over, 2 stops under, plus the origi-
nal exposure. The range of expo-
sure compensation is as follows:
−2.0, −1.0, 0, +1.0, +2.0.

✦ **Choose two frames under- or
overexposed, or three frames
over- or underexposed.** When you
choose to only overexpose or only
underexpose your bracketed shots,
choosing +2 frames gives you one
image shot at normal exposure and
one shot overexposed; choosing
+3 frames gives you two shots
overexposed and one normal expo-
sure. Conversely, choosing −2 or −3
frames gives you the same range as
the overexposures except the

images are underexposed. As with
the other settings, the increments
can be adjusted from 0.3, 0.7, or
1.0 EV.

Now that you understand all your options,
to activate Auto-bracketing, follow these
steps:

1. **Press and hold the Function but-
ton.** Look at the LCD control panel
on the top of the camera. If Auto-
bracketing is off, the LCD displays
OFF, meaning you are not bracket-
ing any frames.

2. **While still holding the Function
button, rotate the Main
Command dial to the right to
choose the number of frames to
bracket.** Choose from 3, 5, 7, or 9
shots. Rotate the dial to the left to
choose +2, +3, −2, or −3 (two
frames over or under or three
frames over or under).

3. **With the Function button still
pressed, rotate the Sub-command
dial to choose the exposure com-
pensation increments.** Choose
from 0.3, 0.7, or 1.0 EV.

Once you have chosen your settings, release
the Function button and shoot the photos.
Shoot the specified number of images for
your bracket set. You can choose to shoot
them one at a time using the Single shoot-
ing mode, or you can press and hold the
shutter until the bracket set is completed
using Continuous shooting mode.

In CSM e7 you can change the order in
which the bracketed images are taken. At
the default setting, the camera first takes the
metered exposure, then follows with the
underexposed images, and then finishes up
with the overexposed images. You can also

choose to have the camera begin with the underexposures with the metered exposure and finish up with the overexposures. This gives you a series of images that run from darkest to lightest.

Caution *You must go back into the Auto-bracketing menu and change the setting to OFF to disable Auto-bracketing; otherwise the camera will continue to bracket all of your images whether you want it to or not.*

5.14 An image bracketed at −2 EV

In addition to helping ensure that you got the correct exposure, you can also use different elements from the exposures and combine them using image-editing software to get a final image that has a wider tonal range than is possible for your image sensor to capture. This technique is known as HDR, or High Dynamic Range. You can use a few different programs to create an HDR image. Photoshop Creative Suite 3 (CS3), as well asCS2, has a tool called Merge to HDR that enables you to select two or more images (using three to five images is recommended) and automatically merges the separate images for you. Although HDR is a very good tool for getting more tonal range in your images, be careful not to overuse it. In recent years, photographers have had the tendency to take this technology too far, creating unrealistic, overly processed looking images. Although some photographers like this look, I find it tacky, kind of like a velvet Elvis painting.

The following is a sequence of bracketed images. The auto-bracketing was set to AE only, 5 frames, and the EV increment was set to 1 to show the broad range of exposures you can get with bracketing.

5.15 An image bracketed at −1 EV

5.16 An image bracketed at 0 EV

White Balance bracketing

When using WB bracketing, the setup is the same, but there's some different terminology and some different effects happening. WB bracketing gives you a shot with a standard WB and also gives you shots that are cooler (blue) or warmer (amber).

5.17 An image bracketed at +1 EV

Holding down the Function button (or whichever button you have selected for WB bracketing) and rotating the Main Command dial to the right (from the default setting of 0 frames) allows you to choose how many frames to bracket. You can choose 3, 5, 7, or 9 frames. This option gives you a series of images that range from amber to blue. Rotating the Main Command dial to the left (from the default setting) allows you to choose the option of shooting two or three images of either amber or blue. For example, A2 gives you two images, one warmer than the next. You can choose from A2, B2, A3, or B3.

5.18 An image bracketed at +2 EV

Instead of setting the EV increments with the Sub-command dial as you would for exposure compensation, for the WB option, you adjust the WB increments. The options are 1, 2, or 3. The higher numbers give you a more pronounced change in the WB. Each number increases the color change about 5 Mired (Micro Reciprocal Degrees), so that 1 gives you a change of 5 Mired between images, 2 gives you a change of 10 Mired, and 3 gives you a difference of 15 Mired.

5.19 Five images merged to HDR

The Mired system was developed to deal with the inconsistencies of the Kelvin color temperature system because color temperature produces a greater change in the color of the light at the lower temperatures than it does at higher temperatures. To figure out the Mired number of a specific color temperature, you simply divide 1,000,000 by the color temperature (M = 106 / K). For example, for Daylight (5000 K) you take 1,000,000 and divide by 5000. Your answer is 200, the Mired of daylight.

Working with Light

The most important factor in photography is light; without it, your camera is rendered useless. You need light to make the exposure that results in an image. Whether the light is recorded to silver halide emulsion on a piece of film or to the CMOS sensor on your D700, you can't make a photograph without it.

Not only is light necessary to make an exposure, but it also has different qualities that can impact the outcome of your image. Light can be soft and diffuse, or it can be hard and directional. Light can also have an impact on the color of your images; different light sources emit light at different temperatures, which changes the color cast of the image.

When there is not enough light to capture the image you're after, or if the available light isn't suitable for your needs, you can employ alternative sources of light, such as flash, to achieve the effect you're after.

The ability to control light is a crucial step toward being able to make images that look exactly how you want them to. In this chapter, I explain some of the different types of light and how to modify them to suit your needs.

Natural Light

Though it is by far the easiest type of light to find, natural light is sometimes the most difficult to work with because it comes from the sun, is often unpredictable, and can change from minute to minute. A lot of times I hear people say, "Wow, it's such a nice, sunny day; what a perfect day to take pictures," but unfortunately this is not often the case. A bright day when the sun is high in the sky presents many obstacles.

First, you have serious contrast issues on a sun-drenched day. Oftentimes, the digital sensor doesn't have the latitude to capture the whole scene effectively. For example, it is nearly impossible to capture detail in the shadows of your subject while keeping the highlights from blowing out or going completely white.

Fortunately, if you want to use natural light, it isn't necessary to stand in direct sunlight at noon. You can get desirable lighting effects when working with natural light in many ways. Here are a few examples:

✦ **Use fill flash.** You can use the flash as a secondary light source (not as your main light) to fill in the shadows and reduce contrast.

✦ **Try window lighting.** Believe it or not, one of the best ways to use natural light is to go indoors. Seating your model next to a window provides a beautiful soft light that is very flattering. A lot of professional food photographers use window light. It can be used to light almost any subject softly and evenly.

✦ **Find some shade.** The shade of a tree or the overhang of an awning or porch can block the bright sunlight while still giving you plenty of diffuse light with which to light your subject.

✦ **Take advantage of the clouds.** A cloudy day softens the light, allowing you to take portraits outside without worrying about harsh shadows and too much contrast. Even if it's only partly cloudy, you can wait for a cloud to pass over the sun before taking your shot.

✦ **Use a modifier.** Use a reflector to reduce the shadows or a diffusion panel to block the direct sun from your subject.

6.1 A food shot, using natural light from a window

D700 Flash Basics

A major advantage of the Nikon D700 is the fact that it has a built-in flash for quick use in low-light situations. Even better is the fact that Nikon has additional flashes called Speedlights, which are much more powerful and versatile than the smaller built-in flash.

Nikon Speedlights are dedicated flash units, meaning they are built specifically for use with the Nikon camera system and offer much more functionality than a non-dedicated flash. A non-dedicated flash is a flash made by a third-party manufacturer; the flashes usually don't offer fully automated flash features. There are, however, some non-Nikon flashes that use Nikon's i-TTL flash metering system. The i-TTL system allows the flash to operate automatically, usually resulting in a perfect exposure without your having to do any calculations.

Achieving proper exposures

If you are new to using an external Speedlight flash, exposure can seem confusing when you first attempt to use it. There are a lot of settings you need to know, and there are different formulas you can use to get the right exposure. Once you understand the numbers and where to plug them in, using the Speedlight becomes quite easy.

If you are using your Speedlight in the i-TTL mode, the calculations you would otherwise do manually are done for you, but it's always good to know how to achieve the same results if you don't have the technology to rely on and to understand how to work with the numbers. When you know these calculations, you can use any flash and get excellent results.

Three main components go into making a properly exposed flash photograph: Guide Number (GN), aperture, and distance. If one of these elements is changed, another one must be changed proportionally to keep the exposure consistent. The following sections cover each element one by one and how to put them together.

Guide Number

The first component in the equation for determining proper flash exposure is the Guide Number (GN), which is a numeric value that represents the amount of light emitted by the flash. You can find the GN for your specific Speedlight in the owner's manual. The GN changes with the ISO sensitivity to which your camera is set; for example, the GN for a Speedlight at ISO 400 is greater than the GN for the same Speedlight when it's set to ISO 100 (because of the increased sensitivity of the sensor). The GN also differs depending on the zoom setting of the Speedlight. The owner's manual has a table that breaks down the GNs according to the flash output setting and the zoom range selected on the Speedlight.

Tip *If you plan to do a lot of manual flash exposures, I suggest making a copy of the GN table from the owner's manual and keep it in your camera bag with the flash.*

Note *If you have access to a flash meter, you can determine the GN of your Speedlight at any setting by placing the meter 10 feet away and firing the flash. Next, take the aperture reading from the flash meter and multiply by ten. This is the correct GN for your flash.*

Aperture

The second component in the flash exposure equation is the aperture setting. As you already know, the wider the aperture, the more light that falls on the sensor. Using a wider aperture allows you to use a lower power setting (such as 1/4 when in Manual mode) on your flash, or if you're using the automatic i-TTL mode, the camera fires the flash using less power.

Distance

The third component in the flash exposure equation is the distance from the light source to the subject. The closer the light is to your subject, the more light falls on it. Conversely, the farther away the light source is, the less illumination your subject receives. This is important because if you set your Speedlight to a certain output, you can still achieve a proper exposure by moving the Speedlight closer or farther away as needed.

GN / Distance = Aperture

Here's where the GN, aperture, and distance all come together. The basic formula allows you to take the GN and divide it by the distance to determine the aperture at which you need to shoot. You can change this equation to find out what you want to know specifically:

✦ **GN / D = A.** If you know the GN of the flash and the distance of the flash from the subject, you can determine the aperture to use to achieve the proper exposure.

✦ **A / GN = D.** If you know the aperture you want to use and the GN of the flash, you can determine the distance to place your flash from the subject.

✦ **A × D = GN.** If you already have the right exposure, you can take your aperture setting and multiply it by the distance of the flash from the subject to determine the approximate GN of the flash.

Flash exposure modes

Flashes have different modes that determine how they receive the information on how to set the exposure. Be aware that, depending on the Speedlight or flash you are using, some flash modes may not be available.

i-TTL

The D700 determines the proper flash exposure automatically by using Nikon's proprietary i-TTL system. The camera gets most of the metering information from monitor preflashes emitted from the Speedlight. These preflashes are emitted almost simultaneously with the main flash so it looks as if the flash has only fired once. The camera also uses data from the lens, such as distance information and f-stop values, to help determine the proper flash exposure.

Additionally, two separate types of i-TTL flash metering are available for the D700: Standard i-TTL flash and i-TTL Balanced Fill-Flash (BL). With Standard i-TTL flash, the camera determines the exposure for the subject only, and does not take the background lighting into account. With i-TTL BL mode, the camera attempts to balance the light from the flash with the ambient light to produce a more natural-looking image.

When using the D700's built-in flash, the default mode is the i-TTL BL mode. To switch the flash to Standard i-TTL, the camera must be switched to Spot metering.

The Standard i-TTL and i-TTL BL flash modes are available with Nikon's current Speedlight lineup, including the SB-900, SB-800, SB-600, SB-400, and the R1C1 Macro flash kit.

Manual

When you set your Speedlight (either the built-in or accessory flash) to full Manual mode, you must adjust the settings yourself. The best way to figure out the settings is by using a handheld flash meter or by using the GN / D = A formula I discussed previously.

Auto

With Speedlights that offer the Auto mode (sometimes referred to as Non-TTL Auto Flash), such as the SB-900 and SB-800, you decide the exposure setting. These flashes usually have a sensor on the front of them that detects the light reflected back from the subject. When the flash determines enough light has been produced to make the exposure, it automatically stops the flash tube from emitting any more light.

When using this mode, you need to be aware of the limitations of the flash you are using. If the flash doesn't have a high GN or the subject is too far away, you may need to open the aperture. Conversely, if the flash is too powerful or the subject is very close, you may need to stop the aperture down a bit.

 Caution *When using Auto mode with a non-Nikon flash, be sure not to set the D700's shutter speed above the rated sync speed, which is 1/250 second. If you do, you will have an incompletely exposed image.*

Auto Aperture

Some flashes, such as the SB-900 and SB-800, also offer what is called an Auto Aperture Flash mode. In this mode, you

decide what aperture is best suited for the subject you are photographing, and the flash determines how much light to add to the exposure.

Guide Number distance priority

In the Guide Number distance priority mode available with the SB-800 and SB-900, the flash controls the output according to aperture and subject distance. You manually enter the distance and f-stop value into the flash unit, and then select the f-stop with the camera. The flash output remains the same if you change the aperture. You can use this mode when you know the distance from the camera to the subject.

 Caution *Changing the aperture or the distance to the subject after entering the setting on the flash can cause improper exposures.*

Repeating flash

When in Repeating flash mode, the flash fires repeatedly like a strobe light during a single exposure. You must manually determine the proper flash output you need to light your subject using the formula to get the correct aperture (GN / D = A), and then you decide the frequency (Hz) and the number of times you want the flash to fire. The slower the shutter speed, the more flashes you are able to capture. For this reason, I recommend only using this mode in low-light situations because the ambient light tends to overexpose the image. Use this mode to create a multiple exposure–type image.

To determine the correct shutter speed, use this simple formula: Shutter speed = number of flashes per frame / Hz. For example, if you want the flash to fire ten times with a frequency of 40 Hz (40 times per second), divide 10 by 40, which gives you .25 or 1/4 second.

Flash sync modes

Flash sync modes control how the flash operates in conjunction with your D700. These modes work with both the built-in Speedlight and accessory Speedlights, such as the SB-900, SB-800, SB-600, and so on. These modes allow you to choose when the flash fires, either at the beginning of the exposure or at the end, and they also allow you to keep the shutter open for longer periods, enabling you to capture more ambient light in low-light situations.

Sync speed

Before getting into the different sync modes, you need to understand sync speed. The sync speed is the fastest shutter speed that can be used while achieving a full flash exposure. This means if you set your shutter speed at a speed faster than the rated sync speed of the camera, you don't get a full exposure and end up with a partially under-exposed image. With the D700, you can't actually set the shutter speed above the rated sync speed of 1/250 (unless you're using Auto FP High-Speed Sync; more on that later) when using a dedicated flash because the camera won't let you; so no need to worry about having partially black images when using a Speedlight. But if you're using a studio strobe or a third-party flash, this is a concern you should consider.

Limited sync speeds exist because of the way shutters in modern cameras work. As you already know, the shutter controls the amount of time the light is allowed to reach the imaging sensor. All dSLR cameras have what is called a focal plane shutter. This term stems from the fact that the shutter is located directly in front of the focal plane, which is essentially on the sensor. The focal plane shutter has two shutter curtains that travel vertically in front of the sensor to control the time the light can enter through the lens. At slower shutter speeds, the front curtain covering the sensor moves away, exposing the sensor to light for a set amount of time. When the exposure has been made, the second curtain then moves in to block the light, thus ending the exposure.

To achieve a faster shutter speed, the second curtain of the shutter starts closing before the first curtain has exposed the sensor completely. This means the sensor is actually exposed by a slit that travels the length of the sensor. This allows your camera to have extremely fast shutter speeds, but limits the flash sync speed because the entire sensor must be exposed to the flash at once to achieve a full exposure.

Auto FP High-Speed Sync

Although the D700 has a top-rated sync speed of 1/250, Nikon has built in a convenient option in Custom Settings menu e1 (CSMe1) that allows you to use flash at shutter speeds faster than the rated sync speed. This is called Auto FP High-Speed Sync (the FP stands for focal plane, as in the shutter). Setting CSMe1 to Auto FP allows you to shoot the built-in flash at 1/320 second and other compatible Speedlights (SB-900, SB-800, and SB-600) to a maximum of 1/8000. Earlier I discussed that the sensor must be fully exposed to receive the full flash exposure and that's limited to 1/250, so how on earth does Auto FP flash work?

It's pretty simple actually: Instead of firing one single pop, the flash fires multiple times as the shutter curtain travels across the focal plane of the sensor (hence the Auto FP). The only drawback is that your flash power, or GN, is diminished, so you may need to take this into consideration when doing Manual flash calculations.

Auto FP is a useful feature. It's mainly used when shooting in brightly lit scenes using fill flash. An example would be shooting a portrait outdoors at high noon; of course the light is very contrasty and you want to use fill flash, but you also require a wide aperture to blur out the background. At the sync speed 1/250, ISO200, your aperture needs to be at f/16. If you open your aperture to f/4, you will then need a shutter speed of 1/8000. This is possible using Auto FP.

Note *The D700 built-in flash only does Auto FP up to 1/320.*

Front-curtain sync

Front-curtain sync is the default sync mode for your camera whether you are using the built-in flash, one of Nikon's dedicated Speedlights, or a third-party accessory flash. With Front-curtain sync, the flash is fired as soon as the shutter's front curtain has fully opened. This mode works well with most general flash applications.

One thing worth mentioning about Front-curtain sync is that although it works well when you're using relatively fast shutter speeds, when the shutter is slowed down (also known as dragging the shutter when doing flash photography), especially when you're photographing moving subjects, your images have an unnatural-looking blur in front of them. Ambient light recording the moving subject creates this.

When doing flash photography at slow speeds, your camera is actually recording two exposures, the flash exposure and the ambient light. When you're using a fast shutter speed, the ambient light usually isn't bright enough

to have an effect on the image. When you slow down the shutter speed substantially, it allows the ambient light to be recorded to the sensor, causing what is known as *ghosting*. Ghosting is a partial exposure that is usually fairly transparent-looking on the image.

Ghosting causes a trail to appear in front of the subject because the flash freezes the initial movement of the subject. Because the subject is still moving, the ambient light records it as a blur that appears in front of the subject, creating the illusion that it's moving backward. To counteract this problem, you can use a Rear-curtain sync setting, which I explain later in this section.

Red-eye reduction

We've all seen red-eye in a picture at one time or another — that unholy red glare emanating from the subject's eyes that is caused by light reflecting off the retina. Fortunately, the D700 offers a Red-Eye Reduction flash mode. When this mode is activated, the camera fires some preflashes (when using an accessory Speedlight) or turns on the AF-assist illuminator (when using the built-in flash), which cause the pupils of the subject's eyes to contract. This stops the light from the flash from reflecting

6.2 A shot using Front-curtain sync with a shutter speed of 1 second. Notice that the flash freezes the hand during the beginning of the exposure and the trail caused by the ambient exposure appears in the front, causing the hand to look like its moving backward.

off of the retina and reduces or eliminates the red-eye effect. This mode is useful when taking portraits or snapshots of people or pets when there is little light available.

Slow sync

Sometimes when using a flash at night, especially when the background is very dark, the subject is lit but appears to be in a black hole. Slow Sync mode helps take care of this problem. In Slow Sync mode, the camera allows you to set a longer shutter speed (up to 30 seconds) to capture the ambient light of the background. Your subject and the background are lit, so you can achieve a more natural-looking photograph.

> **Note** Slow sync can be used in conjunction with Red-Eye Reduction for night portraits.

6.3 A picture taken with standard flash at night. Notice the dark background and the bright subject.

Caution *When using Slow sync, be sure the subject stays still for the whole exposure to avoid ghosting, which is a blurring of the image caused by motion during long exposures. Of course, you can use ghosting creatively.*

Rear-curtain sync

When using Rear-curtain sync, the camera fires the flash just before the rear curtain of the shutter starts moving. This mode is useful when taking flash photographs of moving subjects. Rear-curtain sync allows you to more accurately portray the motion of the subject by causing a motion blur trail behind the subject rather in front of it, as is the case with Front-curtain sync. Rear-curtain sync is used in conjunction with Slow sync.

6.4 A picture taken using Slow Sync mode. Notice how the subject and background are more evenly exposed.

6.5 A picture taken using Rear-curtain sync flash

Flash Exposure Compensation

When you're photographing subjects using flash, whether you're using an external Speedlight or your D700's built-in flash, there may be times when the flash causes your principal subject to appear too light or too dark. This usually occurs in difficult lighting situations, especially when you're using TTL metering, and your camera's meter can get fooled into thinking the subject needs more or less light than it actually does. This can happen when the background is very bright or very dark, or when the subject is off in the distance or very small in the frame.

Flash Exposure Compensation (FEC) allows you to manually adjust the flash output while still retaining TTL readings so your flash exposure is at least in the ballpark. With the D700, you can vary the output of your built-in flash's TTL setting (or your own manual setting) from −3 Exposure Value (EV) to +1 EV. This means if your flash exposure is too bright, you can adjust it down to 3 full stops under the original setting. Or, if the image seems underexposed or too dark, you can adjust it to be brighter by 1 full stop. Additionally, the D700 allows you to fine-tune how much exposure compensation is applied by letting you set the FEC incrementally in either 1/3, 1/2, or 1 stop of light.

6.6 A series of images using Flash Exposure Compensation

Fill flash

Fill flash is a handy flash technique that allows you to use your Speedlight as a secondary light source to fill in the shadows rather than as the main light source, hence the term fill flash. Fill flash is used mainly in outdoor photography when the sun is very bright, creating deep shadows and bright highlights that result in an image with very high contrast and a wide tonal range. Using fill flash allows you to reduce the contrast of the image by filling in the dark shadows, thus allowing you to see more detail in the image.

You also may want to use fill flash when your subject is backlit (lit from behind). When the subject is backlit, the camera's meter automatically tries to expose for the bright part of the image that is behind your subject. This results in a properly exposed background while your subject is underexposed and dark. However, if you use the spot meter to obtain the proper exposure on your subject, the background will be overexposed and blown out. The ideal thing is to use fill flash to provide an amount of light on your subject that is equal to the ambient light of the background. This brings

sufficient detail to both the subject and the background, resulting in a properly and evenly exposed image.

All of Nikon's dSLR cameras offer i-TTL BL (Nikon calls this Balanced Fill-Flash) or, in laymen's terms, automatic fill flash, with both the built-in flash and the detachable Speedlights, the SB-900, SB-800, SB-600, and SB-400. When using a Speedlight, the camera automatically sets the flash to do fill flash (as long as you're not in Spot metering mode). This is a very handy feature because it allows you to concentrate on composition and not worry about your flash settings. If you decide that you don't want to use the i-TTL BL option, you can set the camera's metering mode to Spot metering, or if you are using an SB-900, SB-800, or SB-600, simply press the Speedlight's Mode button.

Of course, if you don't own an additional i-TTL dedicated Speedlight or you'd rather control your flash manually, you can still do fill flash. It's actually a pretty simple process that can vastly improve your images when you use it in the right situations.

To execute a manual fill flash:

1. **Use the camera's light meter to determine the proper exposure for the background or ambient light.** A typical exposure for a sunny day is 1/250 at f/16 with an ISO of 200. Be sure not to set the shutter speed higher than the rated sync speed of 1/250.

2. **Determine the flash exposure.** Using the GN / D = A formula, find the setting that you need to properly expose the subject with the flash.

3. **Use FEC to reduce the flash output.** Setting the Flash Exposure Compensation down 1/3 to 2/3 stops allows the flash exposure to be less noticeable while filling in the shadows or lighting your backlit subject. This makes your images look more natural, as if a flash didn't light them, which is the ultimate goal when attempting fill flash.

Note *The actual amount of FEC needed varies with the intensity of the ambient light source. Use your LCD to preview the image and adjust the amount of FEC as needed.*

6.7 A picture taken without fill flash

6.8 A picture taken with fill flash

Bounce flash

One of the easiest ways to improve your flash pictures, especially snapshots, is to use bounce flash. Bounce flash is a technique in which the light from the flash unit is bounced off of the ceiling or off of a wall onto the subject to diffuse the light, resulting in a more evenly lit image. To do this, your flash must have a head that swivels and tilts. Most flashes made within the last ten years have this feature, but some may not.

When you attempt bounce flash, you want to get as much light from the flash onto your subject as you can. To do this, you need to first look at the placement of the subject and adjust the angle of the flash head appropriately. Consider the height of the ceiling or distance from the surface you intend to bounce the light from to the subject.

Unfortunately, not all ceilings are useful for bouncing flash. For example, the ceiling in my studio is corrugated metal with iron crossbeams. If I attempted to bounce flash from a ceiling like that, it would make little or no difference to the image because the light won't reflect evenly and will scatter in all different directions. In a situation where the ceiling is not usable, you can position the subject next to a wall and swivel the flash head in the direction of the wall and bounce it from there. To bounce the flash at the correct angle, remember the angle of incidence equals the angle of reflection.

You want to aim the flash head at such an angle that the flash isn't going to bounce in behind the subject so it is poorly lit. You want to be sure that the light is bounced so that it falls onto your subject. When the subject is very close to you, you need to have your flash head positioned at a more obtuse angle than when the subject is farther away. I recommend positioning the subject at least 10 feet away and setting the angle of the flash head at 45 degrees for a typical height ceiling of about 8 to 10 feet.

An important pitfall to be aware of when bouncing flash is that the reflected light picks up and transmits the color of the surface from which it is bounced. This means if you bounce light off a red surface, your subject will have a reddish tint to it. The best approach is to avoid bouncing light off of surfaces that are brightly colored, and stick with bouncing light from a neutral-colored surface. White

surfaces tend to work the best because they reflect more light and don't add any color. Neutral gray surfaces also work well, although you can lose a little light due to lessened reflectivity and the darker color.

Unfortunately, you can't do bounce flash with the D700's built-in flash; you need an external Speedlight such as an SB-900, SB-800, SB-600, or SB-400.

6.10 A picture taken with bounced flash

6.9 A picture taken with straight flash

Nikon Creative Lighting System Basics

Nikon introduced the Creative Lighting System (CLS) in 2004. In simple terms, it is a system designed to enable you to take Nikon Speedlights off of the camera and attach them to stands. This allows you to position the Speedlights wherever you want and control the direction of light to make the subject appear exactly how you want. The Nikon CLS enables you to achieve

creative lighting scenarios similar to what you would achieve with expensive and much larger studio strobes. You can do it wirelessly with the benefit of full i-TTL metering. To take advantage of the Nikon CLS, you need the D700 and at least one SB-900, SB-800, or SB-600 Speedlight. With the CLS, there is no more mucking about with huge power packs and heavy strobe heads on heavy-duty stands, with cables and wires running all over the place.

The Nikon CLS is not a lighting system in and of itself, but is comprised of many different pieces you can add to your system as you see fit (or your budget allows). The first and foremost piece of the equation is your camera.

Understanding the Creative Lighting System

The Nikon CLS is basically a communication system that allows the camera, the commander, and the remote units to share information regarding exposure.

A commander, which is also called a master, is the flash that controls external Speedlights. Remote units, which are sometimes referred to as slaves, are the external flash units the commander controls remotely. Communications between the commander and the remote units are accomplished by using pulse modulation. *Pulse modulation* is a term that means the commanding Speedlight fires rapid bursts of light in a specific order. The pulses of light are used to convey information to the remote group, which interpret the bursts of light as coded information.

Firing the commander tells the other Speedlights in the system when and at what power to fire. The D700's built-in flash can act as a commander. Using an SB-800 or SB-900 Speedlight or an SU-800 Commander as a master allows you to control three separate groups of remote flashes and gives you an extended range. Using the built-in Speedlight as a commander, you can only control two groups of external Speedlights and have a limited range on how far the camera can be from the remote flashes.

This is how CLS works in a nutshell:

1. **The commander unit sends out instructions to the remote groups to fire a series of monitor preflashes to determine the exposure level.** The camera's i-TTL metering sensor reads the preflashes from all of the remote groups and also takes a reading of the ambient light.

2. **The camera tells the commander unit the proper exposure readings for each group of remote Speedlights.** When the shutter is released, the commander, via pulse modulation, relays the information to each group of remote Speedlights.

3. **The remote units fire at the output specified by the camera's i-TTL meter, and the shutter closes.**

All these calculations happen in a fraction of a second as soon as you press the Shutter Release button. It appears to the naked eye as if the flash just fires once. There is no waiting for the camera and the Speedlights to do the calculations.

Given the ease of use and the portability of the Nikon CLS, I highly recommend purchasing at least one (if not two) SB-900, SB-800 or SB-600 Speedlights to add to your setup. With this system, you can produce almost any type of lighting pattern you want. It can definitely get you on the road to creating more professional-looking images.

 Cross-Reference *For a definitive and in-depth look into the Nikon CLS, read the Nikon Creative Lighting System Digital Field Guide (Wiley, 2007).*

Speedlights

Speedlights are Nikon's line of flashes. They are amazing accessories to add to your kit, and you can control most of them wirelessly. Currently, Nikon offers four shoe-mounted flashes — the SB-900, SB-800, SB-600, SB-400 — along with two macro lighting ring flash setups — the R1 or R1C1 that include two SB-R200 Speedlights. You can also purchase SB-R200s for the R1 kits and the SU-800 Wireless Commander unit. All current Nikon Speedlights are part of the Nikon CLS.

This is not meant to be a definitive guide to the Nikon Speedlight system, but a quick overview of some of the flashes Nikon has to offer and their major features.

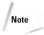 **Note** *The SB-400 cannot be used as a wireless remote.*

SB-900 Speedlight

The SB-900 Speedlight is Nikon's newest and most powerful Speedlight. This flash takes all the features of Nikon's previous flagship flash, the SB-800, and expands on

them, adding more power, a greater range, and a more intuitive user interface. You can use the SB-900 as an on-camera flash, a commander flash that can control up to three groups of external Speedlights on four channels, or a remote flash that you control from the D700 built-in flash, another SB-900, SB-800, or an SU-800 Wireless Commander. The SB-900 automatically detects whether it's attached to an FX- or DX-format camera, ensuring you get the maximum efficiency.

Image courtesy of Nikon, Inc.
6.11 The SB-900 mounted on a D700

Another new feature the SB-900 offers is a choice of three different lighting distribution options: Standard for normal photos, Center-weighted for portrait photography, and Even for evenly illuminating large groups or interior shots.

The SB-900 can also automatically identify the supplied color filters to ensure proper white balance when using the filters.

The SB-900 has a wider range of coverage than the SB-800, covering from 17-200mm in FX mode or 12-200mm in DX mode. With the built-in wide-angle flash diffuser, you can get coverage from 12-17mm in FX mode or 8-11mm in DX mode.

The SB-900 has a GN of 183 at ISO 200 and the 200mm zoom setting and can be used to light subjects as far as 70 feet away.

SB-800 Speedlight

The SB-800 can be used not only as a flash but also as a commander to control up to three groups of external Speedlights on four channels. You can also set the SB-800 to work as a remote flash for off-camera applications. The SB-800 has a built-in AF-assist Illuminator to assist in achieving focus in low light. The SB-800 has a powerful GN of 184 at ISO 200 and can be used to photograph subjects as far as 66 feet away.

The SB-800 offers a wide variety of flash modes:

- ✦ i-TTL and i-TTL Balanced Fill-Flash (i-TTL BL)
- ✦ Auto Aperture Flash
- ✦ Non-TTL Auto Flash
- ✦ Distance Priority Manual Flash
- ✦ Manual Flash
- ✦ Repeating Flash

Image courtesy of Nikon, Inc.
6.12 The SB-800

SB-600 Speedlight

The SB-600 Speedlight is the SB-900 or SB-800's little brother. This flash has fewer features than its bigger sibling but has everything you need. You can use it on the camera as well as off-camera by setting it as a remote. Like the SB-900 and SB-800, the SB-600 also has a built-in AF-assist Illuminator. The SB-600 cannot, however, be used as a commander to control off-camera flash units. The SB-600 has an impressive GN of 138 at ISO 200, which, although it gives about 1 stop less light than the SB-800, is more than enough for most subjects.

6.14 The SB-400

holding the camera vertically. For such a small flash, the SB-400 has a decent GN of 98 at ISO 200.

Caution *The SB-400 does not work wirelessly with the Nikon CLS. It only works when connected to the camera hot shoe or an off-camera hot-shoe cord.*

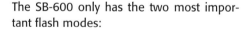

6.13 The SB-600

The SB-600 only has the two most important flash modes:

✦ i-TTL/i-TTL BL

✦ Manual

SB-400 Speedlight

The SB-400 is Nikon's entry-level Speedlight. It can only be used in the i-TTL/i-TTL BL mode. One nice feature is the horizontally tilting flash head that allows you to do bounce flash. Unfortunately, this only works when the camera is in the horizontal position, unless you bounce off a wall when

SU-800 Wireless Speedlight commander

The SU-800 is a wireless Speedlight commander that uses infrared technology to communicate wirelessly with off-camera Speedlights. It can control up to three groups of Speedlights on four different channels. The built-in flash on the D700 can control two groups on four channels, so depending on the type of photography, you may not need to use one of these on the D700 unless you have to have an extra group of flashes or you want to take advantage of the invisible infrared preflashes.

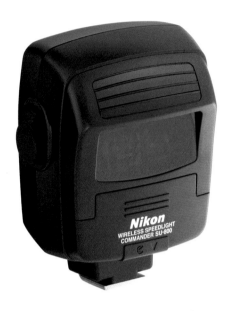

R1/R1C1 Macro flash

The R1C1 kit comes with an SU-800 wireless commander, which is the only difference between it and the R1.

The R1 set consists of a ring that attaches to the lens and SB-R200 Speedlights that attach to the ring. Ring lights are used in close-up and macro photography to provide a light that is direct or on-axis to the subject. This achieves a nice, even lighting, which can be difficult to do when the lens is close to the subject. Unlike a regular ring flash, you can move the SB-R200 Speedlights around the ring to provide different lighting patterns.

Image courtesy of Nikon, Inc.
6.15 The SU-800

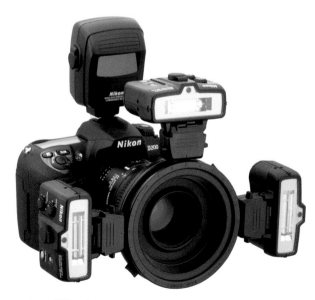

Image courtesy of Nikon, Inc.
6.16 The R1C1 mounted on the D200

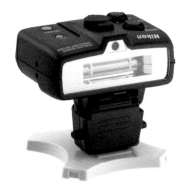

Image courtesy of Nikon, Inc.
6.17 An SB-R200

Using the Built-In Speedlight

The D700's built-in Speedlight is a handy little flash that's great for taking casual snapshots. Although it lacks the versatility of the bigger external flashes, the built-in Speedlight is always there when you need it and requires no extra batteries because it is the camera's battery powers it. Activate it by pressing the flash pop-up button on the top left of the camera (as you would hold it for shooting) near the built-in Speedlight.

The built-in Speedlight is set to i-TTL mode by default (i-TTL appears as TTL in the menu), although you can choose to set it to Manual mode (you set the output). You can also set it to Repeating flash (RPT) or Commander mode, which allows you to use it to control up to two separate groups of remote Speedlights.

You can also use it with all the sync modes your camera offers: Front-curtain sync, Rear-curtain sync, Slow Sync, and Red-Eye Reduction. To change the sync mode, press the Flash mode button located just below the Flash pop-up button. Rotating the Main Command dial while pressing the Flash mode button changes the mode. The selected mode appears in the LCD control panel.

You can also apply exposure compensation by pressing the Flash mode button and rotating the Sub-command dial.

One of the best features of the built-in Speedlight is that you can use it to wirelessly control remote units using the CLS. To take advantage of this feature, you need at least one SB-600, SB-800, SB-900, or SB-R200. Follow these steps to use the built-in Speedlight in Commander mode:

1. **Press the Menu button and use the Multi-selector to navigate to the Custom Settings menu.**

2. **Use the Multi-selector to high-light CSM e Bracketing/flash, and then press the Multi-selector right to enter the CSM e menu.**

3. **Use the Multi-selector to high-light CSM e3 Flash cntrl for built-in flash, and then press the Multi-selector right to view flash control options.**

4. **Press the Multi-selector up or down to choose Commander mode, and then press the Multi-selector right to view settings.**

5. **Press the Multi-selector up or down to choose a flash mode for the built-in flash.** You can choose M, TTL, or --. The last option (--) allows the flash to control the remotes without adding additional exposure.

6. **Press the Multi-selector right to highlight the exposure compensation setting.** Use the Multi-selector up or down to apply exposure compensation if desired. If the built-in flash is set to -- this option is not available.

7. **Use the Multi-selector to set the mode for Group A.** You can choose TTL, AA, M, or --. Press the Mutli-selector right to highlight exposure compensation. Press the Multi-selector up or down to apply exposure compensation if desired. Repeat this process for Group B.

8. **Use the Multi-selector to highlight the Channel setting.** You can choose from channels 1 to 4. These channels can be changed if you are shooting in the same area as another photographer using CLS. If you are both on the same channel, you will trigger each other's Speedlights. If you use CLS alone, it makes no difference which channel you choose.

9. **Press the OK button.** If this button is not pressed, no changes are applied.

When attempting to use wireless CLS, be sure that your remote Speedlights are set to the proper Groups and Channel. If the remotes aren't properly set, they will not fire.

Studio Strobes

Although the Nikon CLS allows you complete wireless control over lighting, it can be somewhat limited. The Speedlights are small, versatile, and portable, but they are limited in range, power, and options for accessories. Sometimes, there is no other option than to use a studio strobe, especially when lighting large subjects or when you need specific accessories to modify the light in a certain way. A studio strobe has a much higher GN than a shoe-mounted Speedlight, which means more power. Studio strobes run on AC power instead of batteries, which means faster recycle times between flashes. Also, many different accessories and light modifiers are available for studio strobes.

There are two different types of studio strobes: standard pack and monolights. Standard pack and head strobes have a separate power pack and flash heads that are controlled centrally from the power pack. Monolights are flash heads that have a power pack built in and you adjust them individually at each head. Monolights tend to be lower in power than standard strobes, but they are more portable and less expensive.

One of the downsides to using studio strobes is that you lose the advantage of i-TTL flash metering. Studio strobes are fired using a PC sync cord which runs from the PC sync terminal of the camera (or another triggering device) to the strobe, which only tells the flash when to fire, not at what output level. You must calculate all the strobe settings. Of course, there are flash meters, which are designed to read the output of the strobe to give you a reading of the proper exposure. And you can always use the handy GN / D = A formula to determine the proper exposure.

One of the plus sides of using studio strobes is the continuous modeling light. Because the strobes are only lit for a fraction of a second, studio strobes are equipped with a constant light source (called a modeling

Firing Your Studio Strobes Wirelessly

You can't use studio lighting setups completely wirelessly because you have to plug the lights in for power, and in the case of standard studio strobes, you have to not only plug in the power pack but also connect the flash heads to the power pack. For the most part, studio strobes are fired via a sync cord, which connects to the PC sync terminal on the D700, or via a hot-shoe sync device such as the Wein Safe-Sync. This is the easiest and most affordable way of firing your studio flashes. Most monolights have a built-in optical sensor that allows the flash to be triggered by another flash. Most standard studio strobe power packs can also be fitted with an optical sensor. This allows you some freedom from the wires that connect your camera to the main flash unit.

More and more photographers these days use radio triggers. Radio triggers use a radio signal to fire the strobes when the shutter is released. Unlike the optical sensor, the radio trigger is not limited to "seeing" another flash to make it fire. Radio triggers can also fire from long distances and can even work from behind walls and around corners. Radio triggers have two parts: the transmitter and the receiver. The transmitter is attached to the camera and tells the receiver, which is connected to the strobe, to fire when the Shutter Release button is pressed. Some newer radio units are transceivers, meaning they're able to function as a transmitter or a receiver (not at the same time, of course) but you still need at least two of them to operate. Radio triggers work very well and free you from being directly attached to your lights, but they can be very expensive. There are a few different manufacturers but the most well known is Pocket Wizard. Pocket Wizard transceivers are fairly pricey, but they are built well and extremely reliable. Recently, there has been a proliferation of radio transmitters and receivers on eBay that are priced very low. I can't attest to how well they work, but a lot of folks on the Internet seem to like them. At around $30 for a kit with one receiver and one transmitter, you won't be losing much if it doesn't work well. Currently, I use the Smith Victor RTK4 radio triggers that I bought from Smith Victor for around $80. I chose this set because I am familiar with the Smith Victor product line and own a few Smith Victor monolights. The Smith Victor RTK4 radio triggers work well; I feel confident recommending them.

light) that allows you to see what effect the strobe is going to have on the subject, although the modeling light isn't necessarily consistent with the actual light output of the flash tube.

When looking for a studio lighting setup, you have thousands of different options. There are a lot of reputable manufacturers offering a lot of different types of lights. Your only limit really is the amount of money you want to spend.

Note *The SB-900, SB-800, SB-600, SB-R200, and built-in flash can be used with the camera's modeling light feature that uses a burst of low power flashes to show where the shadows fall. This, however, isn't a continuous light. The modeling light feature can be set in CSM e4, which allows the modeling light to be shown when the Depth-of-field preview button is pressed and a compatible Speedlight is attached or the built-in flash is up.*

Standard studio strobes are the most powerful and most expensive option. With the standard strobes, you can usually attach up to six flash heads to the power pack, which provides a lot of lighting options. Of course, one power pack and two lights cost about $1,000 to start, not including stands, lighting modifiers (which I cover later in this chapter), and other accessories. If you opt for studio strobes, reputable manufacturers include Speedotron, Dyna-lite, and Profoto.

A more economical approach is to use monolights. Most of the manufacturers that make standard strobes also make monolights. Although they are lower in power than strobes that are powered by a power pack, they are also far more portable because they are lighter and smaller in size. You can outfit monolights with the same light modifiers as the bigger strobe units. I recommend going this route when purchasing lights for a small or home studio setup.

Flash Alternatives

There is a growing movement of amateur photographers who are using non-dedicated hot-shoe flashes to light their subjects. This movement is based on getting the flash off of the camera to create more professional-looking images (such as those you get when using studio lights), but is also centered on not spending a lot of money to achieve these results.

Basically, what these folks, called *Strobists,* are saying is that you don't need big expensive studio lights or expensive dedicated flashes to achieve great images that look like they were lit by a professional.

Small hot-shoe flashes are extremely portable and are powered by inexpensive AA batteries. You can find older-model flashes that don't have all of the bells and whistles of the newer models at reasonable prices.

To get started with off-camera flash, you need a flash with two things: a PC sync terminal and a manual output power setting. If your flash doesn't have a PC sync terminal, you can buy a hot-shoe adaptor that has one on it. This adaptor slides onto the shoe of your flash and has a PC terminal on it that syncs with your flash.

The best flashes to use for this are the older Nikon Speedlights from the mid-1980s to the mid-90s: the SB-24, SB-25, SB-26, and SB-28 Speedlights. These flashes are available at a fraction of the cost of the newer i-TTL SB-800 or SB-600. Unfortunately, with a greater number of people using the Strobist technique, the prices have increased a bit.

Given the number of people now using small hot-shoe flashes off-camera, manufacturers are making accessories to attach these flashes to stands and other accessories to allow light modifiers to be added to them.

To learn more about the Strobist technique and find many tricks and tips, go to http://strobist.blogspot.com/.

You can get a complete setup with two 200-watt-second (ws) monolights (that's 400ws of combined power) with stands, umbrellas, and a carrying case for around $500; that's only a little more than you would pay for a 400ws power pack alone.

When equipping your home or small studio with studio lighting, I recommend starting out with at least two strobes. With this setup, you can pretty easily light almost any subject. A three-light setup is ideal for most small home studios, with two lights for lighting the subject and one light for illuminating the background.

For those of you with a more limited budget, you can still achieve some excellent results using a single strobe head, especially when going for moody low-key lighting. The late Dean Collins was a skilled photographer and a master at lighting who could light some amazing scenes with just one strobe. I highly encourage anyone who is interested in photographic lighting to view some of his instructional videos.

Continuous Lighting

Continuous lighting is just what it sounds like: a light source that is constant. It is by far the easiest type of lighting to work with. Unlike natural lighting, continuous lighting is consistent and predictable. Even when using a strobe with modeling lights, you sometimes have to estimate what the final lighting will look like. Continuous lighting is "what you see is what you get." You can see the actual effects the lighting has on your subjects, and can modify and change the lighting before you even press the Shutter Release button.

Continuous lights are an affordable alternative to using studio strobes. Because the light is constant and consistent, the learning curve is also less steep. With strobes, you need to experiment with the exposure or use a flash meter. With continuous lights, you can use the D700's Matrix meter to yield excellent results.

As with other lighting systems, there are a lot of continuous light options. Here are a few of the more common ones:

✦ **Incandescent.** Incandescent, or tungsten, lights are the most common type of lights. Thomas Edison invented this type of light: Your typical light bulb is a tungsten lamp. With tungsten lamps, an electrical current runs through a tungsten filament, heating it and causing it to emit light. This type of continuous lighting is the source of the name "hot lights."

✦ **Halogen.** Halogen lights, which are much brighter than typical tungsten lights, are actually very similar. They are considered a type of incandescent light. Halogen lights also employ a tungsten filament, but include a halogen vapor in the gas inside the lamp. The color temperature of halogen lamps is higher than the color temperature of standard tungsten lamps.

✦ **Fluorescent.** Fluorescent lighting, which most of you are familiar with, is everywhere these days. It is in the majority of office buildings, stores, and even in your own house. In a fluorescent lamp, electrical energy changes a small amount of mercury into a gas. The

electrons collide with the mercury gas atoms, causing them to release photons, which, in turn, causes the phosphor coating inside the lamp to glow. Because this reaction doesn't create much heat, fluorescent lamps are much cooler and more energy efficient than tungsten and halogen lamps. These lights are commonly used in TV lighting.

✦ **HMI.** HMI, or Hydrargyrum Medium-Arc Iodide, lamps are probably the most expensive type of continuous lighting. The motion picture industry uses this type because of its consistent color temperature and the fact that it runs cooler than a tungsten lamp with the same power rating. These lamps operate by releasing an arc of electricity in an atmosphere of mercury vapor and halogenides.

Incandescent and halogen

Although incandescent and halogen lights make it easier to see what you're photographing and cost less, there are quite a few drawbacks to using these lights for serious photography work. First, they are hot. When a model has to sit under lamps for any length of time, he will get hot and start to sweat. This is also a problem with food photography. It can cause your food to change consistency or even to sweat; for example, cheese that has been refrigerated. On the other hand, it can help keep hot food looking fresh and hot.

Second, although incandescent lights appear to be very bright to you and your subject, they actually produce less light than a standard flash unit. For example, a 200-watt tungsten light and a 200-watt-second strobe use the same amount of electricity per second, so they should be equally bright, right? Wrong. Because the flash discharges all 200 watts of energy in a fraction of a second, the flash is actually much, much brighter. Why does this matter? Because when you need a fast shutter speed or a small aperture, the strobe can give you more light in a shorter time. An SB-600 gives you about 30 watt-seconds of light at full power. To get an equivalent amount of light at the maximum sync speed of 1/250 second from a tungsten light, you would need a 7500-watt lamp! Of course, if your subject is static, you don't need to use a fast shutter speed; in this case, you can use one 30-watt light bulb for a 1-second exposure or a 60-watt lamp for a 1/2-second exposure.

Other disadvantages of using incandescent lights include

✦ **Color temperature inconsistency.** The color temperature of the lamps changes as your household current varies and as the lamps get more and more use. The color temperature may be inconsistent from manufacturer to manufacturer and may even vary within the same types of bulbs.

✦ **Light modifiers are more expensive.** Because most continuous lights are hot, modifiers such as softboxes need to be made to withstand the heat; this makes them more expensive than the standard equipment intended to be used for strobes.

✦ **Short lamp life.** Incandescent lights tend to have a shorter life than flash tubes, so you'll have to replace them more often.

Although incandescent lights have quite a few disadvantages, they are by far the most affordable type of lights you can buy. Many photographers who are starting out use inexpensive work lights they can buy at any hardware store for less than $10. These lights use a standard light bulb and often have a reflector to direct the light; they also come with a clamp you can use to attach them to a stand or anything else you have handy that might be stable.

Halogen work lamps, also readily available at any hardware store, offer a higher light output than a standard light, generally speaking. The downside is they are very hot, and the larger lights can be a bit unwieldy. You also may have to come up with some creative ways to get the lights in the position you want them. Some halogen work lamps come complete with a tripod stand. If you can afford it, I'd recommend buying these; they're easier to set up and less of an aggravation in the long run. The single halogen work lamps that are usually designed to sit on a table or some other support are readily available for less than $20; the double halogen work lamps with two 500-watt lights and a 6-foot tripod stand are usually available for less than $40.

If you're really serious about lighting with hot lights, you may want to invest in a photographic hot-light kit. These kits are widely available from any photography or video store. They usually come with lights, light stands, and sometimes with light modifiers such as umbrellas or softboxes for diffusing the light for a softer look. The kits can be relatively inexpensive, with two lights, two stands, and two umbrellas for around $100. Or you can buy much more elaborate setups ranging in price up to $2,000. I've searched the Internet for these kits and have found the best deals are on eBay.

Fluorescent

Fluorescent lights have a lot of advantages over incandescent lights; they run at much lower temperatures and use much less electricity than standard incandescent lights. Fluorescent lights are also a much softer light source than incandescent lights.

In the past, fluorescent lights weren't considered viable for photographic applications because they cast a sickly green light on the subject. Today, most fluorescent lamps for use in photography are color corrected to match both daylight and incandescent lights. Also, given white balance is adjustable in the camera or in Photoshop with RAW files, using fluorescents has become much easier because you don't have to worry about color-correcting filters and special films.

These days, because more people are using fluorescent lights, light modifiers are more readily available. They allow you to control the light to make it softer or harder and directional or diffused.

Fluorescent light kits are readily available through most photography stores and online. These kits are a little more expensive than the incandescent light kits — an average kit with two light stands, reflectors, and bulbs costs about $160. Fluorescent kits aren't usually equipped with umbrellas or softboxes because the light is already fairly

soft. You can buy these kinds of accessories and there are kits available that come with softboxes and umbrellas, although they cost significantly more.

Unfortunately, there aren't many low-cost alternatives to buying a fluorescent light kit. The only real option is to use the clamp light I mentioned in the section about incandescent light and fit it with a fluorescent bulb that has a standard bulb base on it. These types of fluorescent bulbs are readily available at any store that sells light bulbs.

HMI

This type of continuous light is primarily used in the motion picture industry. HMI lamps burn extremely bright and are much more efficient than standard incandescent, halogen, or fluorescent lights. The light emitted is equal in color temperature to that of daylight.

Although I include them here for general information, these kits are usually too cost-prohibitive for use in average still-photography applications. A one-light kit with a 24-watt light can start at more than $1,000. An 18,000-watt kit can cost more than $30,000!

Light Modifiers

Light modifiers do exactly what their name says they do: They modify light. When you set up a photographic shot, in essence, you are building a scene using light. For some images, you may want a hard light that is very directional; for others, a soft, diffused light works better. Light modifiers allow you to control the light so you can direct it where

you need it, give it the quality the image calls for, and even add color or texture to the image.

Umbrellas

The most common type of light modifier is the umbrella. Photographic umbrellas are coated with a material to maximize reflectivity. They are used to diffuse and soften the light emitted from the light source, whether it's continuous or strobe lighting. There are three types of umbrellas to choose from:

✦ **Standard.** The most common type of umbrella has a black outside with the inside coated with a reflective material that is usually silver or gold in color. Standard umbrellas are designed so you point the light source into the umbrella and bounce the light onto the subject, resulting in a non-directional soft light source.

✦ **Shoot-through.** Some umbrellas are manufactured out of a one-piece translucent silvery nylon that enables you to shoot through the umbrella like a softbox. You can also use shoot-through umbrellas to bounce the light as I previously mentioned.

✦ **Convertible.** This umbrella has a silver or gold lining on the inside and a removable black cover on the outside. You can use convertible umbrellas to bounce light or as a shoot-through when you remove the outside covering.

Photographic umbrellas come in various sizes, usually ranging from 27 inches all the way up to $12\frac{1}{2}$ feet. The size you use

depends on the size of the subject and the degree of coverage you want. For standard headshots, portraits, and small to medium products, umbrellas ranging from 27 inches to about 40 inches supply plenty of coverage. For full-length portraits and larger products, a 60- to 72-inch umbrella is generally recommended. If you're photographing groups of people or especially large products, you'll need to go beyond the 72-inch umbrella.

The larger the umbrella is, the softer the light falling on the subject from the light source. It is also the case that the larger the umbrella is, the less light you have falling on your subject. Generally, the small to medium umbrellas lose about a stop and a half to 2 stops of light. Larger umbrellas generally lose 2 or more stops of light because the light is being spread out over a larger area.

Smaller umbrellas tend to have a much more directional light than larger umbrellas. With all umbrellas, the closer your umbrella is to the subject, the more diffuse the light is.

Choosing the right umbrella is a matter of personal preference. Features to keep in mind when choosing your umbrella include the type, size, and portability. You also want to consider how they work with your light source. For example, regular and convertible umbrellas return more light to the subject when light is bounced from them, which can be advantageous, especially if you are using a Speedlight, which has less power than a studio strobe. Also, the less energy the Speedlight has to output, the more battery power you save. On the other hand, shoot-through umbrellas lose more light through the back when bouncing, but they are generally more affordable than convertible umbrellas.

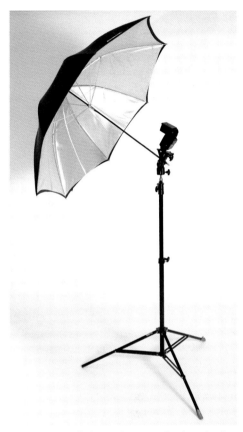

6.18 A Speedlight with a standard umbrella

Softboxes

Softboxes, as with umbrellas, are used to diffuse and soften the light of a strobe or continuous light to create a more pleasing light source. Softboxes range in size from small, 6-inch boxes that you mount directly onto the flash head, to large boxes that usually mount directly to a studio strobe.

The reason you may want to invest in a softbox rather than an umbrella for your studio is that it provides a more consistent and controllable light than an umbrella does.

Softboxes are closed around the light source, thereby preventing unwanted light from bouncing back onto your subject. With the diffusion material, there is less of a chance of creating hotspots on your subject. A hotspot is an overly bright spot usually caused by bright or uneven lighting.

Softboxes are generally made for use with studio strobes and monolights, although special heat-resistant softboxes are made for use with hot lights. Softboxes attach to the light source with a device called a speedring. Speedrings are specific to the type of lights to which they are meant to attach. If you are using a standard hot-shoe flash as your light source, some companies, such as Chimera (www.chimeralighting.com), manufacture a type of speedring that mounts directly to the light stand and allows you to attach one or more Speedlights to the light stand, as well. You mount the speedring to the stand, attach the softbox to the speedring, attach the Speedlight with the flash head pointed into the softbox, and you're ready to go.

Softboxes are available in a multitude of shapes and sizes, ranging from squares and rectangles to ovals and octagons. Most photographers use the standard square or rectangular softboxes. However, some prefer to use oval or octagonal softboxes because they mimic umbrellas and give a more pleasing round shape to the catchlights in the subject's eyes. This is mostly a matter of personal preference. I usually use a medium-sized, rectangular softbox.

As with umbrellas, the size of the softbox you need depends on the subject you are photographing. You can take most softboxes apart and fold them up, and most of them come with a storage bag that you can use to transport them.

6.19 A softbox

Diffusion panels

A diffusion panel is basically a frame made out of PVC pipe with reflective nylon stretched over it. Diffusion panels function similarly to a softboxes, but you have a little more control over the quality of the light.

Diffusion panels are usually about 6 feet tall and have a base that allows them to stand without a light stand. You place the diffusion panel in front of the subject. You then place your light source behind the diffusion panel. You can move the light closer to the diffusion panel for more directional light or farther away for a softer, more even light. For a full-length portrait or a larger subject, you can place two or more lights behind the panel, achieving greater coverage with your lights.

6.20 A diffusion panel

You can use a diffusion panel as a reflector, bouncing the light from your light source on to the subject. You can purchase diffusion panels at most major camera stores at a fraction of the price of a good softbox. You can disassemble the PVC frame easily and pack it away into a small bag for storage or transport to and from location.

Tip *If you're feeling crafty, you can make a diffusion panel from items easily found in your local hardware and fabric stores. Numerous sites on the Internet offer advice on how to construct one.*

Other light modifiers

There are many different types of light modifiers. The main types — umbrellas, softboxes, and diffusion panels — serve to diffuse the light by effectively increasing the size of the light source, thereby reducing contrast. In addition to softboxes and such, other types of light modifiers, such as barn doors and snoots, are worth considering. They are also used to control the direction of the light to make it appear stronger or to focus it on a specific area of the subject. The following list includes some of the more common tools photographers use to direct the light from the light source:

✦ **Parabolic reflectors.** Most light sources come equipped with a parabolic reflector. They usually range from 6 to 10 inches in circumference although you can buy larger ones. Without a reflector, the light from the bare bulb, whether it's a flash tube or an incandescent, scatters and lacks direction, resulting

in the loss of usable light. The reflector focuses the light into a more specific area, actually increasing the amount of usable light by 1 or 2 stops. Parabolic reflectors are commonly used in conjunction with other light modifiers, including umbrellas, barn doors, and grids. When you use an umbrella, you'll always use a reflector to direct the light into the umbrella, which diffuses the light. Using only a reflector gives the light a very hard quality that results in a lot of contrast.

✦ **Barn doors.** Barn doors are used to control the direction of light and to block stray light from entering the lens, which can result in lens flare. Blocking the light is also known as flagging. Barn doors are normally attached to the reflector and come in two types — 4-leaf and 2-leaf. Barn doors consist of panels that are attached to hinges, which allow you to open and close the doors to let light out or keep it in. Typically, barn doors are used when you want a hard light source to shine on a specific area of the subject but you don't want any stray light striking other parts of the subject or the camera lens.

✦ **Grids.** Grids, also known as grid spots or honeycombs, are used to create a light similar to a spotlight. A grid is a round disc with a honeycomb-shaped screen inside of it. When the light shines through it, it is focused to a particular degree, giving you a tight circle of light with a distinct fall-off at the edges. There are different types of grids that con-

trol the spread of light. They run from a 5-degree grid to a 60-degree grid. The 5-degree grid has very small holes and is deep so the light is focused down to a small bright spot. The higher the degree of the grid spot, the more spread out the spot becomes. Grids fit inside of the reflector, just in front of the lamp or flash tube. They are great to use as hair lights and to add a spot of light on the background to help the subject stand out.

✦ **Snoots.** A snoot creates a spotlight-like effect similar to the grid. A snoot is shaped like a funnel and it kind of works that way, too, funneling light into a specific area of the scene. The snoot usually has a brighter spot effect than a grid does. The snoot fits directly over the flash head.

✦ **Reflector.** This type of reflector doesn't directly modify the light coming from the light source, but it is used to reflect light onto the subject. Reflectors are usually white or silver, although some can be gold. Professional reflectors are usually round or oval disks with wire frames that can be easily folded up to a smaller size. You can make your own reflector by using white foam board available at any art supply store and at some photography stores. You can use the white board alone or cover it with silver or gold foil. In a pinch, almost anything white or silver, such as a lid from a Styrofoam cooler or even a white T-shirt, will work.

✦ **Gobos.** A gobo can be anything that "goes between" the light source and the subject or background, often to create a pattern or simulate a specific light source, such as a window. It is usually attached to a stand and placed a few feet in front of the light source.

A common technique in film noir–type photography is to place venetian blinds between a light and the background to simulate sunlight shining through the blinds of the office window of a private eye. You can make gobos or purchase them from a photographic supply house.

Advanced Shooting Techniques

In this chapter, I provide in-depth details of different types of photography with example images of each. These details include information about what lenses and accessories were used and why I used them, as well as any problems I encountered and what I did to resolve or work around them.

Many of the images represent different techniques that you can use to create dynamic and interesting images of your own. This isn't meant to be an all-inclusive how-to photography guide, but a collection of tricks, tips, and techniques that I have learned by working in the field and also working with other photographers.

Action and Sports Photography

Although the high frame rate of 5 frames per second (fps) — 8 with the optional battery grip — of the D700 comes in handy when you're shooting action and sports, often the best approach with shooting action is to get familiar with the movement of the subject, learn when the action is at its peak, and then take your shot.

You can employ a number of different techniques to decrease motion blur on your subject. The most commonly used technique is panning. Panning is following the moving subject with your camera lens. With this method, it is as if the subject is not moving at all because your camera is moving with it at the same speed. When panning is done correctly, the subject

should be in sharp focus while the motion blurs the background. This effect is great for showing the illusion of motion in a still photograph. While panning, you can sometimes use a slower shutter speed to exaggerate the effect of the background blur. Panning can be a very difficult technique to master and requires a lot of practice.

For figure 7.1 I used a monopod and I panned along with this formula car that was blazing by me on a straightaway at about 150 miles per hour. I used a relatively slow shutter speed of 1/100 second to get the background to turn into a complete blur. Generally when doing this type of work, I would use a shutter speed of about 1/320 second, which creates less blur but provides more consistent results. Attempting to do

panning shots with shutter speeds slower than this gives you a higher number of images where the subject is blurred.

For shots like this one, I generally use Center-weighted metering and Shutter Priority mode. I set the autofocus (AF) to Continuous AF (AF-C) and I use Single-point AF at the center point. When you're photographing at the racetrack, even when you're down in the "hot" areas of the track, you need a long telephoto lens. For this shot, I was using a Nikkor 80-20mm f/2.8 with a 1.4X teleconverter to get some extra reach.

Tip Consider using a monopod, which is a one-legged support, when trying the panning technique. Monopods help keep the camera steady while giving you more freedom of movement than a tripod.

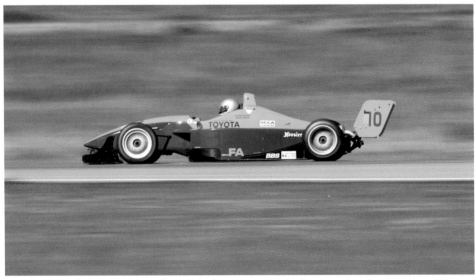

7.1 An example of panning with a slow shutter speed to show motion in an action shot

Techniques

Using flash for action and sports photography is not always necessary or advisable. Sometimes you are so far away from the action, your flash won't be effective, or you are in a situation where flash is not allowed. In these cases, just make sure you have a fast enough shutter speed to freeze the motion. You can either use a wider aperture or higher ISO setting to be sure you get the proper shutter speed.

That being said, sometimes you can use flash to make your action photos more dynamic. When you use flash in conjunction with a slower shutter speed and pan with your subject, you can create amazing images in which the backgrounds blur and bleed into a sharply frozen subject.

Another technique you can use is to adjust the Flash Exposure Compensation (FEC) up a couple of stops to overexpose your subject while adjusting the exposure to a setting that underexposes the background. This makes your subject seem to "pop" out of the image and gives your background deep saturated colors.

For figure 7.2, I was at the 9th Street dirt jumps in Austin, Texas, which is a world-famous spot that attracts BMX riders of all skill levels, from amateur to professional. At any given time, you can usually find a skilled rider pulling some sick tricks. It's difficult to shoot at 9th Street. The jumps are under the cover of trees so the light is fairly dim and you're generally shooting up into the canopy of the trees. The background is very mottled, because extreme bright spots of sky show through the dark leafy tree branches. For

this reason, it's almost a necessity to use a flash to separate the rider from the background. Shooting without a flash gives you an image where the rider blends in with the foliage.

For this shot, I used a three flash setup: one SB-900 on-camera as a commander flash and two SB-800s off-camera mounted on light stands. I positioned the SB-800 left, in between the takeoff and the landing, and aimed up to where the rider would be in the air. I placed a second SB-800 on the opposite side of the jump directly across from the first SB-800 and in the same fashion. If you look closely to the left of the jump, you can see it as a bright spot in the background.

Initially I had the SB-900 set up to Commander mode using the Advanced Wireless Lighting of the Creative Lighting System (CLS) to control the off-camera SB-800s, with each one set to a different group in Through-the-Lens (TTL) mode. I found that the CLS was creating a shutter lag due to the Speedlight communications, and I was missing the peak of the action. It's absolutely necessary to have perfect timing on these types of shots or you miss the zenith of the trick.

To counteract this problem, I went another route. I realized that to get the shutter to release immediately, I needed to use the Speedlights in full Manual mode (M). Using the GN / D = A formula, I estimated the proper settings (1/2 power for the SB-800 across the way and 1/4 power for the one camera left). I then switched the SB-800s to SU-4 mode; this allows another flash to trigger the Speedlights instantly. I set the SB-900 to M and dialed in the power to

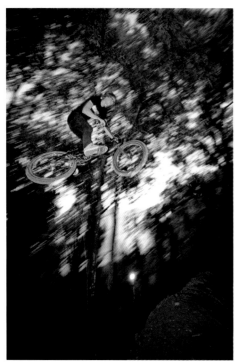

7.2 Using flash to get the subject to "pop"

1/16. I didn't want the on-camera Speedlight to contribute much to the exposure; I just wanted it to trigger the remote flashes. This solved my shutter lag problem, allowing me to catch the jump at the peak.

As far as camera settings, I wanted to use a slow shutter speed to let some of the ambient light in given it was dusk and very dark under the trees (this technique is known as dragging the shutter or shutter drag). If I used a faster shutter speed, the rider would look as though he were flying through a black hole. A slower shutter speed also allowed me to capture some motion blur as I panned along with the rider. I set the camera to M and the exposure settings at 1/40 at f/5 ISO 200.

I set the AF to AF-C and Dynamic-area AF to –9 points. This allowed me to keep the rider continuously in focus as I panned along with him, and the other points around the selected AF point kept the focus on him if he left the selected focus point.

I used an ultra-wide Sigma 12-24mm lens to give the image some perspective distortion, adding an interesting effect. Using this ultra-wide lens makes it look like I'm standing farther away from the action than I really am; the rider was actually only a couple of feet from my lens. Lens choice can have a great effect on the impact of your image. Wide-angle lenses can add some great flare to your photos, but you need to be extremely careful when getting this close to the action. I've had a few riders and bikes crash into my Speedlights and it can be an expensive fix. Luckily I haven't had anyone crash into my camera or lens.

Caution *Being a BMX rider myself and a 9th Street local, I have an "in" with the riders, but if you just show up and start snapping away, some people might get angry. It's always best to ask your subjects if they mind being photographed before snapping photos of them. If you are planning on setting up flashes, you must ask first. Some people don't like the flashes; it can distract or even momentarily blind them, leading to disastrous results.*

Tip *If you're planning on publishing your images, you will want to get your subject to sign a release form. I recommend carrying some of these in your camera bag. Sample release forms can be found on the Internet.*

For figure 7.3, I used flash to light Darin on his skateboard, but I also kept the background in mind when choosing my settings. Although it was nearing dusk, there was still enough light in the sky to give it a normal dull-blue appearance. I was looking to get a very dynamic image and I wanted to underexpose the background to make the skies more punchy and to give the image a darker nighttime appearance.

I first set my camera to spot meter. I then aimed the lens at the brightest spot in the sky, which was just over the horizon. I took the reading, then I subtracted two stops from it, and I had the exposure I was looking for, which was 1/60. This is a relatively slow shutter speed for action shots, but I wasn't worried because I was using a Speedlight. The short duration of the flash is often enough to freeze your subject in motion.

I used two flashes to achieve this shot: the D700 built-in flash as a commander and an SB-800 as a remote. I set the built-in flash to Commander in Custom Settings menu (CSM) e3; I set the mode to "--" so that the Commander wouldn't add any exposure; and I set Group A (the built-in flash can control two groups of remotes, Group A and/or Group B) to TTL. Next I set the SB-800 to function as a remote on Group A and used the AS-19 Speedlight stand to hold it. I positioned the SB-800 on the lip of the ramp, near the center off to the left of the camera. I used the built-in wide-angle diffuser to soften the light just a bit and to give flash a little more coverage.

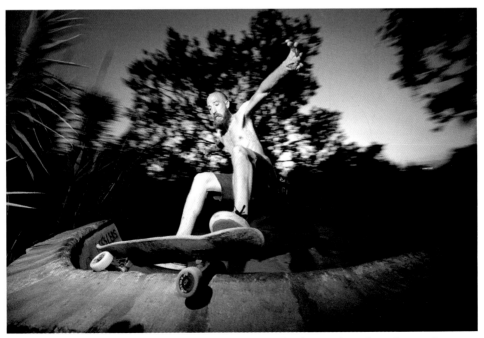

7.3 Overexposing the subject and underexposing the background can have interesting results.

The first couple of shots I took with straight TTL weren't quite bright enough to make Darin really stand out, so I adjusted the FEC in the Commander mode menu to +2 exposure value (EV). This gave me just the amount of light that I was looking for, overexposing my subject a bit.

When setting up for this shot, I knew I wanted an extreme perspective distortion to give the image more impact. Initially I started out with a 16mm f/2.8 fisheye lens by Zenitar. Although the fisheye effect was good, I felt that I wanted to go wider and I didn't want that much barrel distortion. I selected the Sigma 12-24mm lens and set it to its widest setting of 12mm (the widest lens ever made for an FX camera). To get the extreme perspective distortion I was looking for, I had to get really close. I put my lens very near to the coping and hoped that Darin wouldn't slip, sending the skateboard into my camera (and face). When I took this shot, that skateboard wheel was literally 6 inches in front of my lens.

As I was taking the shot, I panned with Darin just a bit to add a small amount of motion blur to the background.

When looking for action scenes to shoot, I tend to gravitate toward the more exciting and edgy events. You may find you favor more low-key action events, but regardless of what appeals to you, just keep your eyes open. Nearly everywhere you look, some kind of action is taking place.

Action and sports photography tips

✦ **Practice panning.** Panning can be a difficult technique to master, but practice makes perfect. The more time you spend practicing it, the better you (and your images) will get.

✦ **Pay attention to your surroundings.** Often when concentrating on getting the shot, you can forget that there are things going on around you. When photographing sporting events, be sure to remember that there may be balls flying around or athletes on the move. It's better to miss a shot than it is to get hurt in the process of trying to get it.

✦ **Know the sport.** In order to be able to effectively capture a definitive shot, you need to be familiar with the sport, its rules, and the ebb and flow of the action. You'll be able to get better shots if you can predict where the action will peak rather than simply hope you will luck into one.

Architectural Photography

Buildings and structures surround us, and many architects pour their hearts and souls into designing buildings that are interesting to the casual observer. This may be why architectural photography is so popular.

Copyright and Permission

In most places, you don't need permission to photograph a building as long as it's a place to which the public has free access. If you are on private property, you should definitely request permission to photograph before you start. If you are inside a building, it is generally a good idea to ask permission before photographing, as well.

Due to recent tightening of security policies, a lot of photographers have been approached by security and/or police, so it's a good idea to check the local laws in the city where you are photographing to know what rights you have as a photographer.

For the most part, copyright laws allow photography of any building on "permanent public display." Although the architect of the structure may own the copyright of the design, it usually does not carry over to photographs of the building. There are exceptions to this, so again, check local laws, especially if you plan on selling your images.

Perspective

Despite the fact that buildings are such familiar, everyday sights, photographing them can be technically challenging and difficult — especially when you're taking pictures of large or extremely tall buildings. A number of different problems can arise, the main one being perspective distortion. Perspective distortion is when the closest part of the subject appears irregularly large and the farthest part of the subject appears abnormally small. Think about standing at the bottom of a skyscraper and looking straight up to the top.

Professional architectural photographers use view cameras with swings and tilts that allow them to adjust the film plane and lens to correct for the distortion. Nikon has three special purpose lenses that deal with perspective control in a similar fashion as view cameras, by allowing the lens to shift and tilt. The wide-angle PC-E Nikkor 24mm f/3.5D is the most useful one for architectural photography.

 For more information on Perspective Control lenses, see Chapter 4

Nikon has made Perspective Control (PC) lenses for many years, but the early models didn't allow for tilts, only shifts. The lens I used to photograph figures 7.4 and 7.5 is a Nikkor 28mm f/3.5 PC. It is completely manual, including the focusing and aperture control. Due to the lens design, the aperture must be opened up to focus and closed down before you press the Shutter Release button.

Perspective distortion occurs when you tilt the lens to an upward angle to fit both the top and the bottom of the building into the frame. When the camera is tilted this way, the image sensor is no longer on the same plane as the building, causing the lines to converge. Shifting the lens up allows you to capture the top of the building while keeping the sensor plane parallel with the building. Instead of tilting the lens up, you shift the lens up.

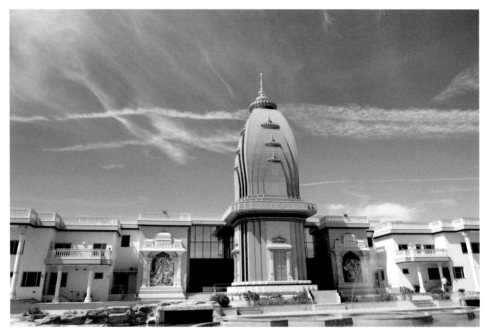

7.4 Using a standard 28mm lens to photograph this building gives it the illusion that it's tipping over.

7.5 Using a 28mm shift lens to photograph this building allowed me to control the perspective distortion, making the building appear straight.

For figure 7.6, perspective distortion wasn't much of a problem. Because the building wasn't very tall and I could get some good distance from it, I was able to photograph it with a standard 12-24mm wide-angle lens without any problems.

I chose to use a long exposure to capture the ambient light of the building and sky. The sky is a deep reddish-orange color from the light pollution in downtown Austin, which is a block away. For this shot, I used Live View and manually focused the lens. I used a small aperture of f/16 to maximize the depth of field and to increase my shutter speed, which was 30 seconds long. Of course, I also used a tripod.

For figure 7.7, I went the opposite direction of the previous architectural images. I specifically introduced perspective distortion to give the photo a wacky flavor, just like the Texas town of Luckenbach. For this shot I used a Sigma 12-24mm ultra-wide lens zoomed to the 24mm setting. The exposure

was 1/320 at f/5.6 ISO 500. I used Matrix metering and Single AF mode using a single AF point. I used the Vivid Picture Control to give the image some interesting vibrancy in the colors.

Architectural photography tips

✦ **Shoot from a distance.** When taking pictures of tall buildings and skyscrapers, try not to take your photograph too close to the base of the building. The perspective distortion can make the structure look abnormal.

✦ **Avoid backlighting.** If the building you are photographing is backlit, you will lose detail in the structure and the background will appear too bright. Try to take your picture when the sun is shining on the part of the building you want to photograph.

7.6 The Long Center for Performing Arts in Austin, Texas

7.7 The U.S. Post Office in Luckenbach, Texas

✦ **Be aware of lens distortion.**
Different lenses can introduce distortion. Wide-angle lenses often suffer from barrel distortion; this can cause the straight lines of the structure that are near the edge of the frame to appear bowed out. Either avoid placing straight lines near the edge of the frame or be sure to correct for the distortion in post-processing.

Concert Photography

Doing concert photography can be both difficult and extremely rewarding, especially if you're a music fan. Getting that quintessential shot of your favorite performer is the reason why many photographers do this type of photography. However, sometimes to get the shot, you have to fight a crowd or get drinks spilled on your camera. Of course, if you're someone who likes to get into the fray, this is great fun.

Tip *I strongly suggest that you invest in good earplugs if you plan to do much of this type of photography.*

A good way to get started with concert photography is to find out when your favorite band or performer is playing and bring your camera. Smaller clubs are usually better places to take good up-close photos, simply because you are more likely to have closer access to the stage. Most local bands, performers, and regional touring acts don't mind

having their photos taken. Offer to e-mail them some images to use on their Web site. This is beneficial for both them and you, as lots of people will see your photos.

> **Note** *Some venues or performers do not allow flash photography at all. In this situation, just try to use the lowest ISO you can while still maintaining a fast enough shutter speed.*

Techniques

With most concert photography, the lighting comes from the stage lights. If you're shooting at a larger venue or concert, typically the stage lighting is all you need, and you can get amazing images using low ISO settings. The stage lighting engineers are paid to make the performers look good; you essentially piggy-back off their expertise, and focus on the composition. For image 7.8, the Supersuckers were playing at a fairly large venue, but the lighting wasn't the best or the brightest. I had to crank up the ISO to 3200. With previous cameras I've owned, this would have rendered the shots barely usable, but not with the D700. At ISO 3200, D700 images are perfectly usable and amazingly low in noise. This was one of the few times that I have used the Auto ISO feature. I knew I needed to hit ISO 3200 for some shots, but not all of them. I didn't want to waste time switching ISO settings throughout the show, so I set the ISO sensitivity auto control to On, the maximum sensitivity to 3200, and the minimum shutter speed to 1/250. You can set the Auto ISO in the Shooting menu under the ISO sensitivity settings option. Using a minimum shutter speed of 1/250 allowed me to freeze the action of the band members so the images weren't blurry.

7.8 Ron Heathman, lead guitarist for the Supersuckers

For these types of lighting situations, I use Spot metering to set the exposure for the performer because I'm not concerned about the background. When you lose detail in the background, it emphasizes the subject of the image much better.

I use a Nikkor 28-70mm f/2.8 lens to capture all the light that I could to keep my shutter speeds up and ISO levels down. Having a fast lens of 2.8 or better is almost a necessity. If your aperture isn't wide enough for you to get a fast enough shutter speed to freeze motion, you're sunk. Vibration Reduction (VR) can't bail you out because VR only counters the effects of camera shake. The 28-70mm lens is a moderately wide to short telephoto lens that

is great for most shooting situations: It allows you to go wide and gives you a little reach if you need it. I shot this image at a focal length of 70mm for 1/250 at f/2.8. I used a single AF point in the center of the frame and set the AF to continuous.

Figure 7.9 represents one of the easiest scenarios to shoot in concert photography. Daytime shows are great for capturing super-sharp images. Usually the performer is underneath the cover of an amphitheatre, the stage lights fill in the shadows, and the light is nicely diffused. Conversely, the lighting can lack the drama that a hard directional spotlight adds to an image.

For this shot, I used Matrix metering to keep the background in control and not blow out the highlights. The exposure was 1/1250 at f/2.8 ISO 200. I used Aperture Priority mode because I wanted a shallow depth of field to blur the background, letting the performer stand out from the background.

Although this event had a photo pit right in front, the stage was about 6 feet high and I got tired of shooting up at everyone. I switched my standard lens (28-70mm) for my Nikkor 80-20mm f/2.8 and went into the general seating area to get a better perspective. I found an angle I could shoot at unobstructed, but realized that even at the 200mm setting, I wasn't close enough to get the framing I wanted. I then switched the D700 from FX to DX crop mode, which gave me a little extra "reach," increasing the effective field of view to that of a 300mm lens. Alternatively, I could have taken the shot in FX mode and cropped it in post-processing, but I'd rather crop in-camera because I'm better at composition when I'm taking the photo.

7.9 Glenn Campbell, the Rhinestone Cowboy, plays for the crowd in Sweet Home, Oregon.

Figure 7.10 is the opposite end of the spectrum. Peter Murphy was performing at Emo's in Austin and the lighting was atrocious — very dim and overwhelmingly red. Digital sensors are very sensitive to red; the red channel is usually the first channel to start clipping and blow out, so red lights often leave you with little image detail to deal with. When this happens, often the only recourse is to use some flash to cut through the red lights or to shoot the concert as-is and deal with it in post-processing. I tried using the flash, but the room was too small and the images came out looking flat and, well, flashed.

One of the easiest ways to deal with blown-out red channels is to simply convert the image to black and white, which was what I opted to do. I often convert images to black and white just for the effect, but in this situation I did so more or less to salvage the shot. The black-and-white effect actually worked out well for this image and I liked it much better than the original color version.

7.10 Peter Murphy performing at Emo's in Austin, Texas

When shooting at high ISO settings, it's imperative to nail the exposure. Your images will suffer from excessive noise when they're underexposed given digital noise shows up more in darker shadow areas. Even at ISO 3200, I wasn't getting a great exposure so I lowered the ISO setting to 800, which reduced the noise levels so I could "push" the exposure later in Photoshop. This gave me a relatively slow shutter speed of 1/60 at f/2.8. I just hoped Peter Murphy would stand still enough for me to catch a few decent shots. In this shot, his head was still so I got a nice sharp focus on his face, but you can see the motion blur on his hands.

Some photographers are staunchly against using flash at concerts, preferring to shoot with the available light. I use some flash at times, because I find the stage lights can oversaturate the performer, resulting in loss of detail. Another downside to shooting with available light is that you might need to use high ISO settings to get a shutter speed fast enough to stop action. Typically you need to shoot anywhere from ISO 800 to 3200, which can result in noisy images and the loss of image detail. Fortunately, the D700 excels in high ISO performance, so it is not as much of an issue as it was with earlier dSLRs.

In figure 7.11, I used some flash to augment the stage lighting. The stage lighting wasn't positioned exactly right and guitarist Dan Bolton, from the Supersuckers, was often out of the spotlight, resulting in under-exposure.

When he was rocking out during this guitar solo, he wasn't directly in the spotlight, so I popped up the built-in flash on the D700 and snapped this shot. I'd set the flash mode to Slow Sync (I usually use it for concerts) and it gave me a shutter drag effect, freezing the subject while allowing some ambient light to come through. This added some ghosting, which gives the image a sense of motion and energy.

I zoomed my Nikkor 28-70mm f/2.8 out to the widest setting of 28mm because I was less than 3 feet away. I used a single AF point set near the top of the frame because I was composing a lot of vertical shots. The exposure was Spot metered and its settings were 1/8 at f/2.8 ISO 3200.

Other things to consider when you are doing concert photography are the rules of the venues or the band, which you should know before going in. Some bands, especially particularly famous ones, only allow photographers to shoot from a photo pit in front of the stage. More often than not, you will be limited in your shooting time – the general rule is two to three songs and that's it. This rule is so that the fans can enjoy the show without photographers being in the way.

Most well-established acts also do not allow flash to be used during the performance. Most of the time, you will need to get a press pass, which involves being affiliated with a magazine or newspaper. You may be able to contact the band's management prior to the gig to secure credentials.

7.11 Dan Bolton of the Supersuckers performing in Austin, Texas

Concert photography tips

✦ **Experiment.** Don't be afraid to try different settings and long exposures. Slow Sync flash enables you to capture much of the ambient light while freezing the subject with the short, bright flash.

✦ **Call the venue before you go.** Be sure to call the venue to ensure that you are able to bring your camera in.

✦ **Bring earplugs.** Protect your hearing. After spending countless hours in clubs without hearing protection, my hearing is less than perfect. You don't want to lose your hearing. Trust me.

✦ **Take your Speedlight off your camera.** If you're using one of the Nikon accessory flashes, such as the SB-800 or SB-600, invest in an off-camera TTL hot-shoe sync cord such as the Nikon SC-29 TTL cord. You can also try using the built-in flash as a commander and take advantage of your D700's wireless flash capabilities. When you're down in the crowd, your Speedlight is vulnerable. The shoe mount is not the sturdiest part of the flash. Not only is using the Speedlight off-camera safer, but you have more control of the light direction by holding it in your hand. This reinforces my suggestion to experiment — move the Speedlight around, hold it high, hold it low, or bounce it. With digital, it doesn't cost a thing to experiment.

Macro Photography

Macro photography is easily my favorite type of photography. Sometimes you can take the most mundane object and give it a completely different perspective just by moving in close. Ordinary objects can become alien landscapes. Insects take on a new personality when you can see the strange details of their faces, especially their multifaceted eyes.

Technically, macro photography can be difficult, because the closer you get to an object, the less depth of field you get, and it can be difficult to maintain focus. When your lens is less than an inch from the face of a bug, just breathing in is sometimes enough to lose focus on the area that you want to capture (or to scare the bug off). For this reason, you usually want to use the smallest aperture you can (depending on the lighting situation) and still maintain focus. I say

"usually" because a shallow depth of field can also be very useful in bringing attention to a specific detail.

 Caution *When shooting extremely close-up, the lens may obscure the light from the built-in flash, resulting in a dark area on the bottom of the images.*

Macro photography requires special lenses or filters to allow you to get closer to your subject. Most lens manufacturers offer lenses that are designed specifically for this purpose. These macro lenses give you a reproduction ratio of 1:1, which means that the image projected onto the sensor is exactly the same size as the physical subject. Some other lenses you can use for macro photography are actually telephoto lenses. Although you can't get close to the subject with a telephoto, the extra zoom gives you a close-up perspective. Telephoto lenses usually have a reproduction ratio of 1:4, or the image projected onto the sensor is one-quarter of its actual size.

For figure 7.12, I used a Micro-Nikkor 105mm f/2.8G VR telephoto lens. Using a longer macro lens is handy, especially when photographing living things. Shorter lenses require you to get closer to the subject, which often scares it off. With the 105mm VR lens, you can focus extremely close-up, while standing at a bit of a distance. When you focus close-up with a telephoto lens, camera shake, as well as subject size, is magnified. Macro photography is an area where VR excels: You can hand hold the camera at slower shutter speeds. This is useful because you often have to use small apertures to get increased depth of field. This shot of a dragonfly was taken a 1/80 at f/8 ISO 200. The exposure was Spot metered with single-point AF and AF set to single focus.

7.12 A dragonfly

Macro lens alternatives

There are alternatives to dedicated macro lenses. One more affordable option is an extension tube. This tube attaches between the lens and the camera body and gives your lens a closer focusing distance, allowing you to reduce the distance between the lens and your subject. Extension tubes are widely available, easy to use, and come with AF or manual focus. However, they do reduce the aperture of the lens they are attached to, causing you to lose a bit of light.

Another inexpensive alternative to macro lenses are close-up filters. A close-up filter is like a magnifying glass for your lens. It screws onto the end of your lens and allows you to get closer to your subject. Filters come in a variety of different magnifications, and can be stacked, or screwed, together to increase the magnification even more. Using close-up filters can reduce the sharpness of your images because the quality of the glass isn't quite as high as the glass of the lens elements. It is most obvious when you're stacking filters.

Reversing rings, adapters that have a lens mount on one side and filter threads on the other, are another affordable alternative. You screw the filter threads into the front of a normal lens as you would for a filter, and then attach the lens mount to the camera body. You mount the lens to the camera backwards. This allows you to closely focus on your subject. Take care when using reversing rings not to damage the rear element of your lens. Not all lenses work well with reversing rings. The best ones to use are fixed focal-length lenses that have aperture rings for adjusting the f-stop. Zoom lenses simply do not work well, nor do lenses that have no aperture control (Nikon "G" lenses).

Another very good alternative to expensive autofocus macro lenses is to use an older manual-focus macro lens. You can use lenses from other camera companies. The lens I use for macro photography most often, a Pentax Macro-Takumar 50mm f/4,

was actually made for older Pentax screw-mount (M42) camera bodies. I found an adapter on eBay for attaching M42 lenses to Nikon F-mount cameras. The lens and adapter together were less than $50. The lens allows me to get a 4:1 magnification, which is 4X life size.

For figure 7.13, I photographed this little guy I found in my shower. I used the Pentax Macro-Takumar 50mm f/4 I mentioned previously. I set the lens to get a 4:1 ratio because this critter was so tiny; its head wasn't even as big as the fingernail on my little finger. Luckily the gecko was fairly sedate: I had to get right on top of him to achieve focus, which I did manually.

It was pretty dark in the shower stall, so I used a high ISO setting of 1600. The camera was set to Matrix metering and the exposure was 1/30 at f/8.

Macro photography tips

✦ **Use the self-timer.** When using a tripod, use the self-timer to make sure the camera isn't shaking from pressing the Shutter Release button.

✦ **Use a low ISO.** Because macro and close-up photography focus on details, use a low ISO to get the best resolution.

✦ **Use a remote shutter release.** If using a tripod, use a remote shutter release to help reduce blur from camera shake.

7.13 *Hemidactylus frenatus*, common house gecko

Night Photography

Taking photographs at night brings a whole different set of challenges that are not present when you take pictures during the day. The exposures become significantly longer, making it difficult to hand hold your camera and get sharp images. Your first instinct may be to use the flash to add light to the scene, but as soon as you do this, the image loses its "nighttime" charm. It ends up looking like a photograph taken with a flash in the dark. In other words: a snapshot.

Techniques

When taking photos at night, you want to strive to capture the glowing lights and the delicate interplay between light and dark. The best way to achieve this is to use a tripod and a longer exposure. This allows you to capture the image, keeping your subjects in sharp focus even with the long exposures that are often necessary.

You can use flash effectively at night for portraits, but you almost never want to use it as your main light. Ideally, you want a good balance of flash and ambient light. To get this effect, set your flash to the Slow Sync or the Rear/Slow Sync setting. This allows longer exposures so the ambient light is sufficiently recorded while the flash adds a nice bright "pop" to freeze the subject for sharp focus.

Cross-Reference *For an example of a Slow Sync flash portrait, see the section in Chapter 6 on flash modes.*

Whenever I get a chance, I like to photograph the city skyline at night. This is when cities look the best. The lights bring the skyline to life and give it a vibrancy that can't be found during the day. For figure 7.14, I wanted to create a glass-like appearance on the flowing river, so using a timed exposure and a tripod was a necessity. When taking photographs like this, I usually use manual settings for both the focus and exposure

7.14 A Columbus, Ohio, skyline from the Scioto River

modes. I use Live View to compose and focus my images. I preview the images and make any necessary adjustments to shutter speed and aperture. To fire the shutter without causing camera shake, I use a Nikon MC-30 10-pin remote shutter release. If you don't have one, you can set the camera's self-timer to fire the shutter after the camera has had time to stop shaking from your pressing the Shutter Release button.

For this shot, I wanted to use a small aperture to create a long exposure, but I didn't want to use too small of an aperture because using apertures above f/11 can cause your images to lose some sharpness due to diffraction. I started out at f/11 and checked the camera exposure meter, which indicated a shutter speed of 20 seconds. After taking a test shot at that exposure, I found that the sky was exposing too much and the city lights were blowing out and losing their color. I halved the exposure time to 10 seconds. This was enough time to blur the water, yet still keep the sky very dark and the lights filled

with highly saturated colors. For this image, I used a Custom Picture Control that I created that adds saturation and sharpness to the image.

Night photography tips

✦ **Bring a tripod.** Without a tripod, the long exposure times will cause your photos to be blurry.

✦ **Use the self-timer.** Pressing the Shutter Release button when the camera is on the tripod often causes the camera to shake enough to blur your image. Using the self-timer gives the camera and tripod enough time to become steady so your images come out sharp.

✦ **Try using Slow Sync flash.** If using flash is an absolute must, try using Slow Sync to capture some of the ambient light in the background.

Painting with Light

When doing long exposures in low-light situations, you can often use a little bit of external light to add dimension or color, or to bring out some details in your subject. This technique is called *painting with light*. You can fire a handheld Speedlight or shine a flashlight on dark areas that aren't receiving enough ambient light.

When using this technique, you want to be sure to use a low-power light so you don't overlight your subject, thus causing the image to look like a flash exposure.

Continued

Continued

For example, when I was photographing this image, the statue was coming out too dark because there wasn't as much ambient light falling on the subject as there was being captured from the city skyline. To bring out some detail in the statue, I set up an SB-600 and set it to Manual. I dialed in a flash setting of 1/32. This added a little shine to the statue.

Portrait Photography

Portrait photography can be one of the easiest or one of the most challenging types of photography. Almost anyone with a camera can do it, yet it can be a complicated endeavor. Sometimes simply pointing a camera at someone and snapping a picture can create an interesting portrait; other times elaborate lighting setups may be needed to create a mood or to add drama to your subject.

A portrait, simply stated, is the likeness of a person — usually the subject's face — whether it is a drawing, a painting, or a photograph. A good portrait should go further than that. It should go beyond simply showing your subject's likeness and delve a bit deeper, hopefully revealing some of your subject's character or emotion, also.

You have lots of things to think about when you set out to do a portrait. The first thing to ponder (after you've found your subject, of course) is the setting. The setting is the background and surroundings, the place

where you'll be shooting the photograph. You need to decide what kind of mood you want to evoke. For example, if you're looking to create a somber mood with a serious model, you may want to try a dark background. For something more festive, you may need a background with a bright color or multiple colors. Your subject may also have some ideas about how he or she wants the image to turn out. Keep an open mind and be ready to try some approaches that you may have not considered.

There are many different ways to evoke a certain mood or ambience in a portrait image. Lighting and background are the principal ways to achieve an effect, but there are other ways. Shooting the image in black and white can give your portrait on evocative feel. You can shoot your image so that the colors are more vivid, giving it a live, vibrant feeling, or you can tone the colors down for a more ethereal look.

Studio considerations

Studio portraits are essentially indoor portraits, except that with studio portraits the lighting and background is controlled to a much greater extent. The lighting and background sets the tone of the image.

The most important part of a studio setting is the lighting setup. Directionality and tone are a big part of studio lighting, and you need to pay close attention to both. You have quite a few things to keep in mind when setting up for a studio portrait, such as:

✦ **What kind of tone are you looking for?** Do you want the portrait to be bright and playful or somber and moody? Consider these elements, and set up the appropriate lighting and background.

✦ **Do you want to use props?** Sometimes having a prop in the shot can add interest to an otherwise bland portrait.

✦ **What kind of background is best for your shot?** The background is crucial to the mood and/or setting of the shot. For example, when shooting a high-key portrait, you must have a bright, colored background. You can also use props in the background to evoke a feeling or specific place. One photographer I know went so far as to build walls, complete with windows, inside his studio. He then set up a couch, end tables, and lamps to create a 1970s-style motel room for a series of photographs he was shooting on assignment.

✦ **What type of lighting will achieve your mood?** Decide which lighting pattern you are going to use, and light the background if needed.

Studio portraits require more thought and planning than other types of portraits. They also require the most equipment; lights, stands, reflectors, backgrounds, and props are just a few of the things you may need. For example, for 7.15, I used a 200-watt second strobe set up at camera right, bounced from a 36-inch umbrella for the main light, and a reflector to add a little fill on the left.

The idea for this shoot was thoroughly planned out. We were going for a sort of gritty urban look with a retro feel. I placed Lynn next to a brick wall in my studio. I used a Nikkor 28-70mm f/2.8 set to an aperture of 5.6 so that I could get a deeper depth of field to keep some of the elements of the brick wall in focus. The shutter speed was set to the default sync speed of 1/60. Although I shot this image in RAW, I set the Picture

Control to monochrome so I could preview my images in black and white because I had predetermined that the images were to be converted to black and white in post-processing. I prefer to convert my images to black and white in Photoshop for complete control over the tonality of the image.

| Cross-Reference | *For more information on lighting and accessories, see Chapter 4.* |

7.15 Lynn

Portrait lighting patterns

Professional photographers use different types of lighting patterns, generally to control where the shadow falls on the face of the subject. If the shadows aren't controlled while lighting your subject, your portrait can appear odd, with strange shadows in unwanted places. In addition to the lighting patterns, there are two main types of lighting — broad lighting and short lighting. Broad lighting occurs when your main light is illuminating the side of the subject that is facing toward you. Short lighting occurs when your main light is illuminating the side of the subject that is facing away from you. In portrait lighting, there are five main types of lighting patterns.

✦ **Shadowless.** This is when your main light and your fill light are at equal ratios. Generally, you will set up a light at 45 degrees on both sides of your model. This type of light can be very flattering, although it can lack moodiness and drama.

7.16 Shadowless lighting

✦ **Butterfly or Hollywood glamour.** This type of lighting is mostly used in glamour photography. The name is derived from the butterfly shape of the shadow that the nose casts on the upper lip. You achieve this type of lighting by positioning the main light directly above and in front of your model.

achieved by placing the main light at a 15-degree angle to the face, making sure to keep the light high enough that the shadow cast by the nose is at a downward angle and not horizontal.

7.18 Loop, or Paramount, lighting

7.17 Butterfly lighting

✦ **Loop or Paramount.** This is the most commonly used lighting technique for portraits. Paramount Studios used this pattern so extensively in Hollywood's golden age that this lighting pattern became synonymous with the studio's name. This lighting pattern is

✦ **Rembrandt.** The famous painter Rembrandt van Rijn used this dramatic lighting pattern extensively. It's a moody pattern achieved from using less fill light. The light is placed at a 45-degree angle and aimed a little bit down at the subject. Again, I emphasize using little or no fill light. This pattern is epitomized by a small triangle of light under one eye of the subject.

7.19 Rembrandt lighting

7.20 Split lighting

✦ **Split.** This is another dramatic pattern that benefits from little or no fill. You can do this by simply placing the main light at a 90-degree angle to the model.

Posing and composition considerations

We convey a lot of our expressions and emotions through body language so it goes without saying that how a person is posed can make a huge impact on the general mood or feeling of the image.

Posing your model can be one of the most daunting tasks. Oftentimes to get the right pose, your model will have to move like a

contortionist, bending into awkward positions. It's important to remember that your models or clients expect you to know what you're doing. You need to be confident and assertive. Acting timid or being afraid to ask your model to do what you need will get you nowhere in the portrait business.

One of the easiest ways to learn about posing is to study poses from other photographers or artists. Open a fashion magazine or browse the Internet. I keep a folder on my desktop where I copy small files of images with interesting poses. If I'm feeling particularly uninspired during a photo shoot, I open up the folder to get some ideas and the creative juices flowing. Some of my favorite poses don't even come from other photographers,

but from artists. Alberto Vargas and Gil Elvgren painted pinup girls in the 1940s. Their art is iconic and fun. Check out their work for some inspiration.

When posing your model, you need to keep an eye on everything from stray hairs to clothing bunching up in weird ways to awkward limb positions. Before you trip the shutter, be sure to take your time to really look close at everything in the frame.

You should also pay close attention to the hands. Hands can subliminally reveal a lot of information about how a person is feeling. Make a conscious effort to tell your models or clients to relax their hands. When a model's hands are relaxed, she looks and feels more relaxed. If the model's hands are clenched up or tense, your portraits look forced or she looks uncomfortable. Hands are an extension of the arms and arms can have an emotional impact on your image, as well. For example, having your subject cross his arms can show strength and determination or even obstinance, depending on the facial expression.

Positioning the head is another major consideration when shooting portraits. When the model's head is straight up and down, looking directly down the lens, it can convey strength or even hostility. Titling the model's head to the side a bit usually makes the image more relaxed, especially when she is smiling, and it helps portray kindness and empathy in some cases.

For figure 7.21 I broke one of the major rules of portraiture. I used an extreme wide-angle Sigma 12-24mm lens set to 12mm. This is generally unacceptable, but sometimes rules are made to be broken. Using an

ultrawide-angle lens can make a great portrait and experimentation is fun; as I've said before, with digital, it doesn't cost you a dime to try something out to see if it works.

7.21 Portrait of Heather, shot using an ultrawide lens

The obvious perspective distortion that is unwanted in traditional portraits works in my favor here, giving the portrait a distinct feeling of empowerment. I also used a couple of special effects to make this shot even more dynamic. I used the same trick I discuss earlier in the section on action photography: I underexposed the background by 2 stops and overexposed the model by 1 stop. Using the camera's spot meter, I took a reading off of the brightest part of the sky. I manually set

the exposure for 1/500 at f/8. I chose this aperture because it is the one at which this lens appears the sharpest. I used one SB-800 and one SB-600 at camera left. I set up the SB-800 on a light stand to light Heather's face and upper body and fired at a shoot-through 36-inch umbrella. I set the second Speedlight on the ground with the AS-19 stand and fired slightly upward to light her legs and feet. This Speedlight was fired without a modifier, save for the built-in wide-angle diffuser. The off-camera Speedlights were controlled by the D700's built-in Speedlight. The SB-800 was set to Group A, TTL mode + 1.7 EV to compensate for the loss of light from the umbrella. The SB-600 was set to Group B TTL mode +1 EV.

Some general posing tips include

✦ **One foot behind.** One of the first things I do is have the person put one foot behind the other. This helps distribute the weight evenly and gives a more relaxed appearance. Having the person lean back slightly is also helpful.

✦ **Come in at an angle.** You almost never want the subject to face straight ahead (unless you're a police photographer). Having your subject angled slightly away from the camera with one shoulder closer to the camera is a good idea.

✦ **Tilt the head.** Tilt the head a bit to avoid having your subject look static, giving the portrait a casual feel. Of course, if the subject isn't casual, you won't want to do this. For example, for a CEO of a corporation, you would want to portray strength and character, so keeping the head straight would be ideal.

✦ **Watch the hands!** I can't stress this enough. Also try to keep the hands at an angle; the flat side of the back of the hand or the palm facing the camera can look odd. A $^3/_4$ view or the side of the hand is preferable.

7.22 This pose suggests empowerment and self-confidence.

Some things to be aware of when composing your portrait include:

✦ **Don't sever limbs!** Be sure not to frame the image in the middle of a knee joint or elbow. Don't cut off the toes or fingers. If a foot or hand is in the image, be sure to get it all in the frame.

✦ **Watch out for mergers.** Be aware of the background as well as the subject. Oftentimes you can get so involved with looking at the model, you can forget about the rest of the photograph. You don't want your model to look like she has a tree sprouting out of her head or a lamp suddenly growing out of her shoulder.

✦ **Fill the frame.** Make your subject the overwhelming part of the image. Having too much background can distract from the subject of the image.

Indoor

When shooting portraits indoors, more often than not there isn't enough light to make a correct exposure without using flash or some sort of other additional lighting. Although the built-in flash on the D700 sometimes works very well, especially outdoors, I find that when I try to use it for an indoor portrait, the person ends up looking like a "deer caught in headlights." This type of lighting is very unnatural looking and doesn't lend itself well for portraiture.

The easiest way to achieve a more natural-looking portrait indoors is to move your subject close to a window. This gives you more light to work with and the window acts as a diffuser, softening the light and giving your subject a nice glow. For figure 7.23, I positioned Heather next to the window to take advantage of the soft light. To her right side, I set up a reflector and bounced the window light onto her face, making the reflector the key light, causing the side of her face closest to the window to be in shadow, but giving

7.23 An indoor portrait shot using window light

the edge of her face a nice defining rim light. The reflector also served to add a reflection or catch light to her eyes, making them appear more vibrant and alive.

I shot this portrait with a Nikkor 80-200mm lens set to 200mm to compress Heather's facial features. I set the aperture to f/2.8 to blur out the background, giving it a nice bokeh. I chose Matrix metering to keep the exposure even and I used a single AF point and single-servo AF mode. The exposure setting was 1/125 at f/2.8 ISO 1600, which indicates how dim the scene actually was. I used a monopod to reduce blur from camera shake.

Another easy way to get nice portrait lighting indoors is to use an additional light source, such as one of the Nikon Speedlights. As with the built-in flash, photographing your subject with the Speedlight pointed straight at him or her is unadvisable. When you're using one of the shoe-mounted Speedlights, the best bet is to bounce the flash off the ceiling or a nearby wall to soften the flash or use a flash diffuser (the SB-900 and SB-800 Speedlights come with a diffusion dome). Ideally, use the flash off-camera, utilizing the wireless capabilities of the D700's built-in flash and Nikon CLS.

Outdoor

When you shoot portraits outdoors, the problems that you encounter are usually the exact opposite of the problems you have when you shoot indoors. The light tends to be too bright, causing the shadows on your subject to be too dark. This results in an image with too much contrast.

In order to combat this contrast problem, you can use your flash. I know that this sounds counterintuitive; you're probably thinking, "If I have too much light, why

should I add more?" Using the flash in the bright sunlight fills in the dark shadows, resulting in a more evenly exposed image. This technique is known as fill flash.

Another way to combat images that have too much contrast when you're shooting outdoors is to have someone hold a diffusion panel over your model or move your model into a shaded area, such as under a tree or a porch. This helps block the direct sunlight, providing you with a nice, soft light for your portrait.

In figure 7.24, I was shooting at one o'clock in the bright midday sun, which is probably the worst time to shoot. I moved the model under a canopy of trees. This helped a bit,

7.24 An outdoor portrait shot using a diffusion panel to reduce contrast

but there was still dappled sunlight coming through, causing hot spots all over her. I brought in a diffusion panel to block the stray sunlight, giving us a nice diffuse light to work with.

 Cross-Reference *For more information on fill flash and diffusion panels, see Chapter 6.*

Portrait photography tips

✦ **Plan some poses.** Take a look at some photos on the Internet and find some poses that you like. Have these in mind when photographing your models.

✦ **Use a tripod.** Not only does the tripod help you get sharper images, but it also can make people feel more comfortable when you're not aiming the camera directly at them. The camera can be less intimidating when it's mounted to a stationary object and you can make direct eye contact with your subjects. Using Live View can help with this.

✦ **Have some extra outfits.** Ask your model to bring a variety of clothes. This way you can get some different looks during one shoot.

Product and Still-Life Photography

If you have a client that presents you with a product, or you're photographing something for an online auction, or you're simply photographing a still life for fun, the goal is to make the product stand out — to sell the product.

Considerations

In product photography, lighting is the key to making the image work. You can set a tone using creative lighting to convey the feeling of the subject. You can also use lighting to show texture, color, and form to turn a dull image into a great one.

Product photography can involve one subject or a collection of products. If you are shooting a collection, try to keep within a particular theme so the image has a feeling of continuity. Start by deciding which object you want to have as the main subject, and then place the other objects around it, paying close attention to the balance of the composition.

The background is another important consideration when you're photographing products or still-life scenes. Having an uncluttered background that showcases your subject is often best, although you may want to show the particular item in a scene, such as photographing a piece of fruit on a cutting board with a knife in a kitchen.

Diffused lighting can be essential in this type of photography. You don't want harsh shadows to make your image look like you shot it with a flash. The idea is to light it so it doesn't look as if it were lit. If your product has interesting texture, you may need to use a harder light source to highlight that area. There's only one rule in product photography and that is to make the subject look good no matter what it takes.

Even with diffusion, the shadow areas need some filling in. You can use a second light as fill or a fill card. A fill card is a piece of white foam board or poster board used to bounce some light from the main light back into the shadows, lightening them a bit. When using two or more lights, be sure that

your fill light isn't too bright, or it can cause you to have two shadows. Remember, the key to good lighting is to emulate the natural lighting of the sun.

For figure 7.25, I used a simple two-light setup to light my old battle-scarred Telecaster and Twin Reverb. These are two of my most prized possessions and have traveled tens of thousands of miles in many vans and have seen many stages, some famous and some not so. For this shot, I used my studio strobes fired through softboxes to achieve diffuse, even lighting. When doing studio shots such as this one, I set my camera entirely to Manual. I meter the exposure using a Sekonic L-358 flash meter.

I start out first by deciding what I want my aperture setting to be. I needed a small enough aperture to get enough depth of field to keep both the guitar and amplifier in focus. In this case, f/9 would definitely give me enough depth of field without softening the image due to diffraction. I set the shutter speed to the standard sync speed of 1/60 at ISO 200.

To the left side of the guitar and amp, I set up a 200 watt-second Smith-Victor monolight about 4 feet from the amplifier shooting through a medium softbox for diffusion. This was my key, or main, light. On the left side, I set up the same type of light, but I used a smaller softbox and moved the light a little closer to diffuse it even more. (The closer the light source, the more diffuse it is.) I set the main strobe to 1/4 power and the fill to 1/32. I purposely angled the strobes away from the background to keep the light off of it, letting it go dark so that the guitar and amplifier were the predominant feature in the scene.

Food photography is another type of product photography, and it can be extremely lucrative. Here in Austin, new restaurants pop up frequently and they all need food photos for their menus.

I find the best way to light food is window lighting. I'll bring a reflector along with me to add some fill, but I rarely use additional lighting unless I absolutely have to shoot in the evening. In the case where I need to use a Speedlight, I'll bounce the light off of a wall to diffuse it.

One of the keys to successful food photography is to make the composition interesting. Simply photographing food sitting on a plate can be static and boring; finding different angles and using selective focus can add some interest to the image.

7.25 Fender Telecaster and Twin Reverb

I photographed the dish in figure 7.26 about 10 feet from the window in the restaurant. The window light was the only source of illumination. I used a Nikkor 50mm f/1.8 lens with the aperture wide open to use selective focus to draw attention to the center of the dish, with the focus falling on the mussels in the center and the grilled focaccia bread off to the right. I shot this in Aperture Priority mode and adjusted my ISO setting until I got a shutter speed of 1/60 to be sure that there was no blur from camera shake. The scene was metered using Matrix metering to ensure that the exposure was even. The mussels were some of the tastiest I have ever eaten. (This is one of the perks of doing food photography.)

7.26 Steamed mussels with grilled focaccia

Product and still-life photography tips

✦ **Keep it simple.** Don't try to pack too many objects in your composition. Having too many objects for the eye to focus on can lead to a confusing image.

✦ **Use items with bold colors and dynamic shapes.** Bright colors and shapes can be eye-catching and add interest to your composition.

✦ **Vary your light output.** When using more than one light on the subject, use one as a fill light with lower power to add a little depth to the subject by creating subtle shadows and varied tones.

Wildlife Photography

Photographing wildlife is a fun and rewarding pastime that can also be intensely frustrating. If you know what you want to photograph, it can mean standing out in the freezing cold or blazing heat for hours on end, waiting for the right animal to show up. But when you get that one shot you've been waiting for, it's well worth it.

Probably the best way to get great images of wildlife is to do some research on your intended subject. Knowing the creature's habits and the areas that it might be located in is invaluable information.

You can find wildlife in many different places: zoos, wildlife preserves, and animal sanctuaries as well as out in the wild. One of the easiest ways to capture wildlife photos is to be where you know the animals are.

7.27 A Great Blue Heron

Considerations

Wildlife photography is another one of those areas of photography where people's opinions differ on whether you should use flash. I tend not to use flash to avoid scaring off the animals. But, as with any type of photography, there are circumstances in which you might want to use a flash, such as if the animal is backlit and you want to bring out some detail. If you must use flash, be careful that you don't startle the animal. Frightened animals can be aggressive. I suggest only using flash when absolutely necessary and then only when photographing smaller non-threatening animals such as birds.

Opportunities to take wildlife pictures can occur when you're hiking in the wilderness, or when you're sitting out on your back porch enjoying the sunset. With a little perseverance and luck, you can get some great wildlife images, just like the ones you see in National Geographic.

I was hiking in a local state park when I spotted the Great Blue Heron in figure 7.27. I was using a Nikkor 80-20mm f/2.8, but even zoomed to 200mm, I couldn't quite get enough reach so I switched the camera to DX mode to give a closer look to the image. I was using a monopod to reduce the effect of camera shake that is prevalent with long focal lengths. This image was metered using the Center-weighted mode. The exposure was 1/200 at f/2.8 ISO 800.

Even in the city or urban areas, you may be able to find wildlife, such as songbirds perched on a power line or hawks in trees near roadsides. A lot of cities have larger parks where you can find squirrels or other smaller animals. For example, I've photographed animals such as peacocks and armadillos at a park near my studio.

I don't often go on wildlife safaris, so I get my wildlife photography fix at the zoo. In figure 7.28, I photographed a gorilla at the zoo in Fort Worth, Texas. While I was shooting this photo, he let out a hoot, making this great face.

Even though you can get closer to the animals in the zoo than you normally would in the wild, using a telephoto lens is essential; for the most part, the animals will be at a distance and a long lens allows you to get up-close, personal portraits such as this one. For this shot, I used a Nikkor 80-200mm f/2.8D and a monopod to ensure a sharp shot. The shot was Matrix metered for an exposure of 1/640 at f/2.8 ISO 320.

The wide aperture of the Nikkor 80-20mm f/2.8D comes in handy in zoo situations for a number of reasons. First and foremost, a fast lens gathers a lot of light, allowing you to shoot at faster shutter speeds to reduce the effect of camera shake and/or it allows you to shoot at a lower ISO setting to reduce noise. One of the main reasons I like a wide aperture lens at the zoo is for the shallow depth of field. This allows you to blur out the background details so your pictures look like you shot them in the wild. The shallow depth of field also comes in handy when you're photographing animals through fences. Getting the lens close to the fence and opening up the aperture makes the fence almost disappear.

I was hiking in the Guadalupe Mountains in Texas when I spotted this black bear in figure 7.29 taking a swim. Not wanting to get too close to disturb the bear (I didn't want to get eaten), I put on my Nikkor 80-200mm f/2.8D with a Kenko 1.4X AF Teleconverter to get some extra reach. Adding a teleconverter gives you extra reach, but it comes at a price. Your image quality is generally a little lower given the extra glass elements. I didn't have a

7.28 A gorilla

7.29 The black bear, *Ursus americanus*

monopod with me, so to be sure I had a fast enough shutter speed to combat camera shake, I raised the ISO sensitivity to 400. This gave me an exposure of 1/1000 at f/2.8. The camera was set to Matrix metering.

The most important thing to remember about wildlife photography is to be careful. Wild animals can be unpredictable and aggressive when confronted by humans. There is no doubt in my mind that although that bear looked playful, it would have mauled me without giving it a second thought. Always keep a safe distance from wild game.

Wildlife photography tips

✦ **Use a telephoto lens.** This allows you to remain inconspicuous to the animal, enabling you to catch it acting naturally.

✦ **Seize an opportunity.** Even if you don't have the lens zoomed to the right focal length for capturing wildlife, snap a few shots anyhow. You can always crop them later if they aren't perfect. It's better to get the shot than not.

✦ **Be patient.** It may take a few hours, or even a few trips, to the outdoors before you have the chance to see any wild animals. Keep the faith; it will happen eventually.

✦ **Keep an eye on the background.** When photographing animals at a zoo, keep an eye out for cages and other things that look man-made — and avoid them. It's best to try to make the animal look like it's in the wild by finding an angle that shows foliage and other natural features.

Viewing and In-Camera Editing

With the D700's large, three-inch, 920,000-dot VGA LCD screen, you can view your images with much more clarity than was possible with earlier Nikon dSLR cameras. Nikon also offers some different options on the D700 that aren't available on some of their other cameras. One option is the ability to view and show your images on an HDTV. The D700 also offers quite a few in-camera editing features that allow you to save some time in post-processing and give you the option to fine-tune your images for printing without ever having to download them to a computer.

Viewing Your Images

In the past, Nikon has always offered two different ways to view your images while the CompactFlash (CF) card is still inserted in the camera. You could view the images directly on the LCD screen on the camera or you could hook your camera up to a standard TV using the EG-D100 video cable that's supplied with the camera. Both options are still available with the D700, but now there is also a third option: You can connect your camera to an HDTV or HD monitor.

When viewing through an external device such as a TV or HDTV, the view is the same as would normally be displayed on the LCD screen. The camera's buttons and dials function exactly the same.

Another feature worth mentioning is that you can use an HDTV, an HD monitor, or a standard TV when using the Live View feature. This allows you to view the exact image as it's

being projected on the sensor. This can be extremely beneficial in commercial product photography because you can check focus, composition, and exposure in real time on a large HD screen. Combine this feature with Nikon's Camera Control Pro2 software and you've really got a great setup.

 Cross-Reference *For more information on Live View, see Chapter 2.*

To connect your camera to a standard TV, follow these steps:

1. **Turn the camera off.** This can prevent damage to your camera's electronics from static electricity.

2. **Open the connector cover.** The connector cover is on the left side of the camera when the lens is facing away from you.

3. **Plug in the EG-D100 video cable.** The cable is included with the camera in the box. Plug the cable into the Video out jack. This is the connection at the top.

4. **Connect the EG-D100 to the input jack of your television or VCR.**

5. **Set your TV to the video channel.** This may differ depending on your TV. See the owner's manual if you are unsure.

6. **Turn on the camera and press the Playback button.**

To connect your camera to an HDTV or HD monitor, follow these steps:

1. **Turn off the camera.**

2. **Open the connector cover.** The connector cover is on the left side of the camera when the lens is facing away from you.

3. **Plug in a type A HDMI cable to your camera's HDMI out jack.** These cables are available separately at most electronics stores. The connection is the second one down from the top.

4. **Connect the HDMI cable to the HD device.**

5. **Set the HD device to the proper input channel.** See the owner's manual for your specific device.

6. **Press the Playback button.**

The camera default setting allows the camera to automatically choose the appropriate resolution for the HDMI device that it is connected to. To manually choose a resolution, go to the Setup menu, select the HDMI menu option, and then choose Auto (default): 480p, 576p, 720p, or 1080i. See your HD device's owner's manual for more information.

 Note *The "p" and "i" after the resolution number refer to how the image is displayed on an HDTV or HD monitor. With "i" the data is sent in alternating fields with the odd fields being displayed first then the even fields. With "p" the video is displayed progressively with all pixels of the frame being displayed together.*

The Retouch Menu

Starting with the D300, Nikon now offers in-camera editing features on a professional-level dSLR. Formerly, this type of option was only available on compact digital cameras and consumer-level dSLRs. These in-camera editing options make it simple for you to print straight from the camera without downloading it to your computer or using any image-editing software.

The Retouch menu doesn't make any destructive edits to your images, meaning that the software doesn't change the existing image but saves a JPEG copy of the retouched image, leaving the original image untouched. This a great feature to have in case you need to quickly make a JPEG copy of your RAW file to send off to an art director or editor.

You can access the Retouch menu two ways.

The first method:

1. **Press the Play button to enter Playback mode.** Your most recently taken image appears on the LCD screen.

2. **Use the Multi-selector to review your images.**

3. **When you see an image you want to retouch press the OK button to display the Retouch menu.**

4. **Use the Multi-selector to highlight the Retouch option you want to use.** Depending on the Retouch option you choose, you may have to select additional settings.

5. **Make adjustments if necessary.**

6. **Press the OK button to save the settings.**

/ **Note** *The retouched image is saved as a copy JPEG that is saved after the last image that was captured. A retouch symbol icon is displayed in the upper-left corner of the thumbnail to remind you that this is a retouched image. Further retouching cannot be applied to a retouched JPEG.*

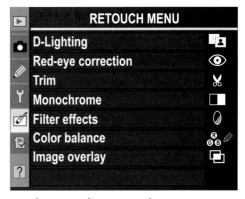

8.1 The Retouch menu options

The second method:

1. **Press the Menu button to view menu options.**

2. **Use the Multi-selector to scroll down to the Retouch menu.** It's the fifth menu down and appears as an icon with a paintbrush.

3. **Press the Multi-selector right and then use the Multi-selector up and down buttons to highlight the Retouch option you want to use.** Depending on the Retouch option you select, you may have to select additional settings. Once you have selected your option(s), thumbnails appear.

4. **Use the Multi-selector to select the image to retouch and then press the OK button.**

5. **Make the necessary adjustments.**

6. **Press the OK button to save your adjustments.**

Retouch Menu Options

You can select a few options in the Retouch menu. They vary from cropping your image to adjusting the color balance to taking red-eye out of your pictures. And remember, your original images are untouched, so you can experiment with these features all you want without worrying about ruining your original.

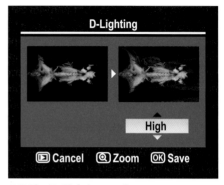

8.2 The D-Lighting option

D-Lighting

This allows you to adjust the image by brightening the shadows. This is not the same as Active D-Lighting. D-Lighting uses a curves adjustment to help to bring out details in the shadow areas of an image. This option is meant for backlit subjects or images that may be slightly underexposed.

When you select the D-Lighting option from the Retouch menu, you can use the Multi-selector to choose a thumbnail and the Zoom in button to get a closer look at the image. Press the OK button to choose the image to retouch. Two thumbnails are displayed: One is the original image, and the other is the image with D-Lighting applied.

You can use the Multi-selector up and down buttons to select the amount of D-Lighting: Low, Normal, or High. You can review the results in real time and compare them with the original before you save them. Press the OK button to save your adjustments, the Playback button to cancel them, and the Zoom in button to view the full-frame image.

Red-eye correction

This option enables the camera to automatically correct for the red-eye effect on people that sometimes results from using the flash. This option is only available on photos taken with flash. When you choose images to retouch from the Playback menu by pressing the OK button during preview, this option is grayed out and cannot be selected if the camera detects that a flash was not used. When you attempt to choose an image directly from the Retouch menu, a message displays stating "Cannot select this file."

Once you've selected the image, press the OK button; the camera then automatically corrects the red-eye and saves a copy of the image to your CF card.

If you select an image where flash was used but no red-eye is present, the camera displays a message stating that red-eye is not detected in the image and no retouching will be done.

 Cross-Reference *For more information on red-eye and how to avoid it, see Chapter 6.*

Trim

This option allows you to crop your image to remove distracting elements or to allow you to get a closer view of the subject.

You can choose different aspect ratios for your crop by rotating the Main Command dial. The choices are 3:2, 4:3, and 5:4. This changes the ratio between the height and width of your image. You can crop to a certain aspect ratio if the determining factor of your print is that you are going to frame it. 3:2 is the native aspect ratio of the D700's sensor. Here's a list of the available aspect ratios and common sizes of papers and frames you can use with this ratio for a crop.

✦ **3:2.** 4 × 6, 13 × 9, 11 × 17

✦ **4:3.** 5 × 7

✦ **5:4.** 2.5 × 3, 4 × 5, 8 × 10, 16 × 20

You can also use the Zoom in and Zoom out buttons to adjust the size of the crop. This allows you to crop closer in or farther out depending on your needs.

You can use the Multi-selector to move the crop around the image so you can center the crop on the part of the image that you think is most important.

To preview your final cropped image, press and hold the button in the center of the Multi-selector. If you are not pleased with the crop, release the button and use the Multi-selector to move the crop to a more suitable area.

When you are happy with the crop you have selected, press the OK button to save a copy of your cropped image.

8.3 Using the in-camera crop (Trim) option

Monochrome

This option allows you to make a copy of your color image in a monochrome format. There are three options:

✦ **Black-and-white.** The black-and-white option simulates the traditional black-and-white film prints done in a darkroom. The camera records the image in black, white, and shades of gray. This mode is suitable for use when the color of the subject is not important. It can be used for artistic purposes or, as with the sepia mode, to give your image on antique or vintage look.

✦ **Sepia.** The sepia color option duplicates a photographic toning process that is done in a traditional darkroom using silver-based black-and-white prints. Toning a photographic image requires replacing the silver in the emulsion of the photo paper with a different silver compound, thus changing the color, or tone, of the photograph. Antique photographs were generally treated to this

type of toning; therefore, the sepia color option gives the image an antique look. The images have a reddish-brown cast to them. You may want to use this image when trying to convey a feeling of antiquity or nostalgia to your photograph. This option works well with portraits as well as still-life and architecture photos.

✦ **Cyanotype.** The Cyanotype is another old photographic printing process; in fact it's one of the oldest. When exposed to the light, the chemicals that make up the cyanotype turn a deep blue color. This method was used to create the first blueprints and was later adapted to photography. The images taken when in this setting are in shades of cyan to blue. Because cyan and blue are considered "cool" colors, this mode is also referred to as cool. You can use this mode to make very interesting and artistic images.

When using the Sepia or Cyanotype options, you can use the Multi-selector up and down buttons to adjust the lightness or darkness of the effect. Press the OK button to save a copy of the image or press the Playback button to cancel the adjustments without saving them.

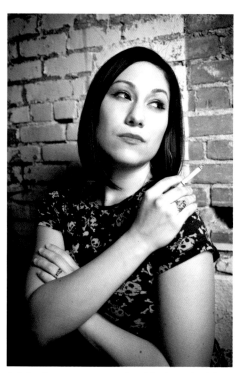

8.4 An image converted to black and white

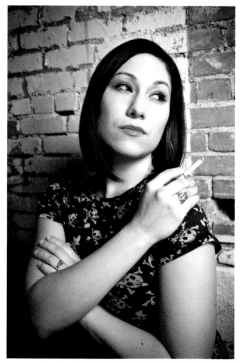

8.5 An image converted to sepia

8.6 An image converted to cyanotype

Filter effects

Filter effects allow you to simulate the effects of using certain filters over your lens to subtly modify the colors of your image. Two filter effects are available:

✦ **Skylight.** A skylight filter is used to absorb some of the ultraviolet (UV) rays emitted by the sun. The UV rays can give your image a slightly bluish tint. Using the skylight filter effect causes your image to be less blue.

✦ **Warm filter.** A warming filter adds a little orange to your image to give it a warmer hue. This filter effect can be useful when you're using flash because flash can sometimes cause your images to look a little too cool.

After choosing the desired filter effect, press the OK button to save a copy of your image with the effect added.

Color balance

You can use the color balance option to create a copy of an image on which you have adjusted the color balance. Using this option, you can use the Multi-selector to add a color tint to your image. This effect neutralizes an existing color tint or adds a color tint for artistic purposes.

Press the Multi-selector up to increase the amount of green, down to increase the amount of magenta, left to add blue, and right to add amber.

A color chart and color histograms are displayed along with an image preview so you can see how the color balance affects your image. When you are satisfied with your image, press the OK button to save a copy.

8.7 Color chart and histograms using the color balance option

Image overlay

This option allows you to combine two RAW images and save them as one. You can only access this menu option by entering the Retouch menu using the Menu button (the longer route); you cannot access this option by pressing the OK button while in Playback mode.

 Note *To use this option you must have at least two RAW images saved to your memory card. This option is not available with JPEG or TIFF images.*

To use this option, follow these steps:

1. **Press the Menu button to view the menu options.**

2. **Use the Multi-selector to scroll down to the Retouch menu, and press the Multi-selector right to enter the Retouch menu.**

3. **Use the Multi-selector up or down to highlight Image overlay.**

4. **Press the Multi-selector right.** This displays the Image overlay menu.

5. **Press the OK button to view RAW image thumbnails.** Use the Multi-selector to highlight the first RAW image to be used in the overlay. Press the OK button to select it.

6. **Adjust the exposure of Image 1 pressing the Multi-selector up or down.** Press the OK button when the image is adjusted to your liking.

7. **Press the Multi-selector right to switch to Image 2.**

8. **Press the OK button to view RAW image thumbnails.** Use the Multi-selector to highlight the second RAW image to be used in the overlay. Press the OK button to select it.

9. **Adjust the exposure of Image 2 pressing the Multi-selector up or down.** Press the OK button when the image is adjusted to your liking.

10. **Press the Multi-selector right to highlight the Preview window.**

11. **Press the Multi-selector up or down to highlight *Overlay* to preview the image, or use the Multi-selector to highlight *Save* to save the image without previewing.**

8.8 Image overlay screen

Side-by-side comparison

This option allows you to view a side-by-side comparison of the retouched image and the original copy of the image.

To use this option, follow these steps:

1. **Press the Play button and use the Multi-selector to choose the retouched image to view.**

2. **Press the OK button to display the Retouch menu.**

3. **Use the Multi-selector to highlight Side-by-side comparison, and then press the OK button.**

4. **Use the Multi-selector to highlight either the original or retouched image.** You can then use the Zoom in button to view it closer.

5. **Press the Play button to exit the Side-by-side comparison option and return to Playback mode.**

8.9 The Side-by-side comparison screen

Appendixes

Accessories

A number of accessories and additional equipment are available for the Nikon D700. They range from batteries and flashes to tripods and camera bags, and can enhance your shooting experience by providing you with options that aren't available with the camera alone.

MB-D10 Battery Grip

The MB-D10 is arguably one of the most important accessories you can buy for the D700. It is available only from Nikon and attaches to the bottom of your D700. Not only does this grip offer you an extended shooting life by allowing you to fit additional batteries to your camera, but it also offers the ease and convenience of a vertical shutter release, a Main Command and Sub-command dial, and an Autofocus-On button (AF-ON) button. This means that if you hold your camera in the vertical position, you can use the Shutter Release button on the MB-D10 to fire the camera and adjust settings without having to hold your camera awkwardly, with your elbow up in the air, to press the camera's Shutter Release button.

The MB-D10 grip comes with two adapters so you can use different types of batteries. The MS-D10EN enables you to use a standard EN-EL3e battery in the grip. The MS-D10 enables you to fit eight AA batteries in the grip.

If you're willing to spend even more money, you can also fit an EN-EL4 or EN-EL4a battery into the MB-D10. The EN-EL4 is the battery that comes standard with the D2X, D2XS, D2H, D2HS, and D3 professional-level cameras. EN-EL4 batteries are reported to have a very long life. If you do opt to go this route, be forewarned that this battery requires a separate charger and a BL-3 battery chamber cover that fits onto the end of the MB-D10 to hold the battery in place. These options can be expensive.

In addition to extra battery life and the vertical controls, the MB-D10 also allows you to shoot at a faster frame rate than with the camera body alone. The standard frame rate is up to 5 frames per second (fps); you can shoot up to 8 fps with the MB-D10!

Caution *The MB-D10 only allows 8 fps shooting when you're using either AA or EN-EL4 batteries. If you use a standard EN-EL3e battery, you only get the standard 5 fps.*

The MB-D10 is made with a sturdy magnesium frame, which is the same material used for the D700 body, and means the grip feels like it's actually a part of the camera rather than an added piece.

WT-4a Wireless Transmitter

The WT-4a wireless transmitter enables you to control your camera wirelessly using Nikon Camera Control Pro software, or to transmit or transfer images to your computer through a wireless LAN connection or a wired Ethernet connection. This can be handy when you are shooting in a controlled environment such as a studio. You can then preview your images on your computer monitor to be sure of the accuracy of the colors and focus.

You can control your camera directly from the computer with the optional Nikon Camera Control Pro 2 software. This means

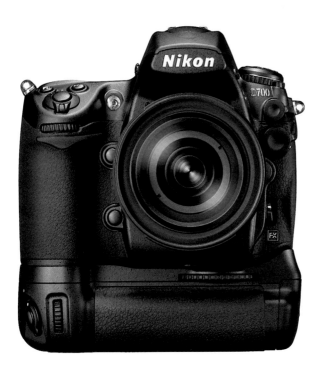

Image courtesy of Nikon, Inc.
A.1 The D700 with the MB-D10 battery grip

when you shoot products in the studio, you can set up your camera on a tripod and change the aperture, shutter speed, and ISO. You can then take the picture by firing the shutter directly from the computer, where you can preview the image and make any further adjustments as needed.

The WT-4a is connected to the D700 using a USB 2.0 cable.

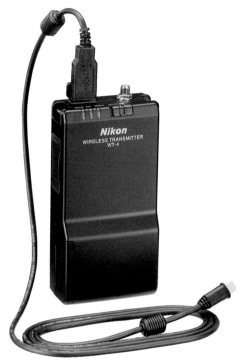

Image courtesy of Nikon, Inc.
A.2 The WT-4a wireless transmitter

ML-3 Modulite Remote Control Set

The handy ML-3 Modulite remote control connects to your camera via the 10-pin connector. The ML-3 has two components, an infrared sensor that attaches to the hot-shoe connector and the transmitter. The infrared sensor allows you to control the camera wirelessly using the ML-3 transmitter. You can use the ML-3 Modulite remote control to reduce camera shake by firing the shutter remotely, to get in a picture yourself, or to even set it up so that the camera fires when something comes between the transmitter and receiver.

MC-36 Multi-Function Remote Cord

The MC-36 multi-function remote cord functions in the same way as the D700's Shutter Release button. You can use it to reduce the camera shake that can come from pressing the Shutter Release button. You can also program the MC-36 to act as an intervalometer to do time-lapse photography; this feature is included in the D700, but if you have an older Nikon film camera with a 10-pin connector, you can use this remote with it.

Tripods

Whether you're a professional photographer or a hobbyist, one of the most important accessories you can have is a tripod. It allows you to get sharper images by eliminating the shake caused by handholding the camera in low-light situations. It can also allow you to use a lower ISO, thereby reducing the camera noise and resulting in an image with better resolution.

There are literally hundreds of types of tripods available, ranging in size from less than 6 inches all the way to 6 feet or more. In general, the heavier the tripod is, the steadier

it keeps the camera. The D700 is a fairly heavy camera, so you will want to purchase a heavy-duty tripod; otherwise, the weight of the camera can cause the tripod to shake, offering no improvement over shooting without a tripod.

There are many different features available on tripods, but the standard ones include

✦ **Height.** This is an important feature. The tripod should be the right height for the specific application for which you are using it. If you are shooting landscapes most of the time and are 6 feet tall, using a 4-foot-tall tripod forces you to bend over to look into the viewfinder to compose your images. This is probably not optimal.

✦ **Head.** Tripods have several different types of heads. The most common type of head is the pan/tilt head. This type allows you to rotate, or pan, with a moving subject and also allows you to tilt the camera for angled or vertical shots. The other common type of head is the ball head. It is the most versatile, and can tilt and rotate quickly into nearly any position.

✦ **Plate.** The plate attaches the camera to the tripod. The D700 has a threaded socket on the bottom. Tripods have a type of bolt that screws into these sockets, and this bolt is on the plate. Most decent tripods have what is called a quick release plate. You can remove a quick release plate from the tripod and attach it to the camera, and then reattach it to the tripod with a locking mechanism. If you're going to be taking the camera on and off of the tripod frequently, this is the most time-efficient type of plate to use. The other type of plate, which

is on some inexpensive tripods, is the standard type of plate. It attaches directly to the head of the tripod. It still has the screw bolt that attaches the camera to the plate, but it is much more time-consuming to use if you plan to take the camera on and off a lot.

When to use a tripod

Many situations are ideal for using a tripod, and the most obvious is when it's dark or lighting is poor. However, using a tripod even when there is ample light can help keep your image sharp. These are just a few situations when you may want to use a tripod:

✦ **When the light is low.** Your camera needs a longer shutter speed to get the proper exposure if there isn't much available light. And when the shutter speed gets longer, you need steadier hands to get sharp exposures. Attaching your camera to a tripod eliminates camera shake.

✦ **When the camera is zoomed in.** When you are using a long focal-length lens, any shaking from your hands is more exaggerated due to the higher magnification of the scene. Your images can be blurry, even in moderate light.

✦ **When shooting landscapes.** Shooting landscape shots, especially when you're using the Landscape scene mode, requires a smaller aperture to get maximum depth of field to ensure that the whole scene is in focus. When the camera is using a smaller aperture, the shutter speed can be long enough to suffer from camera shake, even when the day is bright.

✦ **When shooting close-up.** When the camera is very close to a subject, camera shake can also be magnified. When you're shooting close-ups or macro shots, it may also be preferable to use a smaller aperture to increase depth of field, thus lengthening the shutter speed.

Which tripod is right for you?

Considering so many different types of tripods exist, choosing one can be daunting. Many different features and functions are available in a tripod; here are some things to think about when you're considering purchasing one:

✦ **Price.** Tripods can range in price from as little as $5 to as much as $500 or more. Obviously, the more a tripod costs, the more features and stability it's going to have. Look closely at your needs when deciding what price level to focus on.

✦ **Features.** There are dozens of different features available in any given tripod. Some tripods have a quick release plate, some have a ball head, some are small, and some are large. Again, you need to decide on your specific needs.

✦ **Weight.** This can be a very important factor when you're deciding which tripod to purchase. If you are going to use the tripod mostly in your home, a heavy tripod may not be a problem. On the other hand, if you plan on hiking, a 7-pound tripod can be an encumbrance after awhile. Some manufacturers make tripods that are made out of carbon fiber. While these tripods are very stable, they are also extremely lightweight. However, carbon fiber tripods are also very expensive.

Camera Bags and Cases

Another important accessory to consider is the bag or carrying case you choose for your camera. These can provide protection not only from the elements but also from impact. Camera bags and cases exist for any kind of use you can imagine, from simple cases to prevent scratches to elaborate camera bags that can hold everything you may need for a week's vacation. Some of the bag and case types available include

✦ **Hard cases.** These are some of the best cases you can get. Pelican makes the best ones; they are watertight, crushproof, and dustproof. They are unconditionally guaranteed forever. If you are hard on your cameras or do a lot of outdoor activities, you can't go wrong with these.

Monopods

An option you may want to consider is a *monopod* instead of a tripod. A monopod connects to the camera the same way a tripod does, but it only has one leg. Monopods are excellent for shooting sports and action with long lenses, because they allow you the freedom to move along while providing the support to keep your camera steady.

✦ **Shoulder bags.** These are the standard camera bags you can find at any camera shop. They come in a multitude of sizes to fit almost any amount of equipment you can carry. I have a couple of different shoulder bags, the Naneu Pro Tango and the Correspondent C400. Both fit quite a bit of equipment, including two camera bodies and a slew of lenses and flashes. The Tango bag also holds a 15-inch computer. Other reputable makers include Tamrac, Domke, and Lowepro. Look them up on the Web to peruse the various styles and sizes.

✦ **Backpacks.** Some camera cases are made to be worn on your back, just like a standard backpack. These also come in different sizes and styles, and some accommodate a laptop. The type of camera backpack I use when traveling is a Naneu Pro Alpha. It's designed to look like a military pack, so thieves don't know you're carrying camera equipment. When traveling, I usually pack it up with two Nikon digital single lens reflex (dSLR) camera bodies, a wide-angle zoom, a standard zoom, a long telephoto, two or three prime lenses, two Speedlights, a reflector disk, a 12-inch Apple PowerBook, and all of the plugs, batteries, and other accessories that go along with my gear. Lowepro and Tamrac also make some very excellent backpacks.

✦ **Messenger bags.** Recently more camera bag manufacturers have started to offer messenger bags, which resemble the types of bags that a bike messenger uses. They have one strap that goes over your shoulder and across your chest. The bag sits on your back like a backpack. The good thing about these bags is that you can just grab it and pull it around to the front for easy access to your gear. I also have one of these for when I'm traveling light. My messenger bag is the Echo made by NaneuPro.

✦ **Holster-type bags.** The holster-type camera bag is a bare-bones camera holder. It's made to carry one camera with a lens attached and a few accessories such as batteries and flash cards. In my opinion, the best holster-type bag is the Lowepro Toploader. Lowepro makes several types of holsters to accommodate different cameras and lens combinations. For example, they make bags to fit a standard dSLR with a standard zoom lens and they make a bigger bag to fit larger dSLRs (such as the D700 with MB-D10 grip) with a large telephoto zoom lens (such as a 70-200mm lens). These bags are great when you're traveling with a small amount of equipment on a day trip.

D700 Specifications

Type of camera: Single-lens reflex digital camera

Effective pixels: 12.1 million

Image sensor: CMOS sensor, 36 × 23.9 mm; Total pixels: 12.87 million; Nikon FX format

Image size (pixels): FX format 4256 × 2832 [L], 3184 × 2120 [M], 2128 × 1416 [S]

DX format 2784 × 1848 [L], 2080 × 1384 [M], 1392 × 920 [S]

Dust-reduction system: Self-cleaning sensor unit, image dust-off data acquisition (Capture NX or NX2 required)

Sensitivity: ISO 200 to 6400 in steps of 1/3, 1/2, or 1 EV with additional settings of approximately 0.3, 0.5, 0.7, and 1 EV (ISO 100 equivalent) under ISO 200 and approximately 0.3, 0.5, 0.7, and 1 EV or 2 EV (up to ISO 25600 equivalent) over ISO 6400

File system: Compliant with DCF 2.0, DPOF, and Exif 2.21

Storage system: NEF 12-bit or 14-bit (uncompressed, lossless compressed, or compressed RAW), TIFF (RGB), JPEG: JPEG baseline-compliant

Media: CompactFlash (CF) Card (Type I UDMA compliant), Type II, and Microdrive not supported

Release modes:

✦ **Single frame (S) mode**

✦ **Continuous low speed (CL) mode.**
1 to 5 frames per second, or fps (7
fps with optional MB-D10 and AA
or EN-EL4a batteries or AC adapter)

✦ **Continuous high-speed (CH)
mode.** 5 fps (8 fps with optional
MB-D10 and AA, EN-EL4, or
EN-EL4a batteries or AC adapter),
6 fps (with EN-EL3a battery)

✦ **Live View (LV) mode**

✦ **Self-timer mode**

✦ **Mirror-up (Mup) mode**

White balance: Auto (TTL [Through-the-
Lens] white balance with 1,005-pixel RGB
[red, green, blue] sensor), seven manual
modes with fine-tuning, color temperature
setting, white balance bracketing possible
(2 to 9 frames in increments of 1 to 3)

Live View: Hand-held shooting mode: TTL
Phase-detection autofocus (AF) with 51
focus areas (15 cross-type sensors); Tripod
shooting mode: focal-plane contrast AF on a
desired point within a specific area

LCD monitor: 3-inch, approximately
920,000-dot (VGA), 170-degree wide view-
ing angle, 100 percent frame coverage,
low-temperature polysilicon TFT LCD with
brightness adjustment

Playback function:

✦ Full frame

✦ Thumbnail (4 or 9 segments)

✦ Zoom

✦ Slideshow

✦ RGB histogram indication

✦ Shooting data

✦ Highlight point display

✦ Auto image rotation

Delete function: Card format, All photo-
graphs delete, Selected photographs delete

Video output: NTSC (National Television
System Committee) or PAL (Phase Alternating
Line); simultaneous playback from both
the video output and on the LCD monitor
available

HDMI output: Supports HDMI (High-
Definition Multimedia Interface) version
1.3a; Type A connector is provided as HDMI
output terminal; simultaneous playback
from both the HDMI output terminal and on
the LCD monitor not available

Text input: Up to 36 characters of alphanu-
meric text input available with LCD monitor
and Multi-selector; stored in Exif header

Lens mount: Nikon F mount with AF cou-
pling and AF contacts

Compatible lenses:

✦ **DX AF Nikkor.** All functions possi-
ble

✦ **D-/G-type AF Nikkor (excluding IX
Nikkor lenses).** All functions possi-
ble (excluding PC Micro-Nikkor)

✦ **AF Nikkor other than D-/G-type
(excluding lenses for F3AF).** All
functions except 3D Color Matrix
Metering II possible

✦ **AI-P Nikkor.** All functions except
Autofocus, 3D Color Matrix
Metering II possible

✦ **Non-CPU AI Nikkor.** Can be used in exposure modes Aperture Priority (A) and Manual (M); electronic range finder can be used if maximum aperture is 5.6 or faster; Color Matrix Metering and aperture value display supported if user provides

Viewfinder: Single lens reflex–type with fixed eye-level pentaprism; built-in diopter adjustment (–2.0 to +1.0 m-1)

Eyepoint: 19.5 mm (–1.0 m-1)

Focusing screen: Type-B BriteView Clear Matte screen Mark II with superimposed focus brackets and On-Demand grid lines

Viewfinder frame coverage: Approximately 95 percent (vertical and horizontal)

Viewfinder magnification: Approximately 0.72x with 50mm f1.4 lens at infinity

Autofocus: TTL phase detection, 51 focus points (15 cross-type sensors) by Nikon Multi-CAM 3500FX autofocus module; Detection –1 to +19 EV (ISO 100 at 20 degree C/68 degree F); AF fine adjustment possible. Focal-plane contrast (in Live View [Tripod] mode)

Lens servo: Single-servo AF (S); Continuous-servo AF (C); Manual (M); predictive focus tracking automatically activated according to subject status in Continuous-servo AF

Focus point: Single AF point can be selected from 51 or 11 focus points Live View (Tripod mode); Contrast AF on a desired point within entire frame

AF area mode:

✦ Single point AF

✦ Dynamic Area AF (9 points, 21 points, 51 points, 51 points [3D-tracking])

✦ Automatic-area AF

Focus lock: Focus can be locked by pressing Shutter Release button halfway (Single-servo AF) or by pressing AE-L/AF-L button

Exposure metering system: TTL full-aperture exposure metering using 1005-pixel RGB sensor

✦ **3D Color Matrix Metering II.** 3D Color Matrix Metering II (type G and D lenses); Color Matrix Metering II (other CPU lenses); Color Matrix Metering (non-CPU lenses if user provides lens data; metering performed)

✦ **Center-weighted.** Weight of 75 percent given to 6, 8, 10, or 13 mm diameter circle in center of frame or weighting based on average of entire frame (8 mm circle when non-CPU lens is used)

✦ **Spot.** Meters approximately 3 mm diameter circle (about 2.0 percent of frame) centered on selected focus point (on center focus point when non-CPU lens is used)

Exposure metering range:

✦ 0 to 20 EV (3D Color Matrix or center-weighted metering)

✦ 2 to 20 EV (spot metering) (ISO 100, f/1.4 lens, 20 degrees Celcius)

Exposure meter coupling: Combined CPU and AI (Auto indexing)

Exposure modes:

✦ Programmed Auto [P] with flexible program

✦ Shutter Priority Auto [S]

✦ Aperture Priority Auto [A]

✦ Manual [M]

Exposure compensation: Plus or minus 5 EV in increments of 1/3, 1/2, or 1 EV

Auto exposure lock: Detected exposure value locked by pressing Auto Exposure-Lock/Autofocus-Lock (AE-L/AF-L) button

Auto exposure bracketing: Exposure and/or flash bracketing (two to nine exposures in increments of 1/3, 1/2, 2/3, or 1 EV)

Picture Control system: Four setting options: Standard, Neutral, Vivid, Monochrome; each option can be adjusted

Shutter: Electronically controlled vertical-travel focal plane shutter, 1/8000 to 30 s in steps of 1/3, 1/2, or 1 EV, Bulb

Sync contact: X=1/250 s; flash synchronization at up to 1/320 s (FP) adjustable with built-in Speedlight or optional Speedlight (will reduce Guide Number, or GN)

Flash control:

✦ **i-TTL.** TTL flash control by 1,005-pixel RGB sensor, built-in flash, SB-900, SB-800, SB-600, or SB-400: i-TTL balanced fill flash and standard i-TTL flash

✦ **AA (Auto Aperture-type) flash.** Available with SB-800 and SB-900 used with CPU lens

✦ **Non-TTL Auto.** Available with Speedlights such as SB-800, 28, 27, and 22S

✦ **Range-priority manual flash.** Available with SB-800 and SB-900

Flash Sync mode:

✦ Front-curtain Sync (normal)

✦ Red-Eye Reduction

✦ Red-Eye Reduction with Slow Sync

✦ Slow Sync

✦ Rear-curtain Sync

Built-in Speedlight: Manual pop-up with button release

Guide Number: (ISO 200, m/ft): approximately 17/56 (manual 18); (ISO 100 equivalent, m/ft): approximately 12/39 (manual 13)

Flash compensation: –3 to +1 EV in increments of 1/3, 1/2, or 1 EV

Accessory shoe: ISO 518 Standard hot-shoe contact with safety lock provided

Sync terminal: ISO 519 standard terminal

Creative Lighting System: With Speedlights such as SB-900, SB-800, SB-600, SB-400, and SB-R200, supports Advanced Wireless Lighting, Auto FP High-Speed Sync, Flash Color Information Communication, modeling flash, and FV lock

Self-timer: Electronically controlled timer with duration of 2, 5, 10 or 20 sec.

Depth-of-field preview: When CPU lens is attached, lens aperture can be stopped down to value selected by user (A and M mode) or value selected by camera (P and S mode)

Remote control: Via 10-pin terminal or WT-4A Wireless Transmitter (optional)

GPS: NMEA 0183 (version 2.01 and 3.01) interface standard supported with 9-pin D-sub cable (optional) and MC-35 GPS cable (optional)

Supported languages: Chinese (Simplified and Traditional), Dutch, English, Finnish, French, German, Italian, Japanese, Korean, Polish, Portuguese, Russian, Spanish, and Swedish

Power source: One EN-EL3e Rechargeable Li-ion battery, MB-D10 Multi-Power battery Pack (optional) with one EN-EL4a, EN-EL4 or EN-EL3e Rechargeable Li-ion battery or eight R6/AA-size alkaline (LR6), Ni-MH (HR6), lithium (FR6) batteries, or nickel-manganese ZR6 batteries; EH-5a AC adapter (optional)

Tripod socket: 1/4 in. (ISO 1222)

Custom settings: 48 settings available

Operating environment: Temperature 0–40 degrees Celsius/32–104 degrees Farenheit: under 85 percent (no condensation)

Dimensions (W × H × D): Approximately 5.8 × 4.8 × 3 in. (147 × 114 × 74 mm)

Weight: Approximately 1.82 lbs. (825 g) without battery, memory card, body cap, or monitor cover

Supplied accessories (differ by area and country): EN-EL3e Rechargeable Li-ion battery, MH-18a quick charger, UC-E4 USB cable, EG-D100 video cable, AN-D700 Strap, BM-8 LCD monitor cover, Body cap, DK-5 eyepiece cap, DK-23 rubber eyecup, Software Suite CD-ROM

Optional accessories: MB-D10 Multi-Power Battery Pack, WT-4a Wireless Transmitter, DK-21M magnifying eyepiece, EH-5a AC adapter, Capture NX2 Software, Camera Control Pro 2

Online Resources

lot of valuable information is available on the Internet for photographers. This appendix serves as a guide to some of the resources that can help you learn more about the Nikon D700 and photography in general, as well as help you discover online photo-sharing sites and online photography magazines.

Informational Web Sites

With the amount of information on the Web, sometimes it is difficult to know where to look or where to begin. The following are a few sites to start with when you want to find reliable information about your Nikon D700 or about photography in general.

Nikonusa.com

Nikonusa.com (http://nikonusa.com) gives you access to the technical specifications for Nikon cameras, Speedlights, lenses, and accessories. You can also find firmware updates here should they become available. The Learn and Explore section inspires you to be creative and take great pictures.

Nikon School

Nikon (http://nikonschool.com/) offers courses in digital photography and workflow techniques all over the country in select cities.

Nikonians.org

Nikonians.org (www.nikonians.org) is a forum where you can post questions and discussion topics for other Nikon users on a range of photography-related topics.

Photo.net

Photo.net (http://photo.net) contains resources such as equipment reviews, forums on a variety of topics, tutorials, and more. If you are looking for specific photography-related information and aren't sure where to look, this is a great place to start.

Photo Sharing and Critiquing Sites

Flickr.com

Flickr.com (http://flickr.com) is a site for posting your photos for others to see. The users range from amateurs to professionals, and there are groups dedicated to specific areas, including the Nikon D700.

Photoworkshop.com

Photoworkshop.com (http://photoworkshop. com) is an interactive community that allows you to participate in competitions with other photographers by providing assignments as well as giving you a forum to receive feedback on your images.

ShotAddict.com

ShotAddict.com (http://shotaddict.com) is a photography site that provides photo galleries, product reviews, contests, and discussion forums.

Online Photography Magazines

Some photography magazines also have Web sites that offer photography articles, and they often post information that isn't found in the pages of the magazine. The following is a list of a few photography magazines' Web sites.

Communication Arts
http://commarts.com/CA/

Digital Photographer
http://digiphotomag.com

Digital Photo Pro
http://digitalphotopro.com

Outdoor Photographer
http://outdoorphotographer.com

Photo District News
http://pdnonline.com

Popular Photography & Imaging
http://popphoto.com

Shutterbug
http://shutterbug.net

Glossary

Active D-Lighting A camera setting that preserves highlight and shadow details in high-contrast scenes with a wide dynamic range.

AE (Auto-Exposure) A general-purpose shooting mode where the camera selects the aperture and/or shutter speed according to the cameras built-in light meter. See also *Shutter Priority* and *Aperture Priority*.

AE/AF (Auto-Exposure/Autofocus) lock A camera control that lets you lock the current metered exposure and/or autofocus setting prior to taking a photo. This allows you to meter an off-center subject, and then recompose the shot while retaining the proper exposure for the subject. The function of this button can be altered in the Custom Settings menu (CSM f7).

AF-assist illuminator An LED light that is emitted in low-light or low-contrast situations. The AF-assist illuminator provides enough light for the camera's AF to work in low light.

ambient lighting Lighting that naturally exists in a scene.

angle of view The area of a scene that a lens can capture, determined by the focal length of the lens. Lenses with a shorter focal length have a wider angle of view than lenses with a longer focal length.

aperture The designation for each step in the aperture is called the *f-stop*. The smaller the f-stop (or f/number), the larger the actual opening of the aperture; and the higher numbered f-stops designate smaller apertures, letting in less light. The f/number is the ratio of the focal length to the aperture diameter.

Aperture Priority A camera setting where you choose the aperture, and the camera automatically adjusts the shutter speed according to the camera's metered readings. Aperture Priority is often used by the photographer to control depth of field.

aspect ratio The proportions of an image as printed, displayed on a monitor, or captured by a digital camera.

autofocus The capability of a camera to determine the proper focus of the subject automatically.

backlighting A lighting effect produced when the main light source is located behind the subject. Backlighting can be used to create a silhouette effect or to illuminate translucent objects. See also *frontlighting* and *sidelighting*.

barrel distortion An aberration in a lens in which the lines at the edges and sides of the image are bowed outward. This distortion is usually found in shorter focal-length (wide-angle) lenses.

bokeh A term used to describe the appearance of the out-of-focus areas of a photograph. Derived from the Japanese word *boke*, loosely translated it means "fuzzy."

bounce flash Pointing the flash head in an upward position or toward a wall so that it bounces off another surface before reaching the subject. This softens the light illuminated on the subject. Bouncing the light often eliminates shadows and provides a smoother light for portraits.

bracketing A photographic technique in which you vary the exposure of your subject over three or more frames. By doing this, you ensure a proper exposure in difficult lighting situations where your camera's meter can be fooled.

broad lighting When your main light is illuminating the side of the subject that is facing toward you.

camera shake The movement of the camera, usually at slower shutter speeds, which produces a blurred image.

catchlight Highlights that appear in the subject's eyes.

center-weighted meter A light-measuring device that emphasizes the area in the middle of the frame when you're calculating the correct exposure for an image.

compression Reducing the size of a file by digital encoding, using fewer bits of information to represent the original. Some compression schemes, such as JPEG, operate by discarding some image information, while others, such as RAW with lossless compression, preserve all the detail in the original.

colored gel filters Colored translucent filters that are placed over a flash head or light to change the color of the light emitted on the subject. Colored gels can be used to create a colored hue of an image. Gels are often used to change the color of a white background when shooting portraits or still lifes, by placing the gel over the flash head and firing the flash at the background.

Continuous Autofocus (AF-C) A camera setting that allows the camera to continually focus on a moving subject.

contrast The range between the lightest and darkest tones in an image. In a high-contrast image, the shades fall at the extremes of the range between white and black. In a low-contrast image, the tones are closer together.

D-Lighting A function within the camera that can fix the underexposure that often happens to images that are backlit or in deep shadow. This is accomplished by adjusting the levels of the image after it has been captured. Not to be confused with Active D-Lighting.

DX Nikon's designation for digital single lens reflexes (dSLRs) that use a small APS-C–sized sensor.

dedicated flash An electronic flash unit, such as the Nikon SB-900, ,SB-800, SB-600, or SB-400, designed to work with the automatic exposure features of a specific camera.

default settings The factory settings of the camera.

depth of field (DOF) The portion of a scene from foreground to background that appears acceptably sharp in the image.

diffuse lighting A soft, low-contrast lighting.

digital SLR (dSLR) A single lens reflex camera with interchangeable lenses and a digital image sensor.

DX Nikon's designation for dSLRs with an APS-C sized sensor and the lenses made for use with this sensor size.

equivalent focal length A DX-format digital camera's focal length, which is translated into the corresponding values for 35mm film.

exposure The amount of light allowed to reach the film or sensor, determined by the intensity of the light, the amount admitted by the aperture of the lens, and the length of time determined by the shutter speed.

fill lighting In photography, the lighting used to illuminate shadows. Reflectors or additional incandescent lighting or electronic flash can be used to brighten shadows. One common technique outdoors is to use the camera's flash as a fill.

FX Nikon's designation for dSLRs using a sensor that is equal in size to a frame of 35mm film.

exposure compensation The ability to take correctly exposed images by manually adjusting the exposure, typically in 1/3 stops from the metered reading of the camera. Exposure compensation is usually used in conjunction with auto-exposure settings.

exposure mode Camera settings that let you take photos in Automatic mode, Shutter Priority mode, Aperture Priority mode, and Manual mode. In Aperture Priority, the shutter speed is automatically set according to the chosen aperture (f-stop) setting. In Shutter Priority mode, the aperture is automatically set according to the chosen shutter speed. In Manual mode, both aperture and shutter speeds are set by the photographer, bypassing the camera's metered reading. In Automatic mode, the camera selects the aperture and shutter speed. Some cameras also offer Scene modes, which are automatic modes that adjust the settings to predetermined parameters, such as a wide aperture for the Portrait scene mode and high shutter speed for Sports scene mode.

fill flash A lighting technique where the Speedlight provides enough light to illuminate the subject to eliminate shadows. Using a flash for outdoor portraits often brightens the subject in conditions where the camera meters light from a broader scene.

flash An external light source that produces an almost instant flash of light to illuminate a scene. Also known as *electronic flash*.

flash exposure compensation Adjusting the flash output by +/− 3 stops in 1/3-stop increments. If images are too dark (underexposed), you can use flash exposure compensation to increase the flash output. If images are too bright (overexposed), you can use flash exposure compensation to reduce the flash output.

flash modes Modes that enable you to control the output of the flash by using different parameters. Some of these modes include Red-Eye Reduction and Slow sync.

flash output level The output level of the flash as determined by one of the flash modes used.

front-curtain sync Front-curtain sync causes the flash to fire at the beginning of this period when the shutter is completely open, in the instant that the first curtain of the focal plane shutter finishes its movement across the film or sensor plane. This is the default setting. See also *rear-curtain sync.*

frontlighting The illumination coming from the direction of the camera. See also *backlighting* and *sidelighting.*

f-stop See *aperture.*

full-frame sensor A digital camera's imaging sensor that is the same size as a frame of 35mm film (24×36mm).

histogram A graphic representation of the range of tones in an image.

hot shoe The slot located on the top of the camera where the flash connects. The hot shoe is considered hot because it has electronic contacts that allow communication between the flash and the camera.

ISO sensitivity The ISO (International Organization for Standardization) setting on the camera indicates the light sensitivity. Film cameras need to be set to the film ISO speed being used (such as ISO 100, 200, or 400 film), whereas a digital camera's ISO setting can be set to any available setting. In digital cameras, lower ISO settings provide better quality images with less image noise; however, the lower the ISO setting, the more exposure time is needed.

JPEG (Joint Photographic Experts Group) This is an image format that compresses the image data from the camera to achieve a smaller file size. The compression algorithm discards some of the detail when closing the image. JPEG is the most common image format used by dSLRs.

Kelvin A unit of measurement of color temperature based on a theoretical black body that glows a specific color when heated to a certain temperature. The sun is approximately 5500 K.

lag time The length of time between when the Shutter Release button is pressed and the shutter is actually released; the lag time on the D700 is so short, it is almost imperceptible. Compact digital cameras are notorious for having long lag times, which can cause you to miss important shots.

LCD (liquid crystal display) This is where the camera's images are displayed on the back of the camera.

leading line An element in a composition that leads the viewer's eye toward the subject.

lens flare An effect caused by stray light reflecting off of the many glass elements of a lens. Lens shades typically prevent lens glare, but sometimes you can choose to use it creatively by purposely introducing flare into your image.

lighting ratio The proportion between the amount of light falling on the subject from the main light and the secondary light. An example would be a 2:1 ratio in which one light is twice as bright as the other.

macro lens A lens with the capability to focus at a very close range, enabling extreme close-up photographs.

manual exposure Bypassing the camera's internal light meter settings in favor of setting the shutter and aperture manually. Manual exposure is beneficial in difficult lighting situations where the camera's meter does not provide correct results. When you switch to manual settings, you may need to review a series of photos on the digital camera's LCD to determine the correct exposure.

Matrix metering The Matrix meter reads the brightness and contrast throughout the entire frame and matches those readings against a database of images (over 30,000 in most Nikon cameras) to determine the best metering pattern to be used to calculate the exposure.

metering Measuring the amount of light by using the camera's internal light meter.

mirror lock-up A function of the camera that allows the mirror, which reflects the image to the viewfinder, to be retracted without the shutter being released. This happens to reduce vibration from the mirror moving or to allow sensor cleaning (when the shutter is open).

NEF (Nikon Electronic File) The name of Nikon's RAW file format.

noise Pixels with randomly distributed color values in a digital image. Noise in digital photographs tends to be more pronounced with low-light conditions and long exposures, particularly when you set your camera to a higher ISO rating.

noise reduction A technology used to decrease the amount of random information in a digital picture, usually caused by long exposures and high ISO settings.

pincushion distortion An aberration in a lens in which the lines at the edges and sides of the image are bowed inward. This distortion is usually found in longer focal-length (telephoto) lenses.

Programmed Auto (P) On the camera, the shutter speed and aperture are set automatically when the subject is focused.

RAW An image file format that contains the unprocessed camera data as it was captured. Using this format allows you to change image parameters such as white balance saturation and sharpening after the image is downloaded. Processing RAW files such as Nikon's NEF requires special software, such as Adobe Camera Raw (available in Photoshop), Adobe Lightroom, or Nikon's Capture NX, Capture NX 2, or View NX.

rear-curtain sync Rear-curtain sync causes the flash to fire at the end of the exposure, an instant before the second or rear curtain of the focal plane shutter begins to move. With slow shutter speeds, this feature can create a blur effect from the ambient light, showing as patterns that follow a moving subject with the subject shown sharply frozen at the end of the blur trail. This setting is usually used in conjunction with longer shutter speeds. See also *front-curtain sync*.

red-eye An effect from flash photography that appears to make a person's eyes glow red, or an animal's yellow or green. It's caused by light bouncing from the retina of the eye and is most noticeable in dimly lit situations (when the irises are wide open), and when the electronic flash is close to the lens and, therefore, prone to reflect the light directly back.

Red-Eye Reduction A flash mode controlled by a camera setting that is used to prevent the subject's eyes from appearing red in color. The Speedlight fires multiple flashes just before the shutter is opened.

self-timer A mechanism that delays the opening of the shutter for some seconds after the Shutter Release button has been pressed.

short lighting When your main light is illuminating the side of the subject that is facing away from you.

shutter A mechanism that allows light to pass to the sensor for a specified amount of time.

Shutter Priority In this camera mode, you set the desired shutter speed, and the camera automatically sets the aperture for you. It's best used when you're shooting action shots to freeze motion of the subject using fast shutter speeds.

Shutter Release button When this button is pressed, the camera takes the picture.

shutter speed The length of time the shutter is open to allow light to fall onto the imaging sensor. The shutter speed is measured in seconds or, more commonly, fractions of seconds.

sidelighting Lighting that comes directly from the left or the right of the subject. See also *frontlighting* and *backlighting*.

Single Autofocus (AF-S) A focus setting that locks the focus on the subject when the Shutter Release button is half-pressed. This allows you to focus on the subject and recompose the image without losing focus as long as the Shutter Release button is half-pressed.

Slow sync A flash mode that allows the camera's shutter to stay open for a longer time to allow the ambient light to be recorded. The background receives more exposure, which gives the image a more natural appearance.

Speedlight A Nikon-specific term for its flashes.

spot meter A metering system in which the exposure is based on a small area of the image; usually the spot is linked to the AF point.

TIFF (Tagged Image File Format) A type of file storage format that has no compression, and, therefore, no loss of image detail. TIFFs can be very large image files.

TTL (Through-the-Lens) A metering system where the light is measured directly though the lens.

tungsten light The light from a standard household light bulb.

vanishing point The point at which parallel lines converge and seem to disappear.

Vibration Reduction (VR) A function of the camera in which the lens elements are shifted to reduce the effects of camera shake.

white balance A setting used to compensate for the differences in color temperature common in different light sources. For example, a typical tungsten light bulb is very yellow-orange, so the camera adds blue to the image to ensure that the light looks like standard white light.

Index

Continued

Guides to go

Colorful, portable Digital Field Guides are packed with essential tips and techniques about your camera equipment, iPod, or notebook. They go where you go; more than books—they're *gear*. Each $19.99.

978-0-470-16853-0 978-0-470-12656-1 978-0-470-04528-2

978-0-470-12051-4 978-0-470-11007-2 978-0-7645-9679-7

Also available

Canon EOS 30D Digital Field Guide • 978-0-470-05340-9
Digital Travel Photography Digital Field Guide • 978-0-471-79834-7
Nikon D200 Digital Field Guide • 978-0-470-03748-5
Nikon D50 Digital Field Guide • 978-0-471-78746-4
PowerBook and iBook Digital Field Guide • 978-0-7645-9680-3

Available wherever books are sold

WILEY
Now you know.